EXPOSURE

NATIVE ART + POLITICAL ECOLOGY

RADIUS BOOKS

IAIA Museum of Contemporary Native Arts

The following interviews were conducted by Jenn Shapland
in spring of 2021 to address the history and impacts of uranium
mining and exposure on the Indigenous population in New Mexico.

All interviews have been edited and condensed for clarity.

INTERVIEWEES:

MELANIE LaBORWIT

Museum Educator, curator of Atomic Histories
at the New Mexico History Museum, Santa Fe

DR. JOHNNYE LEWIS

Director of University of New Mexico METALS Sperfund
Research Center, Center for Native Environmental Equity Research

MANNY PINO (ACOMA PUEBLO)

President, Laguna-Acoma Coalition for a Safe Environment

MALLERY QUETAWKI (ZUNI PUEBLO)

Artist-in-Residence, University of New Mexico College
of Pharmacy Community Environmental Health Program

CHRIS SHUEY

Southwest Research and Information Center,
University of New Mexico METALS Superfund Research Center

MELANIE LABORWIT:

It's a weird coincidence, but most uranium, where it is naturally occurring in sufficient quantities for it to be mined, happens to be on federal lands, most of which are tribal. This is not just true here but also in Wyoming, also true in Canada, in Saskatchewan, where it's coming from today, those are mostly on tribal lands. I think a lot of people were sold a bill of goods. When uranium was discovered, there was sort of a myth. There were all kinds of miners, people looking for the next fortune—there were people going around with little Geiger counters, they were looking for the next gold mine. It was about money. In popular science magazines they were selling these kits, "you too can make a great discovery of uranium and make a fortune!" Like gold miners from 100 years ago. All kinds of people were coming out and looking for their treasure, whether Native American or Anglo, there was not a real understanding of what uranium was or how it was going to be used or why it was so valuable.

The scientists involved in the Manhattan Project tested the bomb down at White Sands. Many of the scientists who worked on the project signed a petition to the White House to say, effectively, "Do not use it—we know what it does, do not use it." The Germans had surrendered. But it wasn't just a civilian project, it was also military. The generals asked, "Well, is it a bigger bomb than we've had before, will it end the war? Yes? Okay, then, we'll use it, end of story." They didn't want to know the details. Some of the scientists, though, understood the danger, the real power that was inherent in nuclear energy. Certainly they talked about its potential.

JOHNNYE LEWIS:

The Navajo Nation was extensively mined for the development of the atomic bomb but most heavily afterwards in the nuclear weapons race from the Cold War. And when that ended, and the companies left, they left behind over 500 abandoned mine sites, many of which are not marked, they're not fenced. They are in some cases in the middle of communities. People have walked out with GPS's because they knew where the mine was supposed to be, and they'd be standing right in the middle of it and you couldn't see anything anymore to know it had been there.

MELANIE LaBORWIT:

It's really important for people to think about not just the bomb, which I think is what everybody focuses on, which is plenty big, but to recognize the legacy of uranium mining and also really to think about all kinds of natural resources extraction. One of the mines that I learned about was out near Paguate, which is one of the six villages out on Laguna Pueblo, and at the time that it was running it was the world's largest open pit mine. Of any kind. Uranium gold, coal, all over the world you have open pit mines, this was the biggest open pit mine in the world. Which gives you an idea of the scope. I have a really good friend from Laguna, she's from Paguate, and I said, "Did you know about this?" She said, "Yeah, my uncles worked there." I said, "I'd love to talk to them." She said, "They're all gone. They all died of cancer."

People were driving trucks there, having not been told what any of the dangers of these rocks were that they were blowing to bits. There was detritus all over the place. You blow something to bits, you take the uranium out, and there's all this other rock that was left, and people took it home and built fireplaces with it, the crusher was used to pave roads at Paguate. My friend told me people would come home and they were covered in dust, and they'd take off their uniform and throw it in the washer with the baby's diapers.

In photographs, there are some that show some miners, and they're up to their knees in wet sludge. There was no protective clothing. They had on jeans and a matching denim shirt. They would be down here breathing the dust. Some of them had respirators. We talk about respirators now, there was no sense of the safety measures that were necessary to make people safe on a daily basis.

MANNY PINO:

I began to look at the defense industry, and what percentage of the ore was going to the federal government, to the Department of Defense to make nuclear weapons in the Cold War against the former Soviet Union. I began to see that a significant percentage of the ore from Jackpile was going to make weapons of mass destruction. Even in the Grants mineral belt as well. So I began to inform the public, community people in both Laguna and Acoma. I'd tell the elders, "Do you know what they're doing with this uranium? They're making these weapons that can blow the world up ten times over." The elders would be totally amazed, because they didn't know where the uranium was going. People began asking questions. "Why are we doing this if it's going to blow up the earth?"

MALLERY QUETAWKI:

I don't think any of this would have happened on tribal lands if they had told us what they were going to do. If they had told the tribal communities that this has a potential to harm the environment and possibly you in the future.

MANNY PINO:

As Pueblo people, we believe we're stewards of the land. It contradicts our traditional knowledge when we allow uranium mining, or any form of development, same thing with coal, oil, and gas. The contradiction there between, do we have old tradition or do we participate in technological progress for the economic benefits of employment, and economic contributions to the tribal budget to improve infrastructure on the reservation? So all of those were enticements that the companies used to get the industry in our communities, on our lands. In defense of the tribal governments who made the decisions, they were only looking out for the best interests of their people, but due to the fact that the federal government didn't fully inform them of the impacts, I don't really blame them. But when we look back upon it, many of them regret, at Laguna, that they let the proposals go forward. As now SRIC [Southwest Research and Information Center] is doing soil samples around Jackpile, a metals project looking at other chemical derivatives within the chemistry that evolved from tailings lying dormant in the area for an extended period of time. The Jackpile mine was considered successfully reclaimed in the late 1990s, but here in 2012 they found levels of contamination at the site that were elevated levels that violated current standards. So they're having to re-address the reclamation, the remediation of the Jackpile mine.

MALLERY QUETAWKI:

Because I am from Zuni Pueblo, we consider ourselves custodians and stewards of the land. It's within our cultural decree that we don't desecrate the land, and we don't take unnecessarily. Thinking about that, having that in the back of my mind, and then sitting in on meetings and presentations about all the things that uranium did, and what it can still do, that's where the heartstrings get yanked on my end. The greater tribal nations here in the Southwest have been affected by the uranium mines, they have not been remediated, they have not been cleaned up, there is exposure, and there's not proper signage—things like that really really get under my skin.

MELANIE LaBORWIT:

The mining continued into 1983, when the last one was shut down. It's pretty recent history, and all of that time, nobody who was given these great jobs working in the mines, who were a lot of Native American people, had any idea what the risk was. They were made to—and this went for Anglo people too—feel like they were part of the cause, they were supporting America, it was a good job, it was relatively good paying.

I think that some of these companies certainly did know, and didn't care about the health or welfare of their workers, or the impact that it might have on their communities. Because their communities were too small to register on a map. There were proposals, they were called disposal zones. There were actually proposals in Congress as they were closing these mines down where instead of funding a cleanup, they would just move everybody in Laguna off of the land and put them somewhere else. People were like we've been here for 3000 years we're not going anywhere, fix our water.

MANNY PINO:

The Three Mile Island accident in Harrisburg, Pennsylvania, was April of 1979 I believe, and then four months later, on the Navajo reservation we had the Church Rock spill, which after Three Mile Island is considered the second worst nuclear disaster in the United States. The millions of gallons of ore stored in the mill tailings pond at the Church Rock mill went right down the Puerco River flowing westward toward Arizona. Here it is thirty years later and they still haven't fully reclaimed the area. They're still working in those areas, those chapters of the Navajo Nation in remediating, reclaiming the contaminated soils in those areas.

JOHNNYE LEWIS:

We knew there were mines up on a cliff, and we were conducting interviews, and we actually walked up to houses, and one house that stands in my memory is where mine waste had been pushed over from the top of a mesa over the side of a cliff, and these really fine/refined wastes from the mine had accumulated, and they were nice footing for horses and people were crawling around it, and they had no idea what it was. And so the exposures for communities can be extensive, they can be unrecognized, and we've also got some evidence that this material over the now forty or fifty years since these mines have closed has redistributed and can be impacting other areas.

CHRIS SHUEY:

I remember back to '84, '85, some official out in the Gallup area from Navajo who had been aware of the work we'd been doing with some of the communities called up and said, "Hey, would you be willing to write a letter of support to the Congressional delegation for funding for a new hospital to replace the Gallup Indian Medical Center run by the Indian Health Services?" Yeah, no problem, a couple paragraph letter was sent out. That was thirty some years ago, and that hospital is still there, it is still not replaced, and it is still a mess. It was outdated and antiquated back in that time. We have systematically as a society ignored some of the most vulnerable people in our backyards. And that goes back to the whole issue of racism.

MANNY PINO:

Most of these mining companies, especially those that were operating in the early years, are no longer in existence. You had all these subsidiaries buying out one company after the next after the next, tracing the history of the buyouts of those corporations, and then they go into bankruptcy or no longer exist, then who's legally responsible? That's the term they call the Zombie mines, when the federal government will say well, it's the corporations that did this mess that are responsible. Yeah but you allowed it, right? So all that legal tug of war is still an ongoing kind of finger-pointing process of who's most responsible for this legacy. And the cleanup.

MELANIE LaBORWIT:

Today, Paguate and Laguna Pueblo, actually got some kind of a settlement with EPA [Environmental Protection Agency] and it became a Superfund site. It's miles big. It's huge. If you drive out there now just north of the village, you wouldn't know, if you didn't know to look, you wouldn't know that a mine had been there.

Effectively some of the areas in those places have been made wastelands. The entire area of Jackpile Mine—you realize it was a mine if you know what to look for. But it also struck me as I drove away—there were not any animals grazing in these beautiful grasslands. Big vast grasslands, miles and miles. And there were no animals grazing there.

MANNY PINO:

The Jackpile mine was considered successfully reclaimed in the late 1990s, but here in 2012 they found levels of contamination at the site that were elevated levels that violated current standards. So they're having to re-address the reclamation, the remediation of the Jackpile mine.

You know they say these are low levels, background radiation levels, but when they've been there like thirty, forty, fifty, going on sixty years now, and there's like over a thousand abandoned uranium mines on the Navajo Nation alone, the DOE has determined that the worst 500 have been allocated federal monies to reclaim them. Well what about the other 500 laying dormant on the land? Some of these exposure pathways, of tailings being on the landscape for decades, have contaminated surrounding areas. You know how the wind blows up in mid-Northern New Mexico during this time of the year, 50-60 mph wind, and the pathways through the air, through the spread of contaminated soils into the patterns of key waterways, which are in some cases dormant during most of the year, you know how it is here in the Southwest, but when monsoon season hits, they can become raging waters, raging rivers, another form of the contamination spread. So the fact that the federal government has ignored reclamation on Native land continues to be a health concern and an environmental concern.

JOHNNYE LEWIS:

There has been concern in the communities that they don't know if they are being exposed or not, and they don't know what the health effects are. There were repeated requests to the UN and the US Congress to conduct comprehensive health studies, and those never really happened. And so in 2000 we started working with twenty communities on the Navajo Nation to start collecting data on these community exposures.

What we kept repeatedly hearing was, "what is this doing to our children?"

We have some kids, some babies that are born with uranium in their urine that exceed those levels that I just talked about. That was really the first indication that the uranium can cross the placental barrier, and that the fetus is being exposed. But now that we have data up through age five, we see that those exposures tend to increase over early childhood at least, as long as we have data, for both arsenic and uranium. We see those increasing trends over the first five years of life.

For the people who tend to be in those highest exposure groups, there's also a much higher risk of having preterm birth. And preterm birth is associated with many longer-term developmental delays. We also see a much higher likelihood, almost a doubling, of the rate of autism spectrum disorder, and we're still looking at how that is related directly to exposure, and that's an ongoing question.

There's a relationship between exposure, chronic dysregulation of the immune system, hypertension, and the likelihood of having multiple chronic diseases. If you look at diabetes, kidney disease, cardiovascular disease together, the likelihood that you would have two or three of those conditions is definitely something that's associated with these high rates of exposures. We're also seeing language delay, development of language delay. And we're still trying to track that down.

MALLERY QUETAWKI:

Growing up in Zuni Pueblo, I recognized that so many people are apprehensive of going to the hospital. People did not trust doctors, not so much for the fact that they were afraid of medicine, but it was more about the historical traumas from years past, and the fact that they had no idea how to speak with them, they didn't understand what they were saying. Yes they were speaking English, and Zuni is a language on its own, it isn't taught anywhere but in Zuni, and so it's difficult to communicate, and I recognize that that created a barrier to healthcare. People just didn't want to go to the hospital, because they didn't know how to explain their ailment. They didn't know how to talk about it. That primarily made me want to become a doctor. I wanted to be there and understand that these people have healthcare issues that need to be addressed, because of just so many health impacts in the community that, it's soaring, like diabetes and kidney disease, things of that nature. Watching my family, myself go to a doctor and realize that they had no cultural knowledge to approach people. No proper bedside manner to speak to patients. What I wanted to do was create artwork based on the human anatomy with Zuni designs, cultural icons, and pictures, and now my paintings hang at the Zuni IHS hospital. We recognized that people walked up to these paintings and were looking at them and they saw an importance to it. They said, okay well those are my kidneys right there, that's my heart, how does that work? Why is it so beautiful? Why are these designed this way?

JOHNNYE LEWIS:

I don't think anybody wants to be told that you can have piles and piles and piles of this waste, whether it's nuclear or not—I mean, this is exacerbated because it has a nuclear component—but the waste itself is not good. It's not good psychologically to walk out your door and see somebody else's trash sitting there, in piles that are as big as football fields and taller.

MANNY PINO:

It's like we're second-class citizens, you know. If this was a population in Albuquerque or Phoenix or Denver or someplace like that, the response would probably be a lot greater. And then with the current health disparities that we find on Native nations, now with Covid, many of those underlying conditions we know can be directly correlated with living in a contaminated community, contributing to those health concerns of many Native people today. So these contaminated areas, even the Church Rock spill of the late 1970s, taking like thirty years for the federal government to even begin the cleanup process. Again, the longer these contaminants stay on the land, the greater the threat to future generations.

CHRIS SHUEY:

When it comes to these impacts in Indian Country, it's never on CNN, it's never in the *New York Times*, it's not on the nightly news. There hasn't been a champion, a real visible champion when this stuff doesn't occur in New York City on Manhattan or in LA or San Francisco or Chicago or Houston, it's not important, in the scheme of things. We've seen in coronavirus pandemics the huge disparities that have cost lives in Indian Country, because Native Americans are still an expendable population, that hasn't improved. And until such time as the larger non-Indian population begins to understand and accepts that we of European ancestry stole lands, just came in and took 'em, and a lot of people will say, "Oh well that's what happens, the conquerors get the spoils, and everyone else is subservient." Well that's an Ayn Rand archaic view of society. We have to get over that. And we have to begin to have a whole different perspective on what we know about Native Americans, Native people, Indigenous people. It's not just arts and crafts and beautiful art. The land base has been despoiled, the land base has been reduced. You don't hear talk of reparation. It's still a huge problem.

MALLERY QUETAWKI:

I feel that it is important for researchers and medical professionals and government policy makers to know how important it is that these lands are brought back to as close as possible to healthy as they remember. The connections that Native Americans have to the land, just the spiritual importance to us as a people and our own sovereignty issues that we have surrounding trying to get our ancestral lands back or to even correct wrongs that have been done in the past regarding our land. And the sacredness of us as a people is our physical bodies, especially when it comes to biological sampling. I would like for researchers in the lab to know that when they are working with a specimen, it was given up with the utmost hesitance, and the belief that this specimen will be treated with respect and possibly in fact returned, because as Native Americans when we do return back to the earth, when we do pass on at the end of our lives, our belief and our viewpoint on that is that we return whole. Even hair, blood, fingernails, teeth shedding, things like that are really important to us. The individual is whole by the time that their time comes to rejoin the earth. Taking those ideas and also making sure that the science side knows that, and that these samples were a lot harder to come by than just going to the hospital and taking a blood draw on the average person. This had a lot of thought going into it before it was given up. We're not trying to force feed anybody, especially in these communities, to give up samples. We just want them to be informed. Informed consent is the biggest thing.

EXPOSURE

NATIVE ART + POLITICAL ECOLOGY

The exhibition *Exposure: Native Art and Political Ecology* was co-curated by iBiennale Director Dr. Kóan Jeff Baysa; Nuuk Art Museum Director Nivi Christensen (Inuit); Hokkaido Museum of Modern Art Chief curator and Vice Director Satomi Igarashi; Art Gallery of New South Wales Assistant Curator of Aboriginal and Torres Strait Islander Art Erin Vink (Ngiyampaa), independent curator Tania Willard (Secwepemc Nation), and MoCNA Chief Curator Manuela Well-Off-Man.

EXHIBITION SCHEDULE

August 20, 2021–July 10, 2022
IAIA Musuem of Contemporary Native Arts, Santa Fe, NM

August–November 2022
Fred Jones Jr. Museum of Art, Norman, OK

January–June 2023
Armory Center for the Arts, Pasadena, CA

CONTENTS

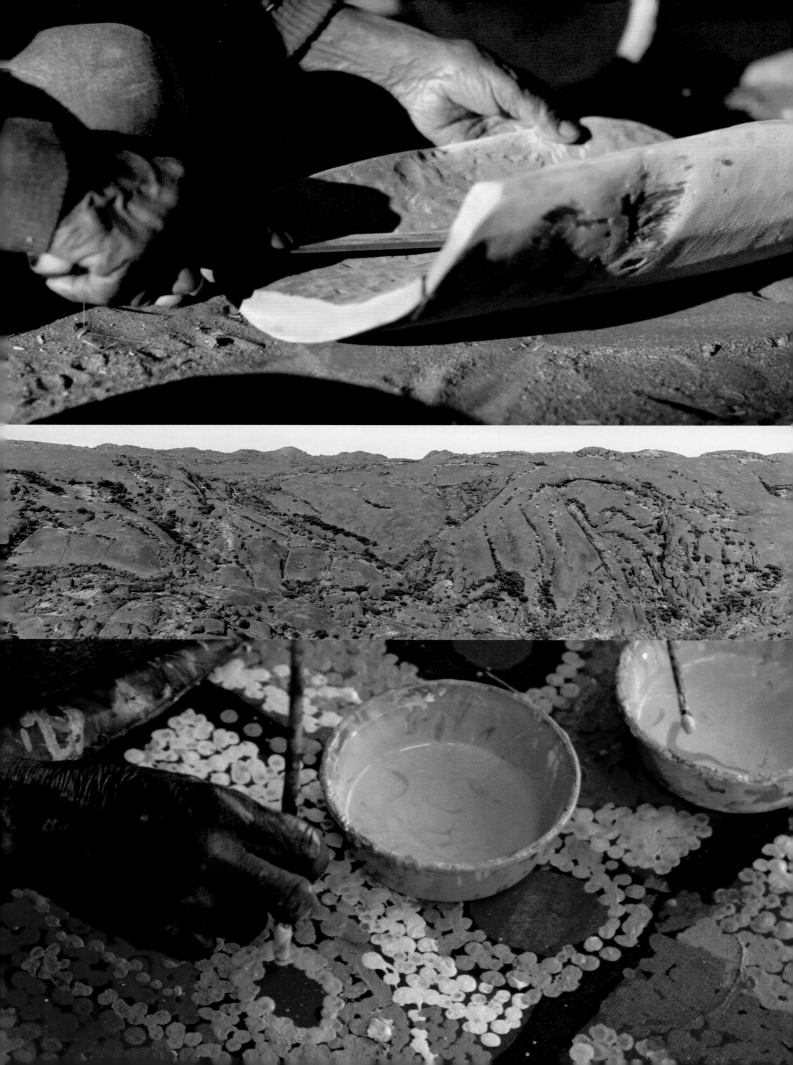

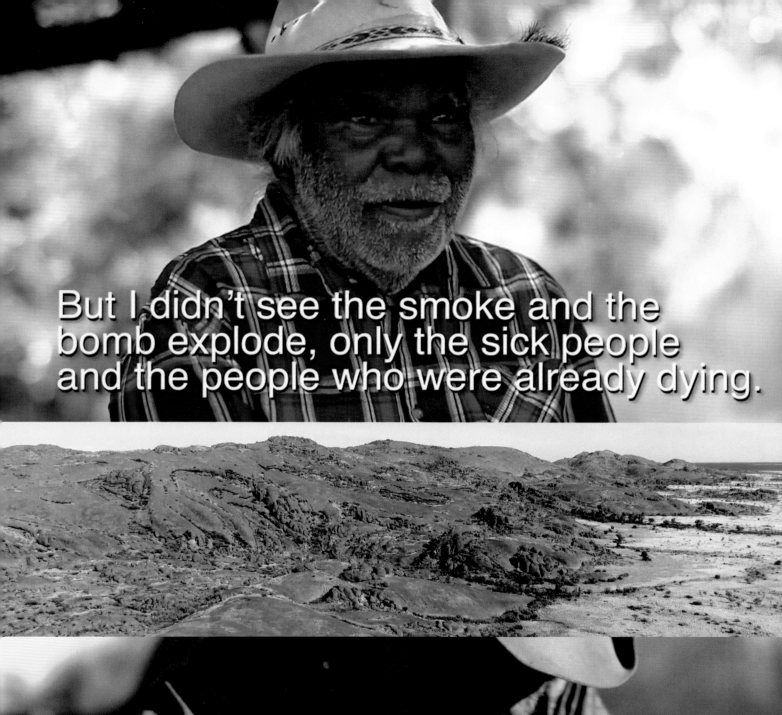

But I didn't see the smoke and the bomb explode, only the sick people and the people who were already dying.

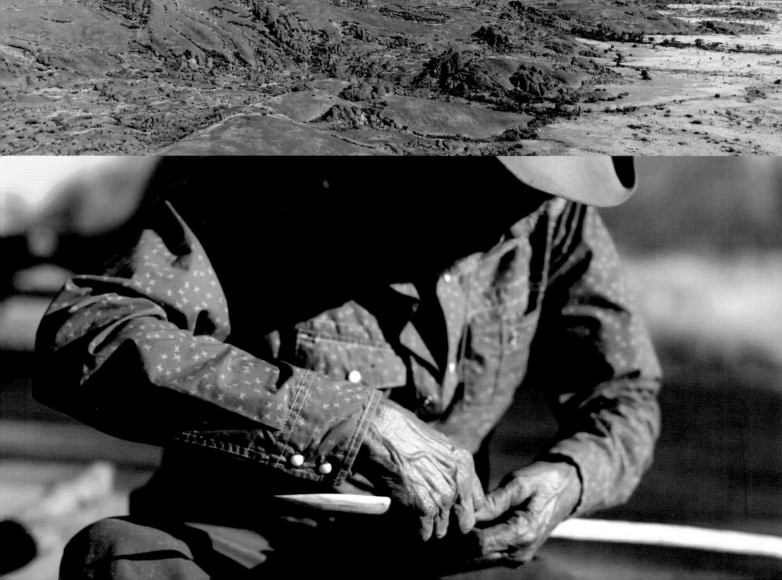

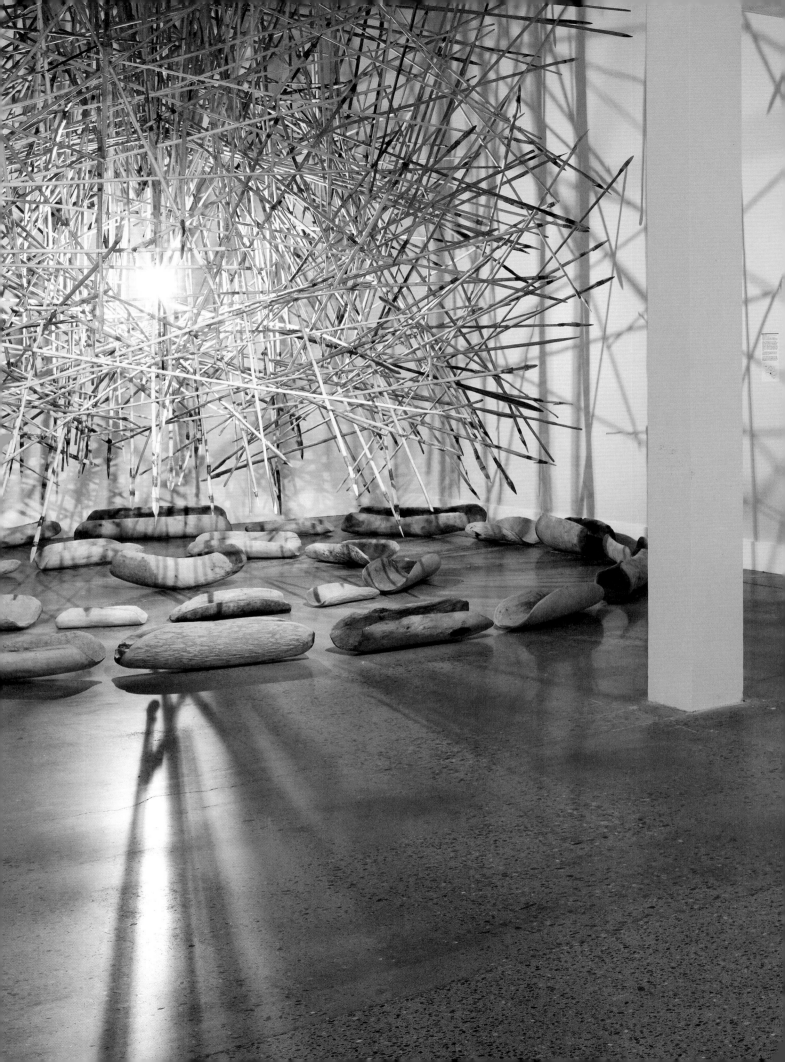

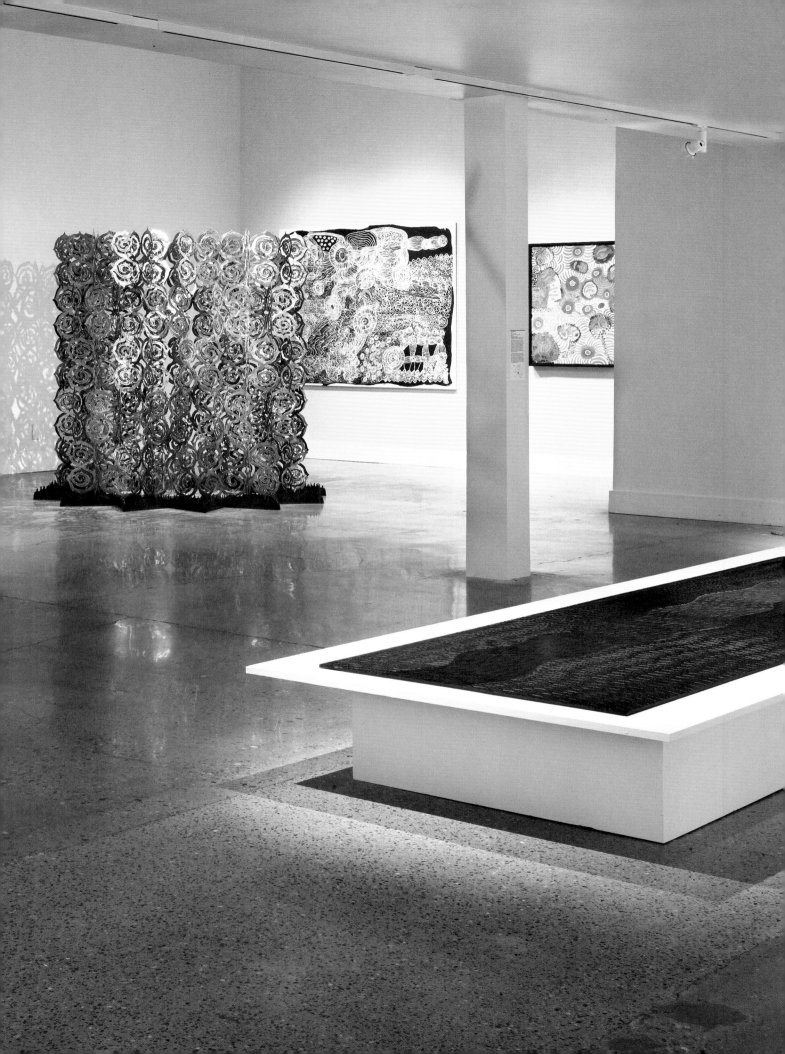

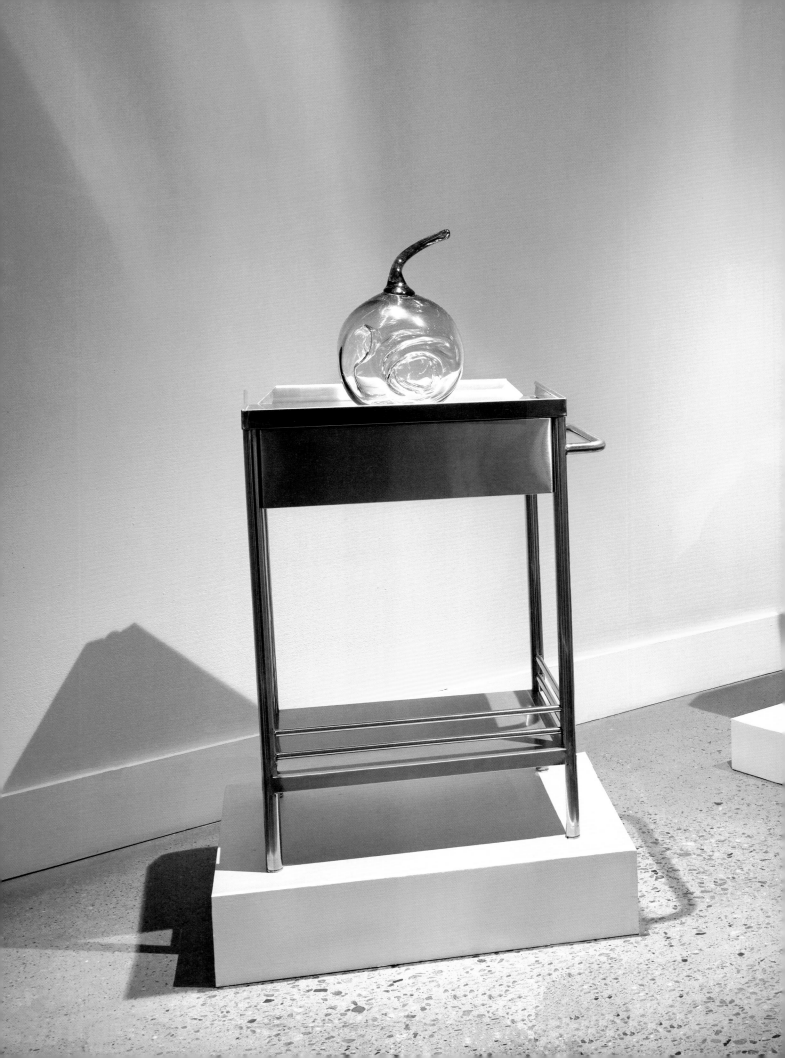

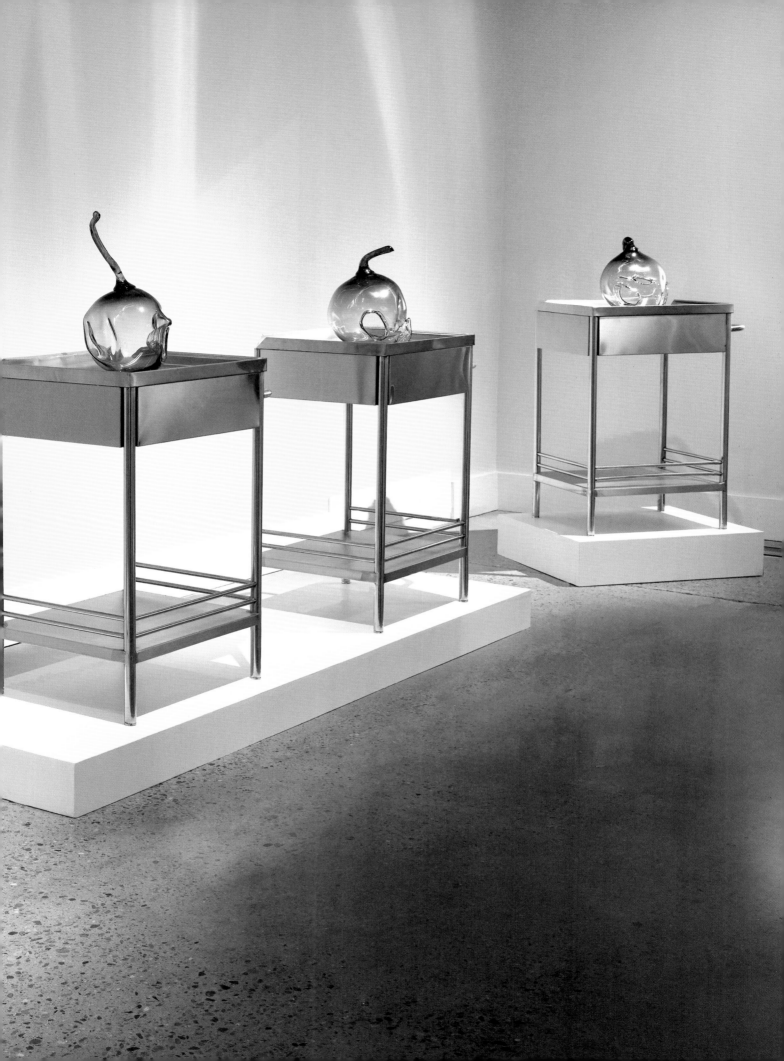

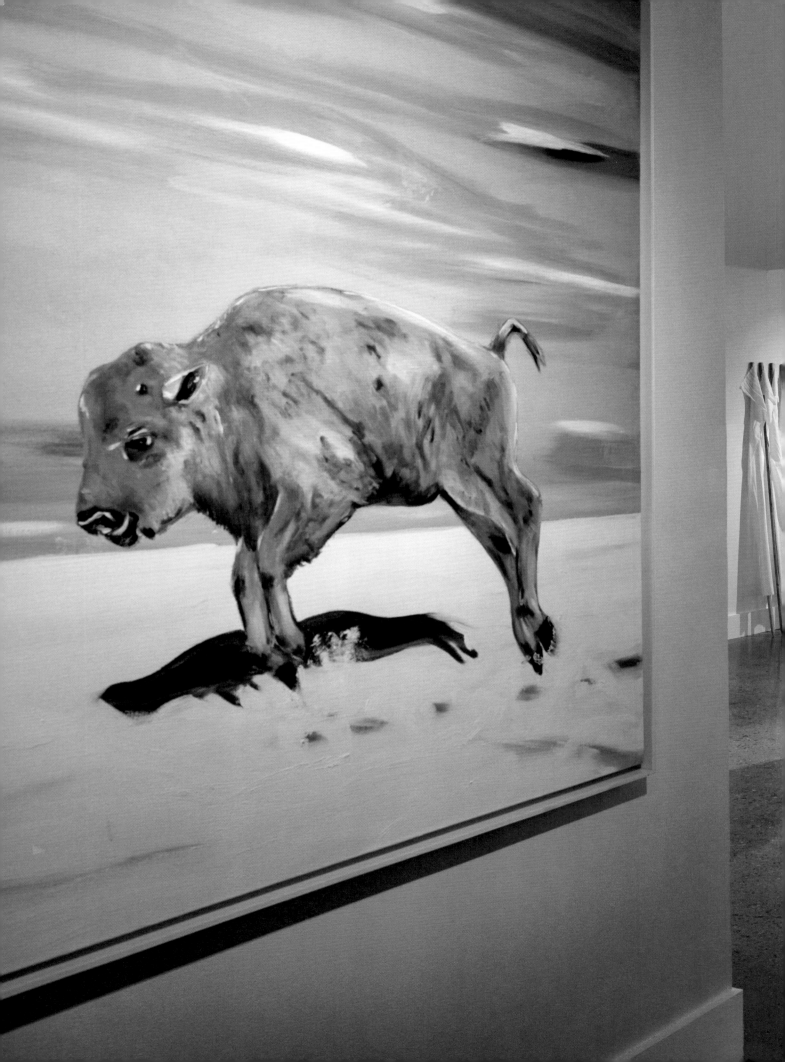

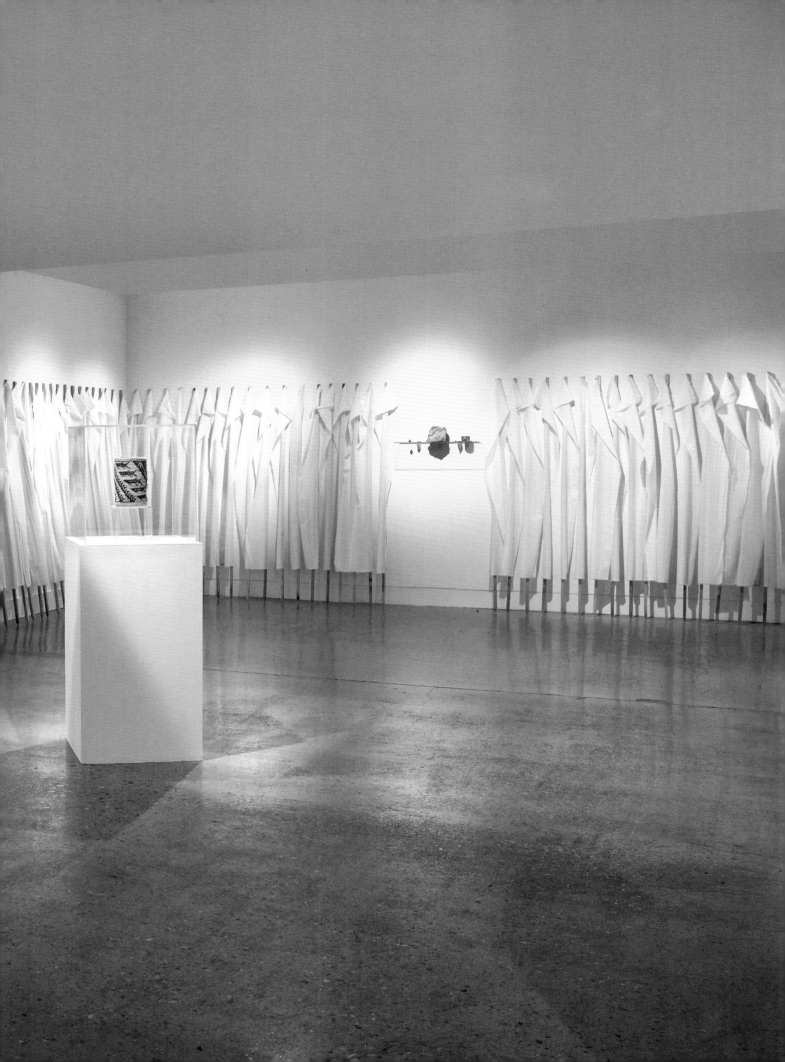

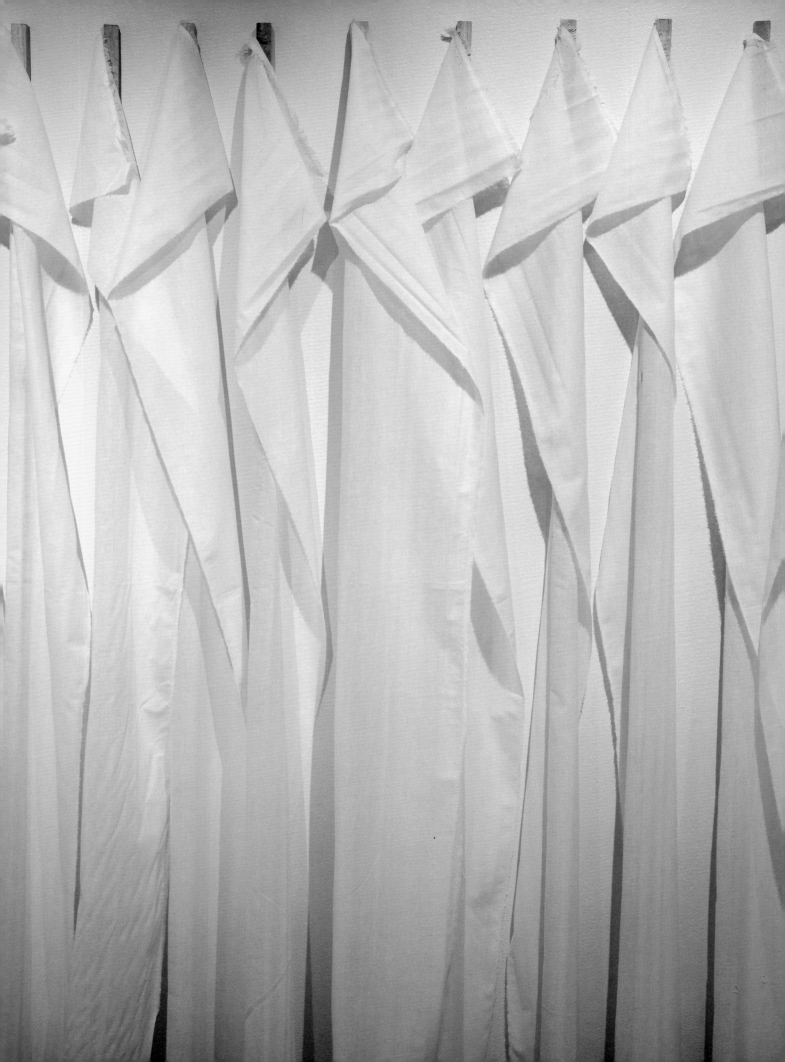

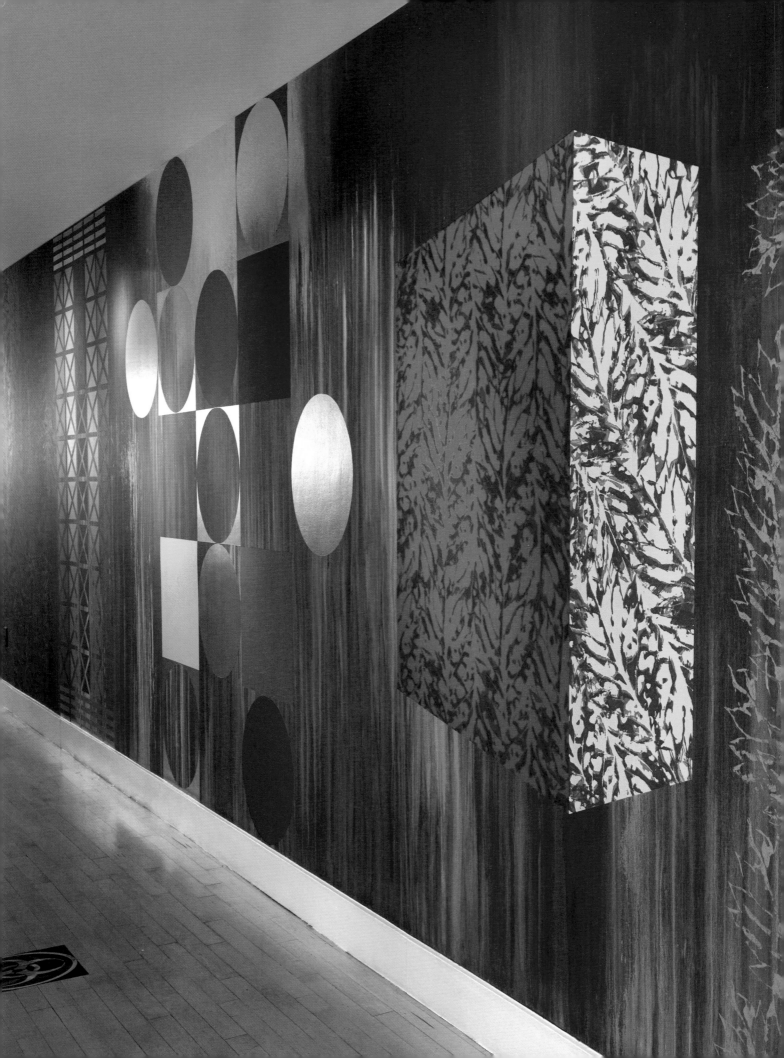

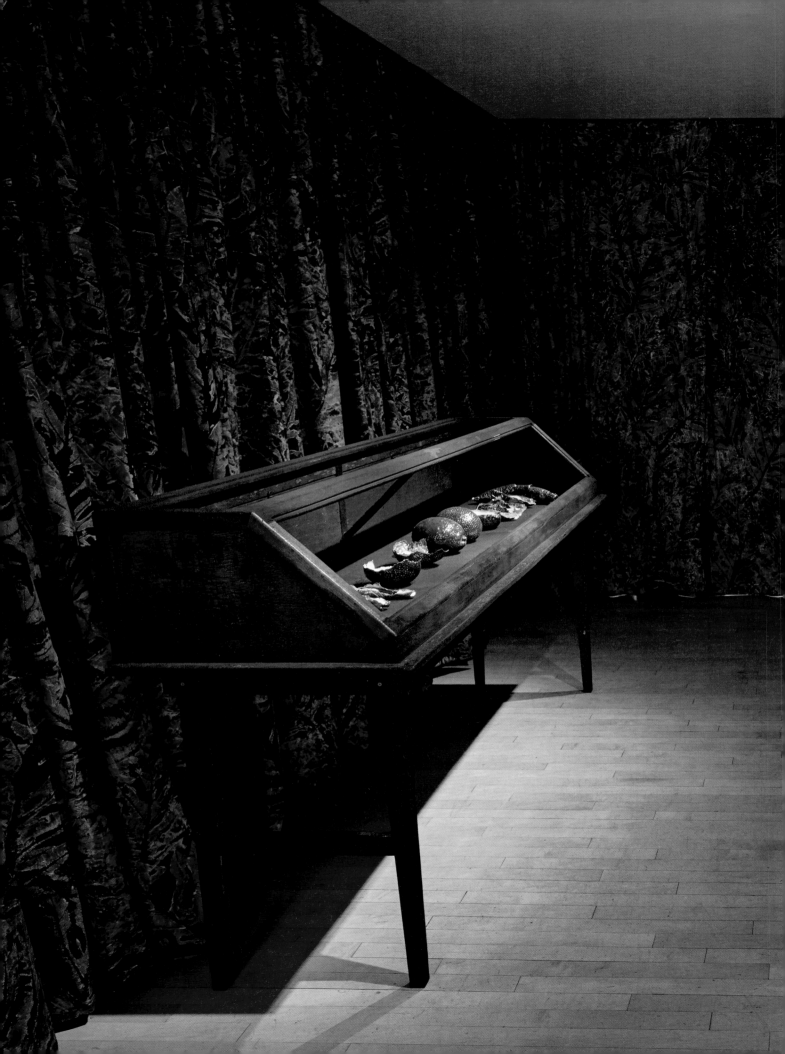

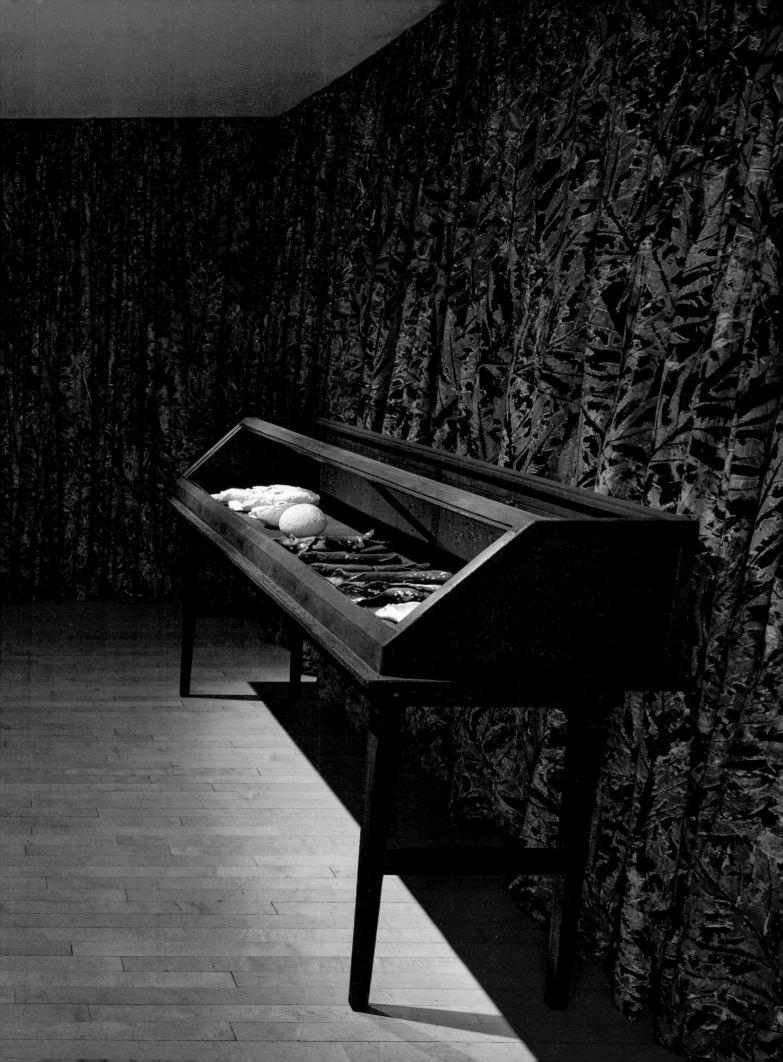

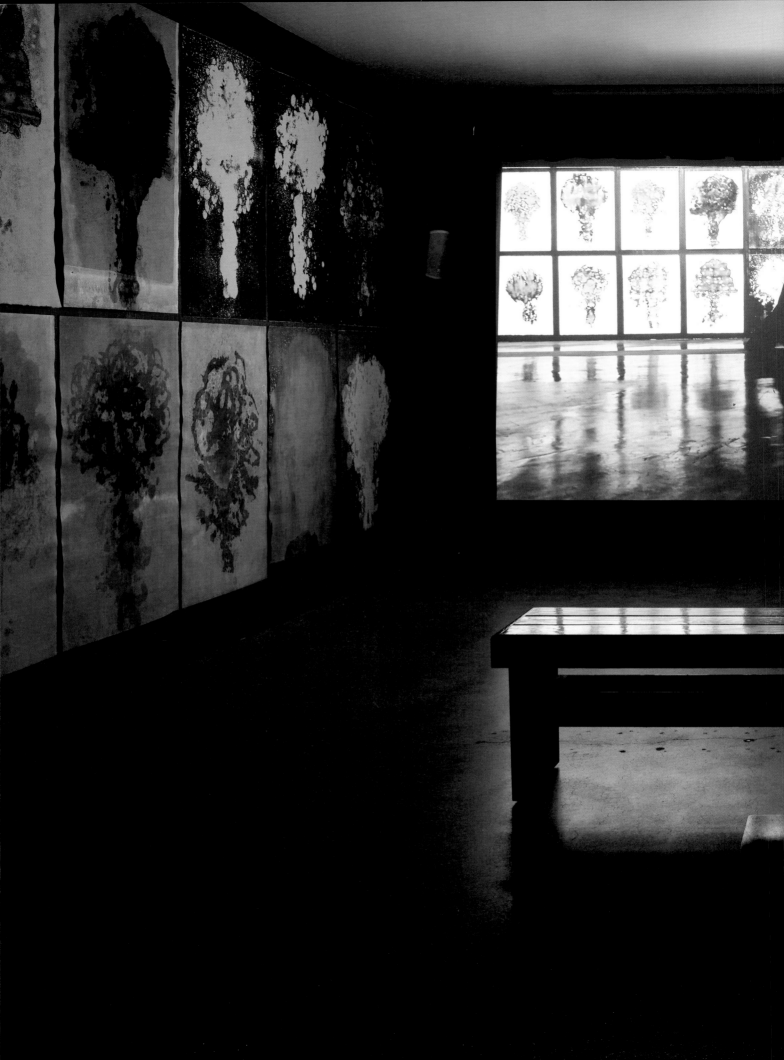

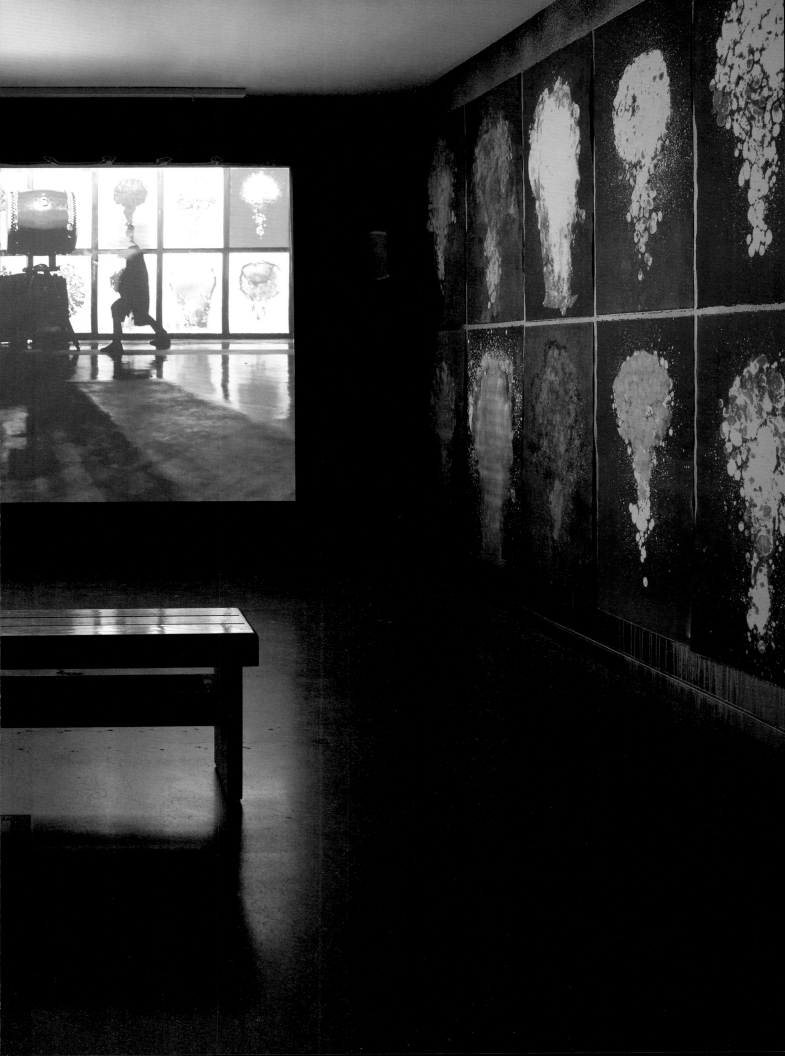

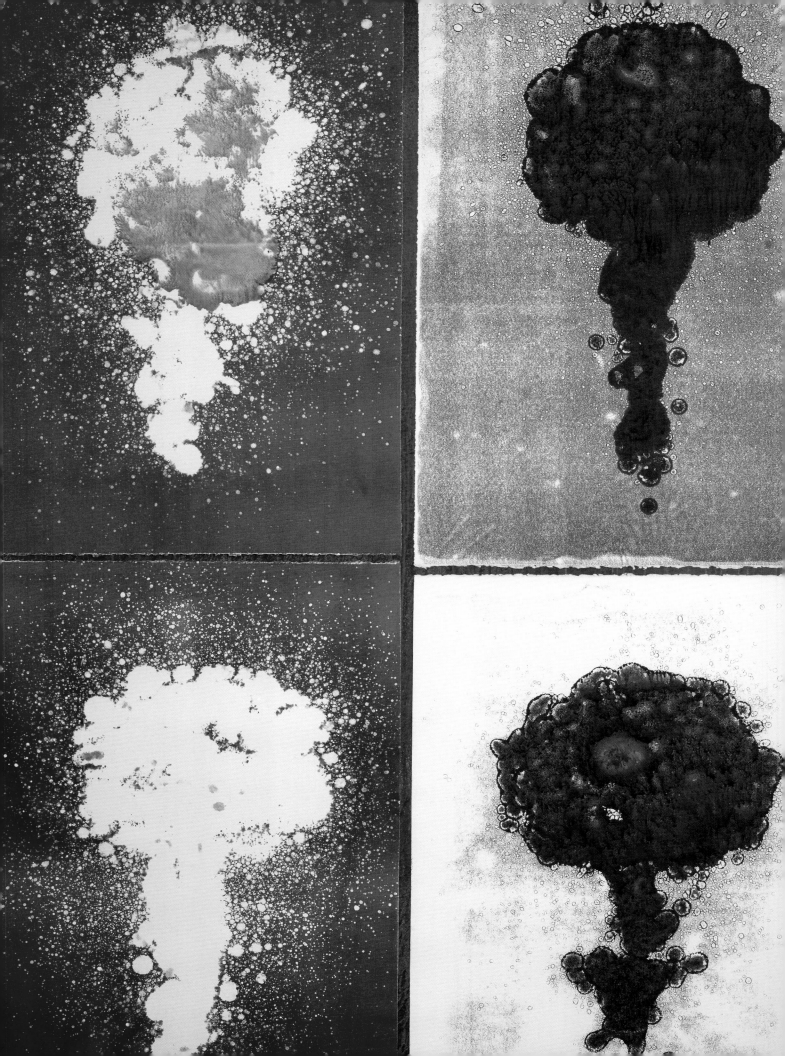

INTRODUCTION

Patsy Phillips (Cherokee Nation)

Director, IAIA Museum of Contemporary Native Arts

Nuclear tests, uranium extraction, and toxic waste have had a deadly impact on Indigenous communities for decades. Sanctioned by governments and big corporations, mining and radioactive storage continue to take place on Indigenous lands. As an agent of change and discourse, environmental issues align with MoCNA's commitment to address the most urgent issues and to seek progressive engagement with various cultures through the arts. Conceptualized by Chief Curator Dr. Manuela Well-Off-Man, *Exposure: Native Art and Political Ecology* uncovers the inequality of mining on Native homelands and serves as a platform to generate public awareness. This initiative exemplifies the power of museums to highlight and communicate the challenges facing Indigenous communities worldwide. *Exposure* focuses on Indigenous Peoples' viewpoints from Australia, Canada, Greenland, Japan, the Pacific Islands, and the United States.

"They never told us uranium was dangerous. . . . We washed our faces in it. We drank in it. We ate in it. It was sweet," says Cecilia Joe, 85, a Navajo (Diné) woman who worked as a miner in 1949 and 1950.[1] The Navajo Nation has a history of uranium mining on their reservation dating back to 1944.[2] The US federal government had studied and documented toxic waste exposure and risk in-depth, but deliberately kept the results secret from the Diné.[3] Sadly, it was not until they began experiencing miscarriages, still-births, congenital disabilities, cancer, lung disease, and kidney damage linked to contamination did they understand the perils. Though the mining on Navajo land is in the past, residents still suffer from the effects of seeping poisonous gases decades later. In Australia, uranium extraction on Aboriginal territory began as early as 1906 by amateurs, and large companies continue to mine their reserves. Suffering the same deleterious health effects as the Navajo from tailings,[4] the Australian government and corporations ignore Aboriginal protests against mining on their reserves. Japan is threatening to place nuclear waste on Hokkaido, the Japanese archipelago's northernmost island, where the country's Indigenous people, the Ainu, live. In the Pacific Ocean, the US conducted nuclear testing between 1946 to 1962 in the Pacific Proving Grounds. Still contaminated from the nuclear fallout, people on the nearby islands continue to suffer health issues.

Greenland's threat of uranium excavation resurfaced after parliament ended its zero-tolerance policy in 2013 and opened the door for companies from other countries to apply for exploration permission.[5] Eighty-nine percent of Greenland's population is Inuit—some who live in fear for their future as their island is under threat of uranium mining. All of these Indigenous Peoples and homelands are negatively affected now and will be for generations into the future.

The artists in *Exposure* reveal major international concerns surrounding nuclear tests, uranium extraction, and toxic waste on Indigenous lands. Indigenous Peoples, like all people, want and deserve their basic needs to be met, such as clean water, uncontaminated food, and fresh air. They want to be healthy; they want their children and families healthy. Unfortunately, uranium mining and nuclear waste on Indigenous lands as it exists do not make this possible. Throughout this exceptional catalog, artists and scholars expose and explore the many complex challenges Indigenous Peoples experience today.

1. Navajo People also refer to themselves by their original name, Diné.

2. Today, there are more than 520 abandoned uranium mines on the Navajo Nation, and the vast majority is not remediated (i.e., cleaned up and environmentally contained). Roughly half of these mines still have gamma radiation levels more than ten times the background level. Nearly all are located within a mile of a natural water source. Furthermore, seventeen are just 200 feet away—or less—from an occupied residence.

3. Mary F. Calvert, "Toxic Legacy of Uranium Mines on Navajo Nation Confronts Interior Nominee Deb Haaland," *Pulitzer Center*, February 23, 2021, https://pulitzercenter. org/stories/toxic-legacy-uranium-mines-navajo-nation-confronts-interior-nominee-deb-haaland

4. Tailings—finely ground residue from ore extraction—are waste byproduct of uranium mining.

5. Greenland is an autonomous territory of Denmark, located between the Arctic and Atlantic oceans. With a population of about 65,000, it is the least densely populated territory in the world. About a third of the population lives in Nuuk, the capital and largest city. Ninety percent of the people who live in Nuuk are Inuit, and 89 percent of Greenland's population is Inuit. The Greenlandic (an Eskimo–Aleut language) and Danish languages are spoken in daily life and public affairs; however, most people can also speak English. Greenland is covered by three-quarters of the only permanent ice sheet outside Antarctica. Nuuk is one of the few towns with paved roads. Driving approximately ten minutes outside of the capitol in any direction are dirt roads. There are virtually no roads connecting towns in all of Greenland.

EXPOSURE: NATIVE ART AND POLITICAL ECOLOGY

Manuela Well-Off-Man, PhD

Exposure: Native Art and Political Ecology documents international Indigenous artists' responses to the impacts of nuclear testing, nuclear accidents, and uranium mining. The exhibition and catalog give Indigenous artists a voice to address the effects of these man-made disasters on Indigenous communities around the world. The first international exhibition of its kind, *Exposure* was developed during the seventy-fifth anniversary of the first nuclear bomb test explosion in New Mexico as well as the bombings of the Japanese cities of Hiroshima and Nagasaki in 1945, and opened during the ten-year anniversary of the Fukushima-Daiichi accident. The main goal for this traveling exhibition and book is to provide a platform for international Indigenous artists to address the long-term effects of nuclear testing, nuclear accidents, and uranium extraction on Indigenous communities and the environment. Much of the atomic testing and related disasters happened many decades ago, with little public knowledge and even less of an understanding of the effects. For this reason, another goal of the exhibition is to create greater awareness of the potentially deadly consequences of nuclear exposure. This includes shedding light on the fact that radioisotopes from nuclear test explosions enter everyone's body and expose us with radiation for our entire lives.[1] Many of these disasters are either forgotten, overshadowed by other environmental catastrophes, or covered up by the companies or governments responsible for them.

Although the United States section of this exhibition focuses primarily on Native artists from the Southwest, the problem of uranium extraction in Indian Country is widespread: the Environmental Protection Agency (EPA) has identified 15,000 abandoned uranium mine locations with uranium occurrence in fourteen western states. About 75 percent of those locations are on federal and tribal lands.[2] There are over 1,000 abandoned uranium mines and mills on the Navajo Nation[2] and over 500 abandoned uranium mines on Navajo and Pueblo lands in New Mexico alone. Before 1962, Native American miners worked in the mines without any protective equipment and lived in houses constructed from contaminated material. Many of them and their family members have died as a result of uranium-related illnesses. Generations later, family members continue to suffer from cancer and birth defects resulting from uranium contamination. New Mexico also became notorious for the development of the first nuclear weapons with the Manhattan Project in Los Alamos, as well as the first atomic bomb test at the Trinity test site, which ultimately led to the first nuclear bomb detonations in Hiroshima and Nagasaki, Japan, in 1945.

The Navajo Nation has one of the world's largest deposits of uranium ore, which has been mined by outside companies since the 1940s. **Will Wilson's** (Diné) triptych *Mexican Hat Disposal Cell, Navajo Nation* (2020) is part of his *Connecting the Dots* series. This drone-based photographic survey documents the contaminated sites of abandoned uranium mines and mills and serves as a platform for voices of resilience.[3] Wilson used the format of a triptych to examine the subject of contamination from uranium mines and disposal sites from multiple perspectives. The Mexican Hat Disposal Cell contains 3.1 million cubic yards of radioactive tailings and waste from demolished buildings that were constructed with contaminated material, including a school. The photos gradually zoom in on a large gray area that looks like a scar in the landscape: it is a twenty-inch layer of coarsely crushed riprap rock that covers a twenty-four-inch-thick radon barrier and the contaminated material. The disposal cell and original mill sites are all on Navajo land. The cell is 1,400 feet long and covers approximately sixty-eight acres. Wilson uses his photography as political intervention and to reclaim a sense of agency. His intention for his *Connecting the Dots* photo survey is to advocate for environmental remediation for the over 500 abandoned uranium mines on Navajo land. One of Wilson's goals is to train Diné scientists and artists in remediation and activism instead of allowing companies to financially benefit from uranium extraction without being held responsible for their pollution. A 2010–2018 University of New Mexico study of 781 Diné women showed that 26 percent had levels of uranium that exceeded amounts found in the highest 5 percent of the US population, and newborns with equally high concentrations show that Navajo continue to be exposed.[4] Wilson's reflections on uranium mining, the resulting

pollution of nature, and the deaths of Native American miners and their families are part of his *Auto Immune Response* series (2005–2019). Featuring himself as a fictional post-apocalyptic narrator, these large panoramic photomontages of Navajo landscapes are both incredibly scenic and dangerously poisonous.

While Wilson's photographs document contamination sites, which are not only toxic health hazards but also eyesores to the landscapes, **Anna Tsouhlarakis'** (Navajo/Creek/Greek) film B*reath of Wind* (2017) reflects on the invisible dangers of radioactivity. Her film explores the long-term effects of the uranium spill near Church Rock, New Mexico, where a 1979 explosion of a nearby dam sent uranium mining waste through the water system which had devastating consequences for the local population. Tsouhlarakis explains in her artist statement, "While not much visible evidence is left of the Church Rock uranium disaster, the catastrophe resurfaces every time the wind blows and sends radioactive particles to the homes and corrals of local residents."[5] Indeed, cancer rates have shown to be highest where radioactive dust has been blown by the wind.[6]

Contamination from radioactive dust is also addressed in the collaborative piece *When They Came Home* (ca. 2017). **Ann Futterman Collier** and **Kim Hahn** (Korean) created a dress in the colors of uranium and the Navajo landscape. Their work tells the story of Navajo miners who brought the poisonous radioactive dust home on their clothing, exposing their families to the deadly material. Using stripes and abstract patterns, **Jane Lilly Benale's** (Diné) weaving is a poetic description of the Navajo land, including the blue sky, life-giving water, sheep, green pastures, layers of brown earth, red ochre rock, turquoise, and healing medicinal plants including juniper and piñon trees. On this land, the sheep now drink uranium-contaminated water. As the artist explains, "offerings of corn pollen for renewal will heal us, and transform us."[7]

Pat Courtney Gold (Wasco/Warm Springs) is another artist who uses customary weaving techniques as a response to radioactive poisoning. Her *Sturgeon Basket* (2005) is woven in the shape of a "sally bag," a Columbia River Plateau (Oregon) basketry style, characterized by a cylindrical shape and used to carry and store foods, medicines, and personal items. Consistent with Wasco sally bag conventions, the design features a ground, skyline, and abstract patterns inspired by ancient petroglyphs from the area. The main motif consists of five sturgeons, fish honored by Pacific Northwest tribes for their strength, size, and longevity: they can grow larger than ten feet, weigh more than 1,000 pounds, and live approximately 100 years. The bottom-most sturgeon is laced with iridescent synthetic threads, which, according to Gold, represent radioactive isotopes from the Hanford Site, a nuclear facility whose waste has contaminated the Columbia River system during the past seven decades. As a result, sturgeons, a traditional food source for area tribes, are suffering from deformations and toxins.

De Haven Solimon Chaffins (Laguna and Zuni Pueblos) has lost many loved ones and has health issues herself due to uranium exposure. Even though her work addresses a serious subject and is very personal, there is often a sign of hope or a hint of humor in her paintings. Most of her relatives worked in the Anaconda Jackpile uranium mine near her home in Laguna Pueblo, NM. *Facing Mortality* (2019) commemorates those family members who died as a result of radiation, including her own son, who appears as a hummingbird in the painting. The title for *Shur/Fine Yellow Cake* (2019) is inspired by the Shurfine cake mix brand available in many grocery stores. Chaffins explains, "the brand is often seen throughout Pueblo Country," and here "yellow cake" also refers to the highly toxic, purified uranium.

Mallery Quetawki's (Zuni Pueblo) diptych *Extraction & Remediation* (2020) chronicles uranium mining on Indigenous lands from the beginnings in the 1940s to recent clean-up efforts of contaminated sacred sites. Her petroglyph drawings on the left part of *Extraction* represent ancient customs and knowledge, which collide with the modern world, symbolized by a circuit board pattern. The uranium vein in the ground has a petroglyph-like design, "as it is meant to 'stay in the ground,' and further along it escapes the ground, signifying extraction and causing the upper environment to become contaminated as the flowers wilt into radioactive symbols," Quetawki explains.[8] The *Remediation* section comments on the need for blending modern science with Indigenous customs and knowledge. She says, "when these ideas work in tandem with one another, we can begin to heal our lands and our people. Our Indigenous ways of life need to be heard and recognized in order to work with current clean-up efforts on our contaminated soils. Sacred sites will always remain sacred and so will our stewardship to the lands in which we were all birthed."[9]

Nuclear colonialism is an international problem: Australia is the second largest uranium producing nation in the world. The country's atomic history began in 1950 when Great Britain secretly negotiated with Australian Prime Minister Robert Menzies to conduct nuclear weapon testing on the Montebello Islands without cabinet consultation.[10] In 1952, Britain carried out twelve major atomic bomb tests in Australia, followed by more than 100 "minor" test explosions on the Montebello Islands, in Emu Field and in Maralinga between 1953 and 1963. The tests have poisoned Aboriginal people and the land, and displaced entire communities. Those who were exposed suffered from miscarriages, disfigurement of children, cancer, lung disease, kidney damage, or death.

For over 17,000 years Australian Aboriginal artists have been illustrating their way of life in relation to nature. The *Exposure* artists continue this tradition, addressing in their own contemporary way how British atomic weapons testing and Australia's uranium mining had devastating effects on their families' and communities' health and lives in their homeland (Country). Pitjantjatjara artists **Karrika Belle Davidson** and **Betty Muffler** personally experienced the atomic bomb tests at Maralinga, South Australia. Muffler was a child when she was exposed to the black mist that contaminated her tribe's land after the atomic bomb tests at Maralinga. Many of her family members, including her parents, didn't survive the exposure to radiation. Her painting *Ngangkari Ngura (Healing Country)* (2019) chronicles her travels through the tribal lands, offering healing to places destroyed by heat and radiation. The painting is rendered in Muffler's characteristic color *kutju* (one color) style using fast, jagged brushstrokes symbolizing the energy that connects her people to their homeland. Davidson's and Muffler's paintings evoke topographical maps. Davidson's *Maralinga Bomb* (2016) features green circles that represent the windbreaks set up to protect people, including her and her son, from the toxic winds. She and several other community members became sick; some of them died. In Muffler's painting the circular shapes represent rockholes that serve as waterholes which have subsequently been contaminated during nuclear tests. The government's removal of Aboriginal families for the atomic weapons testing program enabled and encouraged the control of Aboriginal people from the desert regions, continuing their colonization and discrimination.

One of the central works in *Exposure* is *Kulata Tjuta* (2017) a collaborative installation consisting of over 500 spears (*kulata*) carved by men from the Anangu Pitjantjatjara Yankunytjatjara (APY) Lands, suspended in an atomic explosion frozen in time above thirty-seven wooden bowls (*coolamons*) carved by APY women. The installation and accompanying videos illustrate how Anangu experienced the nuclear tests at Emu Junction and Maralinga between 1953 and 1963. The deadly "black mist" (fallout), symbolized by the pointed shadows, caused illness and death for many Anangu.

Daymil artist **Gunybi Ganambarr's** (Yolngu) sculpture *Gapu* (2017) comments on the major impact uranium mining has on his tribe's land in northeastern Arnhem Land. Ganambarr repurposed a mining conveyor belt, intricately incised with clan symbols, which have for centuries marked their stewardship for their ancestral lands. The diamond design in *Gapu* (freshwater) relates to the meeting of fresh- and saltwater near Gängan, which has always been an important meeting place and sacred site for area clans. However, the government often extinguished title rights of Aboriginal and Torres Strait Islander peoples in favor of mining companies who exploited tribal lands. Traces of white chalk marks in Ganambarr's work hint at this destructive relationship to mining.

For the past decade, **Yhonnie Scarce** (Kokatha/Nukunu) has been investigating the British atomic bomb tests in Maralinga. The toxic fallout traveled to Kokatha land—her grandfather's tribe. Scarce's *Nucleus (U235)* (2021) consists of four blown-glass bush plums with holes and deformations to represent the effects radiation has on the human body. Bush plums are among the traditional food sources for many Aboriginals. The artist explains, "All the bush food I make represents Aboriginal people or culture."[11] The extreme heat of the explosions turned the desert sands to glass, which partly inspired Scarce to use glass as a medium for her works. Her subtitle *U235* stands for uranium 235, which is the only natural nucleus that can easily undergo splitting. However, its half-life is 703.8 million years.

In 1953, uranium was discovered near the Serpent River First Nations Reserve, Canada, in the heart of a sacred mountain. The waste materials of uranium mining have forever poisoned the Serpent River and its watershed. **Carl Beam** (Ojibway) has featured Albert Einstein, who facilitated the development of the atomic bomb, several times over his career. In his etching *Sitting Bull and Einstein* (ca. 1990) he places a portrait of Sitting Bull atop an image of Albert Einstein, prompting viewers to consider the genius of Indigenous knowledge that warns against the harmful ways of Western science. Similar to Beam's reversed hierarchy, **Adrian Stimson's** (Blackfoot) *Fuse 3* (2010) presents the Buffalo prominently in the foreground of the painting, while the atomic explosion is minimized in the background. Although Stimson's work addresses the past buffalo holocaust and the present nuclear threats, his prominent depiction of the Bison also serves as a symbol for survival and cultural regeneration.

Bonnie Devine's (Anishinaabe/Ojibway) installation *Phenomenology* (2015) includes a piece of gneiss, a uranium sample and ninety-two wooden stakes (the atomic number of uranium) covered by ghostly looking muslin sheets. By placing the uranium sample alongside the rock, collected from a uranium processing plant near Devine's home in Serpent River, Ontario, the artist evokes the power of the stone, inviting respect for its known and unknown properties. Originally installed outdoors, the ninety-two white muslin flags fluttered in the wind, warning about the unseen danger of toxic radioactive dust blowing from the uranium plant on her reserve.

Similar to Pat Courtney Gold, **David Neel** (Kwakwaka'wakw) uses a customary artform to warn about nuclear power plants' destruction of nature. *Picturing Nuclear Disaster* (1993), a Northwest Coast-style cedar mask, depicts large nuclear power plants on its forehead, referring to nuclear disasters of Chernobyl, Three Mile Island, and Fukushima.

Because Greenland's ice is melting rapidly, uranium deposits are more accessible than ever before. In 2013, Greenland's parliament ended a zero-tolerance policy for uranium mining. 89 percent of the population are Inuit, and many of them rely on fishing, hunting or farming for their livelihood, which could be jeopardized by toxic and radioactive waste from the proposed Kvanefjeld mine.

Bolatta Silis-Høegh's (Inuit) self-portraits from her *Lights On, Lights Off* series are probably the best-known artistic responses to Greenland's lifted ban on uranium mining. Silis-Høegh became ill when the uranium ban was canceled, stayed in bed for two days with headaches and fatigue, and was very scared for the future.[12] Her painting *Outside* (2015) is the most dramatic of these intense, dark self-portraits. She expresses her rage and fear through slashing brushstrokes, dripping paint, and a bloody sheep head on her vulnerable naked body. Sheep farming is only possible in South Greenland, the location for potential uranium mines. Through her gruesome painting, the artist is warning us that radioactive contamination will lead to deformations and death in animals and humans.

Like Bolatta Silis-Høegh, **Jessie Kleemann** (Inuit) uses her body to express the pain she feels when reflecting on human-made disasters on earth. For her performance *Arkhticós Doloros* (2019), Kleemann exposed her body to the cold winds on Greenland's inland icecap. Next to her is the fast-flowing river of melted inland ice. Because of global warming, Greenland's uranium deposits are now more accessible than ever for extraction. Kleemann wrote a poem following her performance, which emphasizes the connection between the body and the earth. She explains, "Arkhticós Doloros means that we are all in it: it is my pain, it is the Arctic in pain." [13]

While most of the artworks in *Exposure* focus on the deadly effects of radiation, **Ivinguak Stork Høegh's** (Inuit) digital photographs from her series *Qaartorsuaq* (*Big Blast* (2016–2020) illustrate the absurdity of uranium mining and immediate destruction of nature through atomic-bomb-size explosions of Kuannersuit Mountain, which also hint at the use of uranium for nuclear weapons. In her first photocollage, she presents the blown-up landscape as a tondo, a circular format often used in art history to commemorate important events and for its decorative attributes, adding humor to her work. Exaggeration and irony are also apparent in her second work, where a motorcycle gang appears like a threatening invasion of the Kuannersuit area by outsiders and children, borrowed from historic photographs, are frightened for the future even when looking through rose-colored glasses.

On August 6 and 9, 1945, the United States detonated two nuclear bombs over the Japanese cities of Hiroshima and Nagasaki. Over 210,000 people died due to the atomic bombings—most of them were civilians. In March 2011, a 9.0 magnitude earthquake and tsunami struck the eastern coast of Japan, causing a devastating accident at the Fukushima Daiichi Nuclear Power Plant. Radioactive material blew inland and leaked into the groundwater and Pacific Ocean. In Hokkaido, the large northern island that is home to the Ainu, Japan's Indigenous population, surveys have begun to select sites for the disposal of high-level radioactive waste.

Kohei Fujito's (Ainu) sculpture *The Singing of the Needle* (2021) consists of 120 cast iron plates shaped like an Ainu spiral pattern and arranged in a star formation. Each spiral plate has thorns, which are believed to protect the body from demons, protruding on all sides. A painted deer skull attached to a pole is placed in the center of the sculpture. In Ainu culture the deer is revered as *Kamuy* ("deity"). Fujito created the sculpture using Ainu symbols of protection, because he was concerned about the radioactive winds after the Fukushima accident. At that moment, radiation was the worst demon.

OKI (Ainu) is a musician who plays the *tonkori*, a traditional Ainu string instrument, and the founder of the OKI Dub Ainu Band. He became interested in Japanese reggae musician Rankin Taxi's anti-nuclear song "You Can't See It, and You Can't Smell It Either." After the Fukushima accident, Rankin Taxi rewrote the lyrics and OKI's Dub Ainu Band joined the recording. Even though the song is humorous, it also delivers truths about the risks of nuclear power: "innocent kids with thyroid cancer. . . the myth of 'safety' died at Fukushima."

Nuclear bomb testing by the French in French Polynesia, along with the American atmospheric testing 900 miles from Hawai'i and in Micronesia, had severe effects for Tahitians (M–'ohi), Marshallese (Majol) and other Pacific Islanders. Such consequences included forced migration and subsequent discrimination against immigrant Micronesians in Hawai'i, not to mention health issues from radiation exposure for Pacific Islanders.

From 1946–1958, the US conducted sixty-seven nuclear tests within the Marshall Islands, including at the Bikini Atoll. After their displacement to neighboring islands, more than 100 islanders returned to Bikini in 1972 after the United States declared it to be "radiologically safe." However, laboratory tests revealed in 1978 that they had been exposed to dangerously high levels of caesium-137 and strontium-90.[14] The fact that their homeland is uninhabitable indefinitely (the half-life of the plutonium-239 is 24,000 years) was kept from them. Long-term health problems include cancer, miscarriages, stillbirths, and infants with severe birth "defects" including translucent skin and missing bones. **Miriquita "Micki" Davis's** (CHamoru) installation *Pacific Concrete: Portrait of Christian Paul Reyes* (2019) is a deeply personal work about her cousin Christian who was born with these anomalies and survived only about a year. The installation is similar to a memorial and includes photos of Christian and a traditional CHamoru woven mat. It is a story of devotion and love for a child lost due to nuclear exposure.

Kathy Jetñil-Kijiner (Majol) collaborated with **Munro Te Whata** (Maori-Ninuean) and others on *History Project: A Marshall Islands Nuclear Story* (2018) to address these severe health issues. Similar to Will Wilson's *Mexican Hat Disposal Cell*, Kijiner's video poem *ANOINTED* (2017) documents imperfect clean-up attempts after nuclear disasters, resulting in hazardous eyesores on Indigenous lands, such as "The Tomb" on Runit Island, which contaminates the groundwater and marine life.

Alexander Lee's (Hakka/Tahiti) installation *Te atua vahine mana ra o Pere (The Great Goddess Pere)* (2016–2017) evokes a historic progression from Pere's (Pele in Hawai'i) volcanic eruption, as part of the Hawaiian creation story, to the atomic mushroom cloud, as part of Hawai'i's colonial history and the US and France's Pacific nuclear tests. The printed motif on the curtains are leaves of the breadfruit tree, a traditional Polynesian and Hawaiian food, and for Lee a symbol for transformation due to irradiation. The leaves also refer to the Tahitian legend of a man transforming himself into a breadfruit to feed his starving children. Charred vitrines display porcelain flutes, fingerlinks, funnels, fishing wraps, genital wraps, and ceremonial objects, which invite speculation whether these are archaeological finds scorched by Pele's volcanic retribution or relics of a nuclear explosion.[15]

Most of the artists in this exhibition and book have been directly affected by nuclear exposure: they suffer from health issues and have lost loved ones. As a result, their artwork is often deeply personal. Despite the trauma many of these artists and their families have experienced, several of them have created art as a way of healing. All of the artists in this exhibition use different approaches due to different circumstances in their countries and communities, including storytelling, documentary-style photography and video, allegorical sculptures and paintings, body art, irony, and the use of customary materials, processes, and iconography. The majority of artworks focus on the land and the importance of the land to the artist's tribe. Many of the artists in *Exposure* utilize local or tribal knowledge while integrating a mixture of customary and contemporary art forms as visual strategies. However, many of them also blend their tribal designs with contemporary materials or techniques. Several of the artworks also explore the contrast between Indigenous cultures' and mainstream Western culture's very different relationships to uranium and nature. These works are a reminder of the fatal consequences of being exposed to decades of nuclear colonialism.

The creative responses to nuclear disasters in this exhibition are accompanied by detailed analyses by this book's authors, which contribute to a better understanding of the causes and effects of these deadly tragedies. The artworks in this exhibition also reveal a deep expression of the artists' Indigenous identity in connection with the suffering, pollution, and destruction caused by uranium mining and nuclear exposure. Their diverse, visual language addresses their families' and tribes' experiences of death, illness, displacement, dispossession, and slow violence that have long been excluded from the accepted, official narrative.

The artists included in *Exposure* offer critical, experiential, and emotional analyses of the nuclear story and reveal the absence of Indigenous voices in the official narrative, which has been dominated by settler colonialism. Too often, governments, outsider mining companies, and the military initiated uranium extraction and nuclear weapons testing on Indigenous lands without any permission from the tribes. As a result, toxic radiation can still be found in the environment and in the bodies of Indigenous people even decades after exposure. As the artworks in this exhibition reveal, the reasons for uranium mining and nuclear arms testing are rooted in the same ideologies that gave rise to colonialism. Many Indigenous cultures have stories that teach about the importance of leaving uranium in the ground to avoid harm. We need to return to a culture of respect and listen to these stories. Because the half-life of plutonium is 24,000 years and the half-life of U235 is 703.8 million years, it is crucial that artists keep exposing the threats of toxic radiation and nuclear catastrophes for present and future generations.

Endnotes

1. Although there have been important exhibitions related to this subject, they mainly focused on specific nuclear tragedies in their own countries, including Burrinja Cultural Centre's *Black Mist Burnt Country* (Australian touring exhibition 2016–2019); *Hope + Trauma in a Poisoned Land* organized by the Flagstaff Arts Council (August 15–October 28, 2017); Hiroshima-Nagasaki Atomic Bomb exhibitions organized by the Hiroshima Peace Memorial Museum and Atomic Bomb Heritage Section, Nagasaki City Hall; *Atomic Histories: Remembering New Mexico's Nuclear Past* (New Mexico History Museum, June 3, 2018– January 19, 2020), and *Don't Follow the Wind*, an exhibition initiated and organized by the Japanese artist collective Chim↑Pom in response to the Fukushima Daiichi Nuclear Power Plant disaster (2015–present).

2. Doug Brugge, PhD, MS and Rob Goble, PhD, *The History of Uranium Mining and the Navajo People*, accessed February 21, 2021, https://www.ncbi.nlm.nih.gov/pmc/articles/PMC3222290/.

3. Originally, Will Wilson planned to combine his aerial photographs with App-activated portrait photographs that allow Diné people to comment on the uranium mines via a video overlay through Wilson's Talking Tintype App. Wilson also intended to include a map that marks the location of 521 abandoned uranium mines on Navajo lands.

4. Mary Hudetz, "US official: Research finds uranium in Navajo women, babies" in *AP News*, October 7, 2019, accessed March 9, 2021, https://apnews.com/article/334124280ace4b36beb6b8d58c328ae3.

5. Anna Tsouhlarakis in *Hope + Trauma In a Poisoned Land, The Impact of Uranium Mining on Navajo Lands and People*, Coconino Center for the Arts, August 15–October 28, 2017, Flagstaff Arts Council 2017, 36.

6. Traci Brynne Voyles, *Wastelanding: Legacies of Uranium Mining in Navajo Country* (Minneapolis: University of Minnesota Press, 2015), 4-6; 139-140.

7. *Hope + Trauma*, 20.

8. Mallery Quetawki in an email to the author, March 19, 2021.

9. Mallery Quetawki in an email to the author, March 19, 2021. Quetawki's previous paintings were intended to help tribal members to discuss their uranium related illnesses. Sometimes, Native cultural traditions and religious beliefs prevent patients from openly discussing these health issues.

Quetawki's use of tribal designs make patients comfortable to discuss their symptoms. Her paintings also create awareness about how certain customary Southwestern Native foods that contain zinc, such as blue corn, assist in healing DNA proteins damaged by uranium radiation. Quetawki explains, "DNA has the ability to repair itself through complex mechanisms and pathways when damage occurs. Its intricacy of repair can be compared to the creation of beaded items in Native culture … When a beaded necklace comes undone, the stones/beads are restrung by using what is already there … The use of the flower design symbolizes the idea of regrowth."

10. Liz Tynan, "Maralinga nuclear tests, 60 years on: a reminder not to put security before scrutiny" in *The Guardian*, Sept. 26, 2016 https://www.theguardian.com/environment/2016/sep/26/maralinga-nuclear-tests-60-years-on-a-reminder-not-to-put-security-before-scrutiny accessed February 27, 2021. Unsurprisingly, Britain was determined to become the next nuclear nation: the Manhattan Project was originally an Anglo-American collaboration, with British scientists making crucial contributions to the development of the first atomic bomb in the Los Alamos Laboratories in 1943 and 1944.

11. She says that "even in Woomera, where she grew up, (..) children were born with deformities or died at birth…" Yhonnie Scarce in Stephanie Convery, "From Maralinga bombs to bailer shells: the artistic alchemy of Judy Watson and Yhonnie Scarce", *The Guardian*, Jan. 19, 2021, accessed March 7, 2021, https://www.theguardian.com/artanddesign/2021/jan/20/from-maralinga-bombs-to-bailer-shells-the-artistic-alchemy-of-judy-watson-and-yhonnie-scarce.

12. Bolatta Silis-Høegh in Nancy Campbell, "In Clear Sight: Bolatta Silis-Høegh," *Huffington Post*, May 20, 2016, accessed March 16, 2021, https://www.huffingtonpost.co.uk/nancy-campbell/in-clear-sight-bolatta-si_b_10049396.html.

13. Jessie Kleemann, artist statement in *Exposure: Native Art and Political Ecology*, p. 140-143.

14. Kōan Jeff Baysa, *Exposure: Native Art and Political Ecology*, p. 197–205.

15. The charred objects also refer to burning of Polynesian religious artifacts by colonizers. Alexander Lee, artist statement, https://www.alexanderleestudio.com/5633589-2017-te-atua-vahine-mana-ra-o-pere accessed March 8, 2021.

ARTISTS

Adrian Stimson (Blackfoot)

Alexander Lee (Hakka Chinese/Tahiti)

Anna Tsouhlaraskis (Navajo/Creek/Greek)

Ann Collier

APY Art Centre Collective
(Pitjantjatjara/Yankunytjatjara/Luritja/Walpiri/Ngaanyatjarra)

Betty Muffler (Pitjantjatjara)

Bolatta Silis-Høegh (Inuit)

Bonnie Devine (Anishinaabe/Ojibway)

Carl Beam (Ojibway)

Daniel Lin

Dan Taulapapa McMullin (Samoan)

David Neel (Kwakwaka'wakw)

De Haven Solimon Chaffins
(Laguna and Zuni Pueblos)

Gunybi Ganambarr (Yolŋu)

Hilda Moodoo (Pitjantjatjara)

Ivinguak Stork Høegh (Inuit)

Jane Lilly Benale (Diné)

Jessie Kleemann (Inuit)

Jerrel Singer (Diné)

Joy Enomoto (Kanaka Maoli/Caddo)

Kathy Jetñil-Kijiner (Marshallese-Majol)

Karrika Belle Davidson (Pitjantjatjara)

Klee Benally (Diné)

Kim Hahn (Korea)

Kohei Fujito (Ainu)

Kunmanara Queama (Pitjantjatjara)

Malcolm Benally (Diné)

Mallery Quetawki (Zuni Pueblo)

Mariquita "Micki" Davis (CHamoru)

Munro Te Whata (Māori/Niuean)

No'u Revilla (Kanaka Maoli)

OKI (Ainu)

Pat Courtney Gold (Warm Springs)

Rankin Taxi

Solomon Enos (Kanaka Maoli)

Will Wilson (Diné)

Yhonnie Scarce (Kokatha/Nukunu)

ADRIAN STIMSON (BLACKFOOT)

FUSE 1-4 (2010)

I have always been interested in ideas of the apocalypse; perhaps it is an interest created through my experience of being Indigenous in Canada? Or reading *Hiroshima* (John Hersay) and *The Bells of Nagasaki* (Takashi Nagai) at a young age. For many Indigenous people, the destruction of our way of life can be described as an apocalypse—a great disaster. The colonization and resulting genocide decimated First Nations in Canada, yet today we continue to survive and thrive. My intention in creating these works was to pose the question, "Given the magnitude and destruction that the colonial project had and continues to have on First Nations and the environment, can this be forgiven? Or is the settler nation beyond redemption? Can Canada as a nation truly be redeemed for its genocidal ways, or is it doomed to continue on the path of destruction? Only time, self-reflection, and atonement can tell.

The paintings in my *Fuse* series all contain bison situated in wintry landscapes, lit by the blinding flash of an atomic plume swelling on the horizon. In my work, I often use bison as a symbol akin to Indigenous peoples, specifically the Plains, as the bison were a mainstay of Plains culture and life. The almost total annihilation of bison and the people that relied on them happened in a relatively short time, like the flash of an atomic explosion—it offered little room for escape and survival. This annihilation contrasts with much landscape painting of the Americas, whose painters often represented the land with open skies, grand flora and fauna, and without any Indigenous references. Such paintings often evoked *terra nullius*, the land that belongs to no one, thus implying that it was open for colonial settlement. The *Fuse* paintings disrupt that notion by making the bison central, inserting Indigenous ecologies into the dialogue, and interrogating the violence and trauma that is the history of the colonial state. With the destruction of the bison also came the destruction of the land through resource extraction. One cannot ignore the fact that Saskatchewan contains large amounts of uranium. That uranium has been used in the construction of atomic bombs, especially during the atomic race of the second world war. The mining of uranium is dangerous, and the resulting contamination of land is always a concern, especially for those First Nations whose land it's under.

I refer to this definition for *Fuse*: a continuous train of a combustible substance enclosed in a cord or cable for setting off an explosive charge by transmitting fire to it. I see my paintings as akin to a fuse—a continuum of colonization, like the atomic bomb, ready to ignite and destroy everything in its path. A frozen moment in time, just after the ignition, that tension between life and death, the realization that in any moment we can be consumed by that flash. It is a dissonance, an inconsistency between belief and action. Like redemption itself, actions speak louder than words. Can the settler state change? Or is it beyond the ability to change? And if it is beyond redemption, then what?

FOLLOWING SPREAD:

Fuse 3, 2010
Oil and graphite on canvas, 60 × 84 inches
Collection of the Alberta Foundation for the Arts

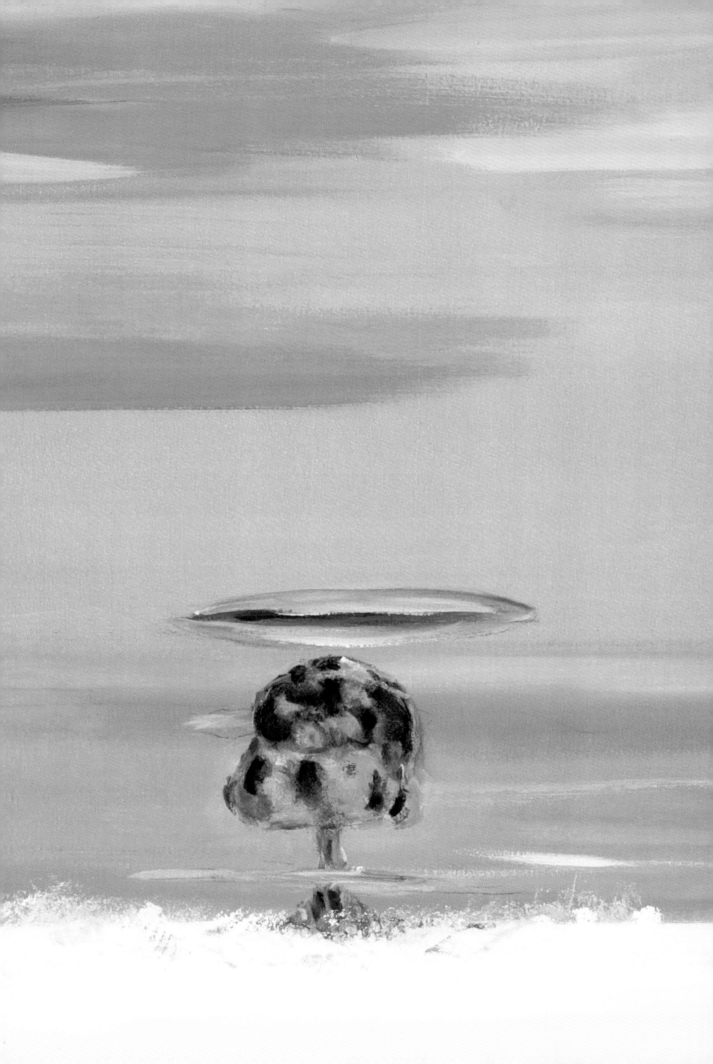

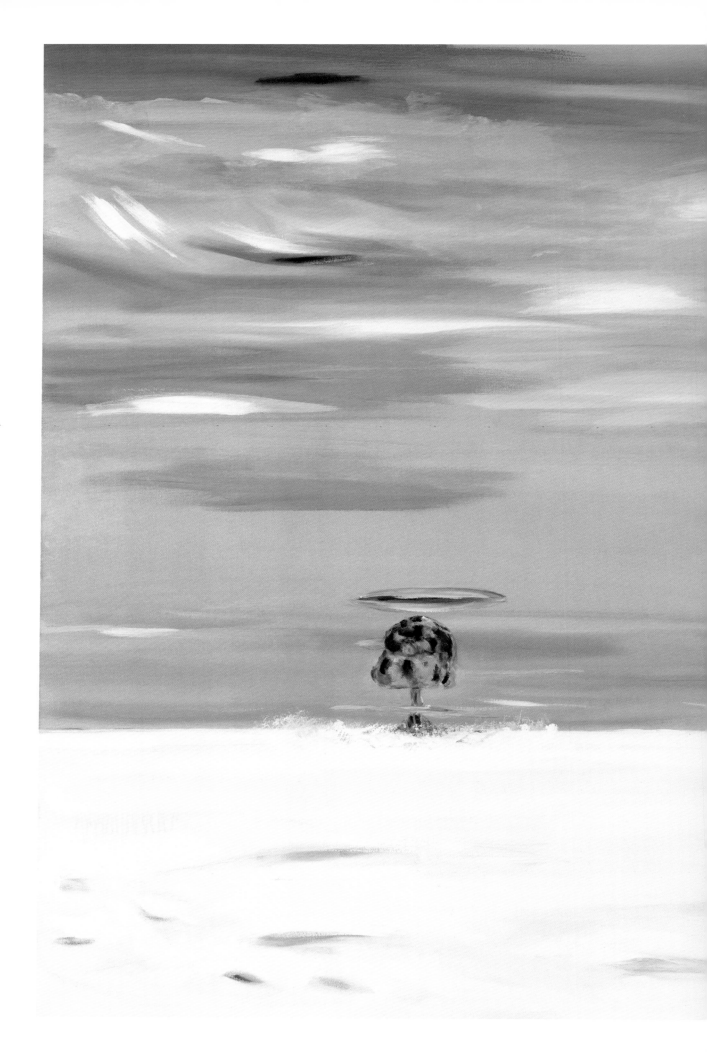

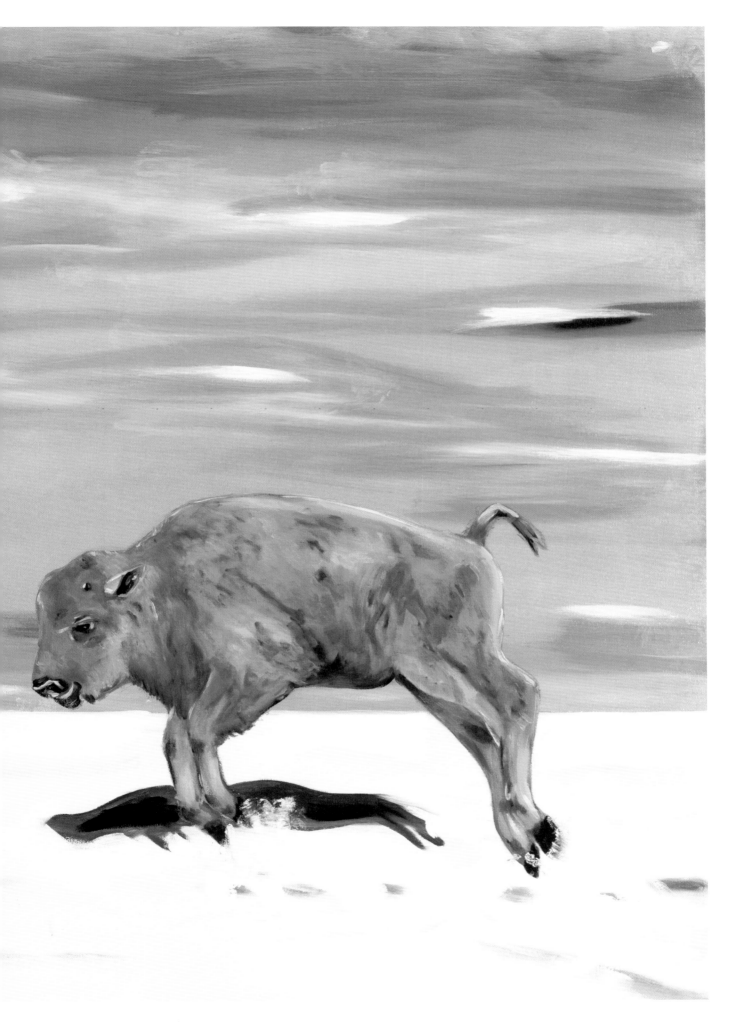

ALEXANDER LEE (HAKKA CHINESE, TAHITI)

SKY-WATERS

My mother always told me that rainwater was the cleanest and most suitable to drink. It was filtered by the skies and did not have the impurities of the soil. Whenever the wind started blowing and the clouds covered the sun, she called me to help her gather basins and place them under the roof gutters. The wind would blow through tree branches; dried leaves floated around, lifting up dust and small debris on its trail. As I felt the first raindrops on my forehead and shoulders, its sound resonated like drumbeats on our metal roof, pounding distinctively at first, but soon cacophonously, cascading down the corrugated metal into the plastic gutters, washing all down into the washbasins we had placed.

Watching the torrent of water gushing down into the buckets was mesmerizing. I would stand, hypnotized by its sheer force, and feel the cool mist of its splatters, my mind exhilarated by its turmoil. After the downpour, we would fill glass containers with it, to be used as cooking and drinking water.

This was Tahiti in the 1980s, when potable water was not standard in French Polynesia. Back then, after a heavy rainfall, water coming out of the faucets would be brown, and one had to let it run a bit so the mud would clear out of the pipes. We drank it from pitchers at the school cantina, or straight out of the faucet on the playground.

It was many years later that I found out about France's forty-six atmospheric nuclear tests over the islands of Moruroa and Fangataufa, in the Tuamotu Archipelago, between 1966 and 1974, the latter being the year of my birth. France would make another 147 underground tests between 1975 and 1996. Even though the memories I describe above happened during the underground tests of the '80s, declassified material shows there have been 368 recorded radioactive fallouts in the 1966–1974 period, thirty-nine of them on the island of Tahiti itself, 1,400 km (about 870 miles) away from Moruroa.

Looking at my mother, now eighty-five and still saving rainwater into washbasins, I wonder how she survived through these radioactive rains? And to my fellow Polynesians and people of this earth, who all drank and have been nourished from these sky-waters, how do we cleanse this world?

—MAHINA, FEBRUARY 24, 2021

Te atua vahine mana ra o Pere (The Great Goddess Pere)–
L' Aube où les Fauves viennent se désaltérer (Dawn, where the beasts quench their thirst), 2017
First installed at the Honolulu Bienniale, 2017; second installation, MoCNA, 2021
Monotypes, cotton, acrylic, porcelain, ceramic, wood, glass, videos

Te atua vahine mana ra o Pere (The Great Goddess Pere) – L' Aube où les Fauves viennent se désaltérer (2017) is an installation in which Alexander Lee reflects on French Polynesia and its nuclear history through Pere (or Pele), the Polynesian goddess of fire who is said to have traveled from Tahiti to Hawai'i. Lee reconstructs a faceted present narrative of Polynesia through its multiple colonial empires and their respective nuclear histories. France conducted forty-six aerial nuclear tests from 1966 until 1974 on the atoll of Moruroa (193 total detonations between 1966-1996), the year of his birth. For Lee, the image of the nuclear explosion is a historical extension of Pere's volcanic eruption.

Lee uses concepts and motifs present in his lexicon of signs that pertain to the current realities, such as the breadfruit leaf made famous by the book *Mutiny on the Bounty.* All of these elements become part of a composition that acts as a visual environment and unfolds as a continuous landscape painting and diorama on the walls at MoCNA.

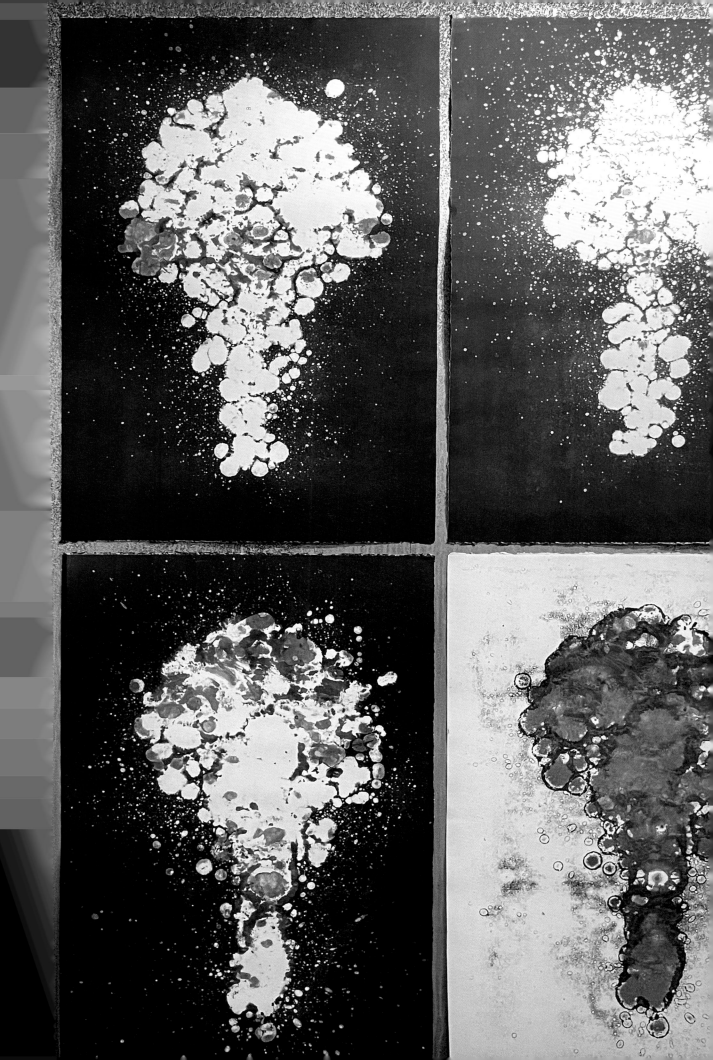

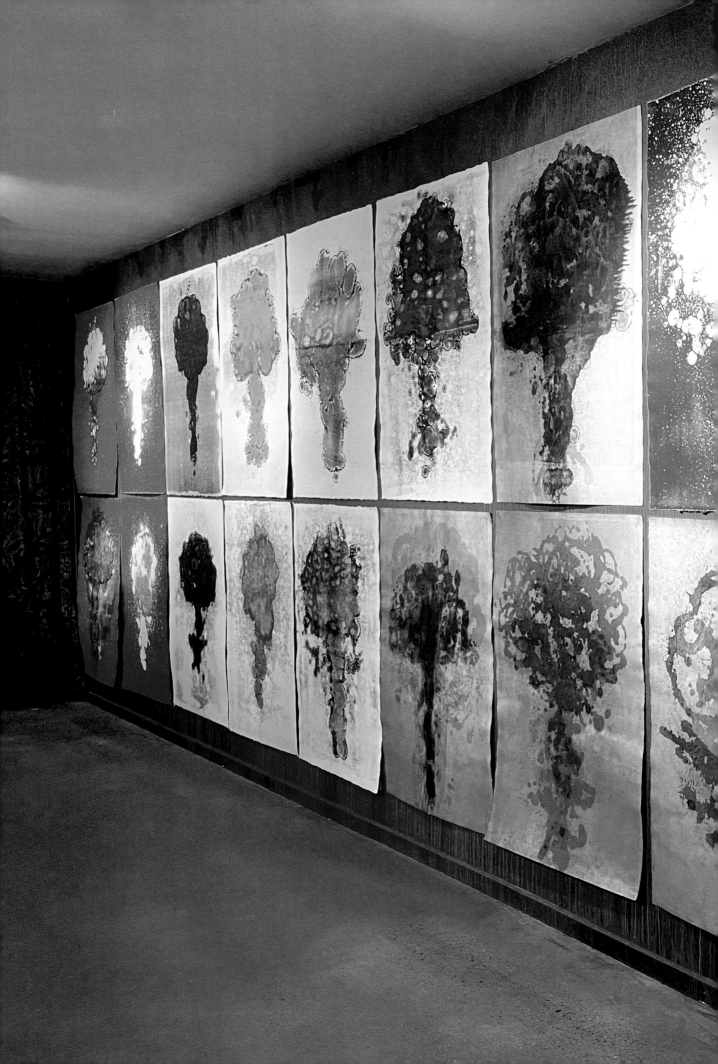

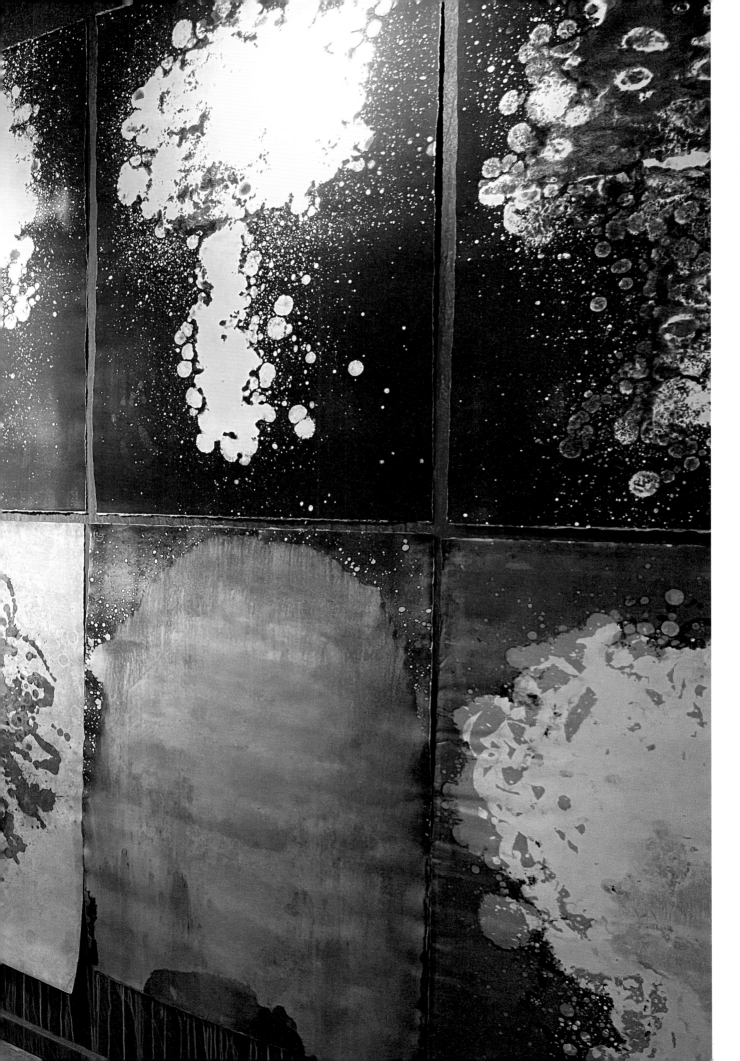

ANNA TSOUHLARASKIS
(NAVAJO/CREEK/GREEK)

Breath of Wind, 2017
Film, 3:18 minutes

Anna Tsouhlarakis' (Navajo/Creek/
Greek) film *Breath of Wind* reflects on
the invisible dangers of radioactivity.
Her film explores the long-term effects
of the uranium spill near Church Rock,
New Mexico, where a 1979 explosion
of a nearby dam sent uranium mining
waste through the water system which
had devastating consequences for the
local population. Tsouhlarakis explains,
"While not much visible evidence is left
of the Church Rock uranium disaster, the
catastrophe resurfaces every time the wind
blows and sends radioactive particles to
the homes and corrals of local residents.
The wind speaks to the forgotten and
diminished stories of the land and people.
It is invisible, constant and unrelenting."

ANN COLLIER
KIM HAHN (KOREAN)
JANE LILLY BENALE (DINÉ)
AND MALCOLM BENALLY (DINÉ)

When They Came Home, 2017
Dyed wool, silver, turquoise
Rug: 37 × 29 inches, Dress: 25 × 18 × 52 inches

Artist's statement:

"When the uranium workers came home, their clothing was tarnished by yellow toxic dust from the mines; their dust stayed in their homes…The Diné bloodlines temper the fabric of the brown earth; the life-giving turquoise, the water is just below and on the land. The red streaks running into water are red ochre rock, earth history, bloodlines of strata. Sheep is life and Water is life."

The rug's multicolored stripes symbolize water, earth, and farming, except for dominant yellow stripes representing the uranium dust that permeates Diné homes. Its understated presence, alongside the larger photo installations, paintings, and other pieces, proves both cathartic for the families involved and eye-opening for those new to this enduring issue.

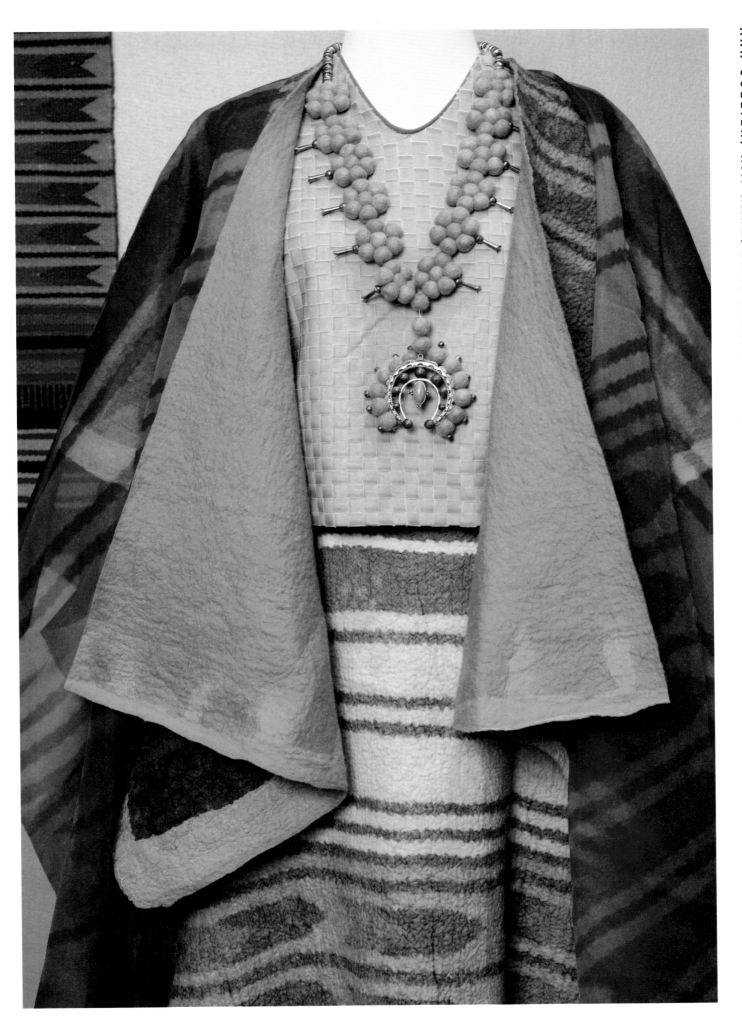

APY ART CENTRE COLLECTIVE
(PITJANTJATJARA/YANKUNYTJATJARA/LURITJA)

Kulata Tjuta (Many Spears), 2017
550 suspended *kulata* (spears), 27 coolamons
Wood, spinifex resin, kangaroo tendon, 6-channel DVD, monitors, sound, color
Ca. 32.8 × 32. 8 feet (10 × 10 meters) circumference

Art Gallery of South Australia, Tarntanya (Adelaide), Australia
Acquired through Tarnanthi: Festival of Contemporary Aboriginal and Torres Strait Islander Art,
supported by Art Gallery of South Australia, Tarntanya (Adelaide), Australia, BHP2017

In 2010, senior men working at Tjala Arts, in the community of Amata in the Anangu Pitjantjatjara Yankunytjatjara (APY) Lands, instigated what is now known as the *Kulata Tjuta* project, or the *Many Spears* project. Initiated by Willy Kaika Bruton, Mick Wikilyiri, Frank Young and four men who have now passed away— Kunmanara (Hector) Burton, Kunmanara (Ray) Ken, Kunmanara (Barney) Wangin and Kunmanara (Tiger) Palpatja—the project began as a means of instilling cultural awareness and pride in the younger generation. The *Tjilpi* (senior men) recognized that skills in weapon and tool making were crucial for cultural identity.

This project coincided with an expanded field of contemporary art opportunities for artists working on the APY Lands, thus leading to the confluence of ancient craft and contemporary art practice. Variations of this project have been staged, with each installation featuring a different number of *kulata*.

Initiated by *Tjilpies* from across the APY Lands, *Kulata Tjuta (Many Spears)* references the effects of the atomic weapons tests on Anangu Country over sixty years ago. The *kulata* hang in an explosive cloud formation, frozen in time and hovering above an installation of hand-carved *piti* (coolamons/bowls) made by Anangu women. Internally lit from a single source, it casts shadows from the explosion on the surrounding walls, alluding to the "black mist" that caused illness and death for many Anangu.

The 550 suspended spears also represent a whirlwind in the desert, called *kupi-kupi*. With strong symbolic power, these swirls are often seen as a manifestation of the spirit of the deceased in Anangu culture.

This work is dedicated to the late Kunmanara (Yami) Lester. Lester lost his sight as a young man through the bomb tests that were conducted on Country. Regardless, Lester worked tirelessly, dedicating his life to ensure the horrors of the Emu Field and Maralinga tests, and its consequences, were made public.

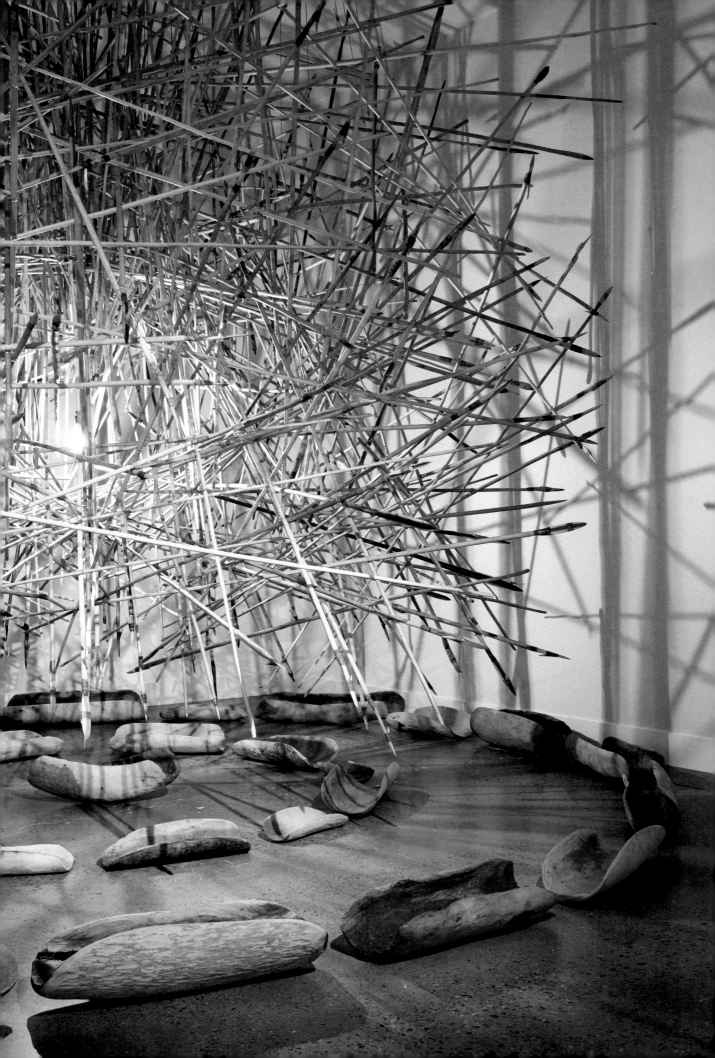

APY ART CENTRE COLLECTIVE

Pitjantjatjara and Yankunytjatjara peoples
Indulkana, Southern Desert region

Alec Baker b 1932

Eric Kunmanara Barney b 1973

Peter Mungkuri b 1946

Vincent Namatjira b 1983

David Pearson b ca.1964

Priscilla Singer b 1968

Pitjantjatjara, Luritja, Yankunytjatjara and Walpiri
peoples, Amata, Southern Desert region

Freda Brady b 1961

Moses Brady b 1993

Michael Bruno b 1944

Cisco Burton b 1963

Kunmanara (Hector) Burton 1937 – 2017

Noel Burton b 1994

Maureen Douglas b 1966

Kunmanara (Ronnie) Douglas 1949 – 2017

Stanley Douglas b 1944

Kunmanara (Willy Kaika) Burton 1941 - 2020

Nyupaya Kaika Burton b 1949

Naomi Kantjuriny b 1944

Kunmanara (Brenton) Ken 1944 – 2018

Freddy Ken b 1951

Kunmanara (Ray) Ken 1940 – 2018

Illuwanti Ken b ca.1944

Kunmanara (Tiger) Palpatja ca. 1920 – 2012

Mary Katatjuku Pan b ca.1944

Aaron Riley b 1974

Adrian Riley b 1961

Kunmanara (Barney) Wangin c 1939 – 2012

Mick Wikilyiri b 1938

Anwar Young b 1994

Frank Young b 1949

Kamurin Young b 1994

Marcus Young b 1998

Yaritji Young b ca.1956

Pitjantjatjara, Luritja and Yankunytjatjara peoples
Pukutja (Ernabella), Southern Desert region

Angela Burton b 1966

Pepai Jangala Carroll b 1950

Kunmanara (Gordon) Ingkatji ca.1930 – 2016

Adrian Intjalki b 1943

Rupert Jack b 1951

Graham Kulyuru b 1939

Errol Morris b 1965

Kevin Morris b 1984

Mark Morris b 1975

William Tjapaltjarri Sandy b 1951

Lydon Stevens b 1967

Lyndon Tjangala b 1994

Pitjantjatjara and Yankunytjatjara peoples
Fregon, Southern Desert region

Taylor Wamyima Cooper b 1940

Arnie Frank b 1960

Witjiti George b 1938

Pitjantjatjara and Yankunytjatjara peoples
Mimili, Southern Desert region

Margaret Ngilan Dodd b 1946

Sammy Dodd b 1946

Kunmanara (Willy Muntjantji) Martin 1950 – 2018

Kunmanara (Mumu Mike) Williams 1952 – 2019

Ngaanyatjarra and Pitjantjatjara peoples
Kalka and Pipalyatjara, Southern Desert region

Jimmy Donegan b 1940

Carol Young b 1972

Roma Young b 1952

Pitjantjatjara peoples
Nyapari, Southern Desert region

Keith Stevens b 1940

Bernard Tjalkuri b ca.1930

Ginger Wikilyiri b 1930

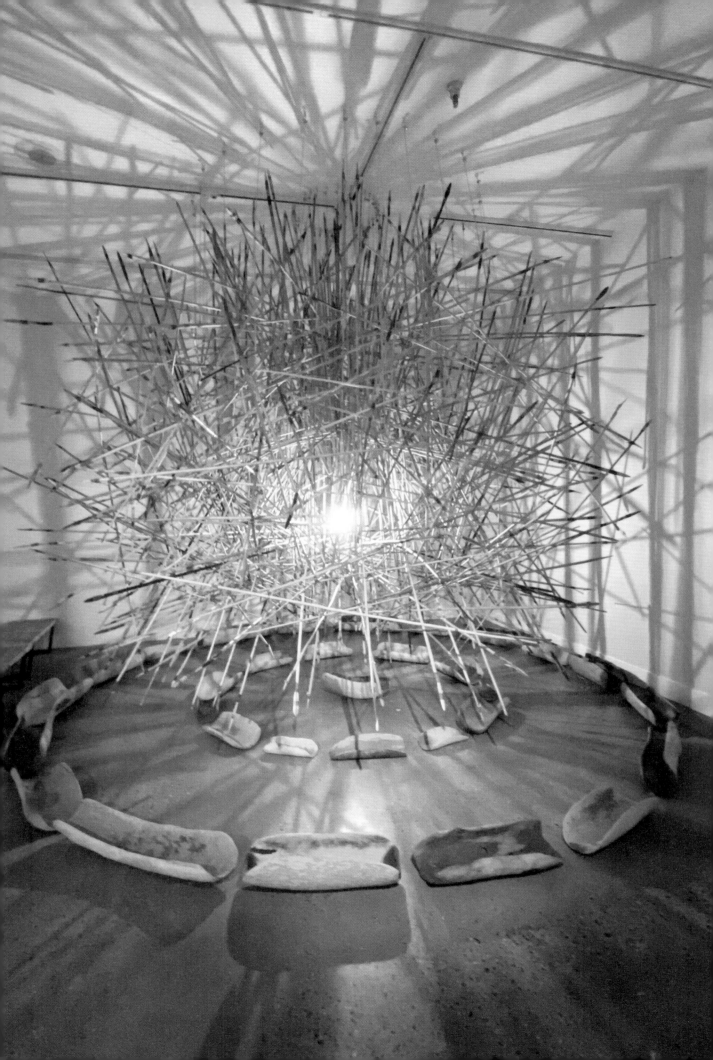

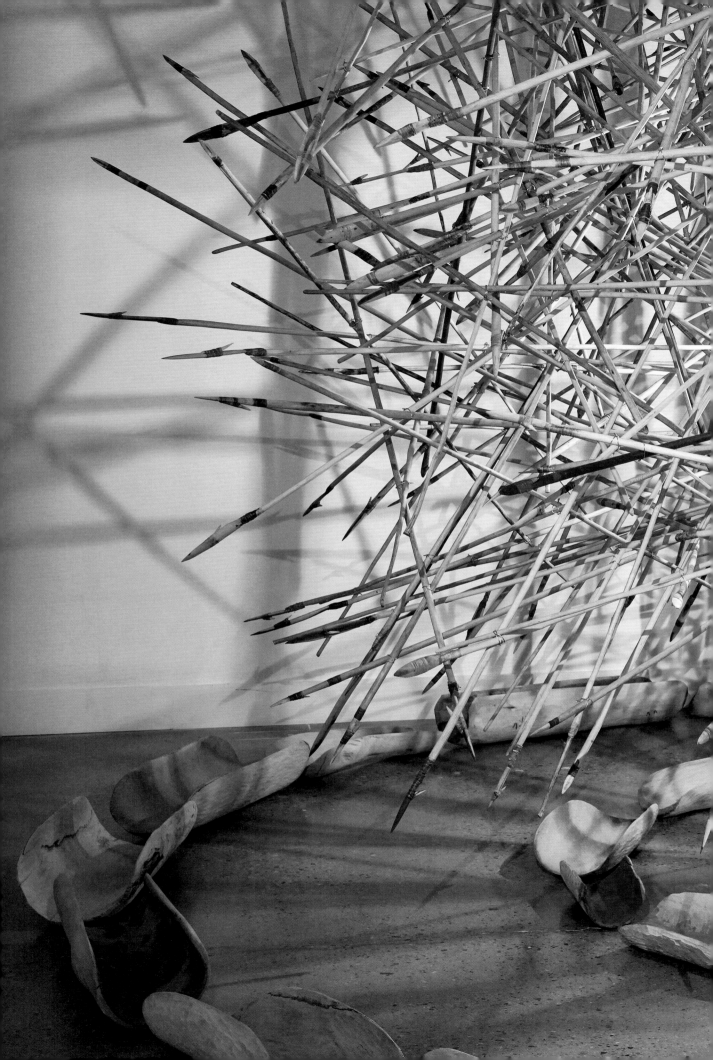

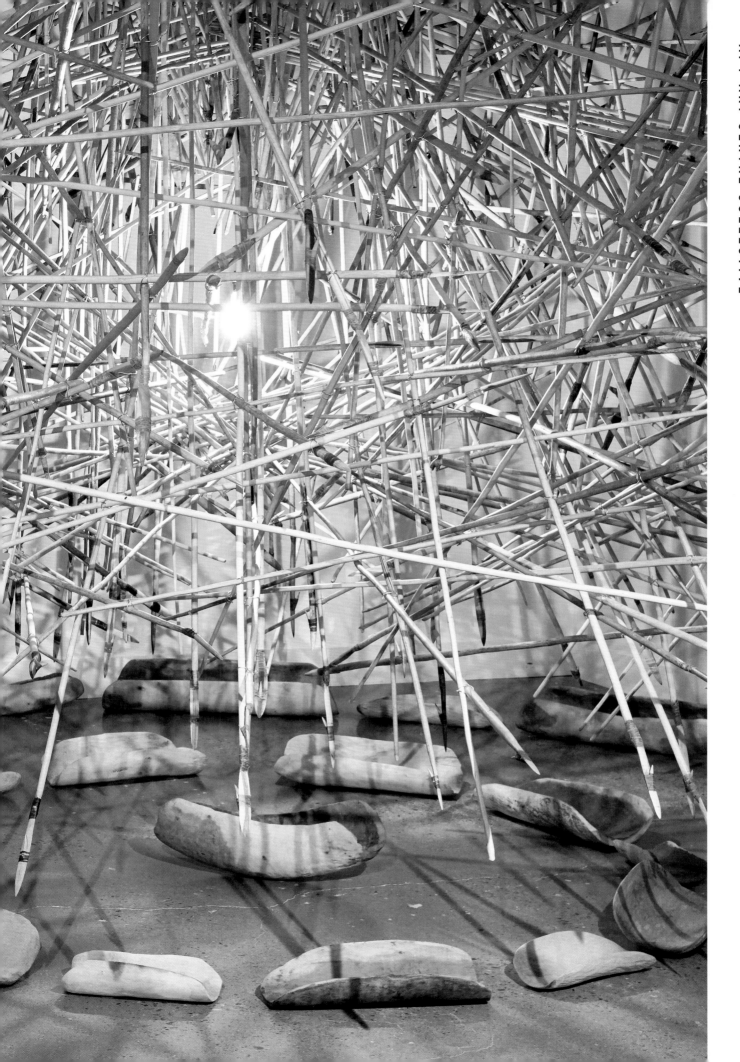

BETTY MUFFLER (PITJANTJATJARA)
WITH ERIN VINK (NGIYAMPAA)

This is my Country, this is ngangkari Country—it's healing, it's good. I've traveled all over the place, everywhere on the APY Lands, sometimes during Marali *(spiritual ngangkari traveling) and sometimes to visit friends and family. I'm a strong* kungka *(woman). I survived the bombings at Maralinga, but many of my family didn't. It's a terrible and sad story. We need to heal this Country, to give more respect to the land. My painting shows many of the good places in my Country.*

—BETTY MUFFLER

In 2017 Betty Muffler was filmed speaking in Pitjantjatjara, discussing the atomic weapons testing program that was undertaken at Maralinga and Emu Junction, along with the effects the bombs had on her family.[1] Betty recalls below how she was living with her two sisters, Mary Pan and Illuwanti Ken at the time of the bombings. Anangu Country had only begun to be settled by white pastoralists or missionaries in 1937, and by the 1950s when the first bombings took place, many Anangu were living at Pukatja (Ernabella) Mission, or camped on the Lands nearby, where they would work. Betty herself, along with her family, lived a life in the bush.

My sisters and I were living with our mother and father. I was a big girl and my two sisters were teenagers. I was hearing that this bomb was coming and my aunties were crying, they were worried that family members would die. My father was thinking about going back home to his place, and he went with my little sister and started traveling there. But my father went the wrong way, toward the bomb area—he was thinking, "I'll be going back to my place," but he went the wrong way. My two aunties and my other families were always crying, they were so worried that my father had passed away at the bomb area.

With the generally poor record keeping pertaining to Aboriginal people, along with Anangu people's frequent movements across Country at any one time, it is difficult to confirm exact personal accounts relating to the bombings. Betty speaks clearly and strongly, however, about how her father was taken to a prison cell by white rangers—along with other Anangu who were found in places that were deemed unsafe—before the bombs went off. Betty recalls that this prison was in Woomera. After the bombs went off, it appears that her father was determined to return to Country, to see the destruction to his traditional lands. It is not clear how long after he went back to his dead Country that Betty's father suffered from severe sickness and passed away.

The bomb's smoke is going everywhere. It killed people—made them sick, some passed away. The bomb smoke had gone into their lungs, into their breathing. My father was telling me to come to him so he could see me before he went blind from the bomb's smoke.

Endnotes

1. This footage was filmed on Country at Walatinna Station with Kunmanara (Yami) Lester for the video component of *Kulata Tjuta*, a large-scale installation to be realized later in 2017 at *Tarnanthi: Festival of Contemporary Aboriginal and Torres Strait Islander Art*, presented by the Art Gallery of South Australia. Other artists present for this conversation included Kunmanara (Mumu Mike) Williams, Kunmanara (Jimmy) Pompey, David Frank, Maisie King, Angkuna Baker and Alec Baker.

Ngangkari Ngura (Healing Country), 2019
Acrylic on linen, 59.8 × 77.9 inches (152 × 198 cm)
Collection of Bérengère Primat Foundation Ópale, Lens, Switzerland

BOLATTA SILIS-HØEGH
(INUIT)

Outside (from the series *Lights On, Lights Off*), 2015
Acrylic on canvas, 82.7 × 63 × 5.9 inches (210 x 160 x 15 cm)
Greenland National Museum ad Archives, Nuuk, Greenland

The revocation of zero tolerance for uranium in Greenland had a huge effect on me…It was a physical reaction. When the uranium ban was canceled I stayed for two days in bed with headaches and fatigue. I had never reacted to political decisions this way before. I was so angry, disappointed and shameful. And very scared for the future. Not knowing what we are getting into and having a sense that we didn't really know what it meant, because we hadn't talked about it.

—BOLATTA SILIS-HØEGH

Bolatta Silis-Høegh's self-portrait *Outside* and her series *Lights On, Lights Off* depict her reactions to the reversal of Greenland's zero-tolerance policy regarding uranium mining. Silis-Høegh was physically ill after learning about this decision. This vulnerability opened her to painting this series, which addresses her personal reactions to the impending consequences on the people and the land.

In the painting she holds her stomach, which is an indication of reproduction, and her head is replaced with a sheep's. This symbolism refers to the deformation of future generations that will occur as a result of radioactive contamination. Silis-Høegh grew up in South Greenland, known as the "pantry" of Greenland, the only area where sheep farming is possible. It is also the location of the Kuannersuit uranium mining project. Producing and distributing sheep from this area would mean feeding Greenlanders contaminated food that would then become a part of their body.

Consequently, Silis-Høegh considers the effects of trauma on the inner emotional landscape of the body as a result of impending trauma on the land and all the interconnected lives which live off it. This is depicted by the juxtaposition of a lifeless Greenlandic landscape in the background and her scarred naked body in the foreground of the painting.

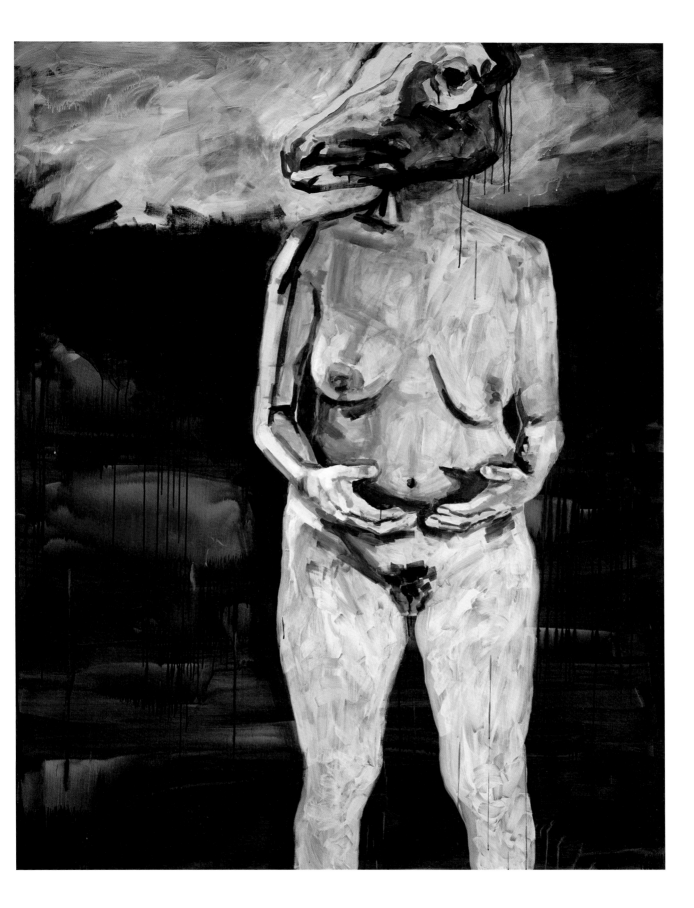

Lights On Lights Off

The Earth itself is unleashed. A maelstrom of anger threatens to swallow the body whole—but the body joins with the natural world, howling in revolt, pain and fear.

The body is the self-portrait of artist Bolatta Silis-Høegh. The violated landscape is her homeland, Kalaallit Nunaat (Greenland). In October of 2013, the Greenlandic Self-Government abolished the country's zero-tolerance ban on uranium extraction. The ruling party, Siumut, reached this decision without consulting the Greenlandic people, as its politicians ignored calls for more substantial public debate regarding the risks posed by uranium mining. This was the spark that inspired Bolatta's rage, laid bare in this series of canvases through blood and scars stretching across her naked flesh.

The news filled Bolatta with a sense of raw vulnerability—which ultimately led her to paint. The artist turned to painting out of expressive necessity, and the result was a series unlike anything she had ever produced. Her past projects' playfully blended references to history and mass culture, cityscapes and small-town

imagery, or her ironic take on climate change in the installation *Sisimiut 2068*, are gone. The dark, bare landscapes that threateningly emerge and the artist's bloody, naked body mark a new direction in her work, which moves toward an inner world where emotion cannot be contained. The environmental anger that sparked Bolatta's need to paint also stirred other anxieties creeping beneath the surface. As the artist processed the threat of uranium poisoning, she began to reflect more broadly on how trauma invades the body. Perhaps the landscape is not just that of Greenland, but a deep, inner landscape with a hidden ecology of emotion. The blood rendered in violently dripping paint hints at what Bataille called base materialism, raw matter that threatens dominant orders of meaning, and has the potential to shake the rigid, unnatural structuring of anthropocentric subjectivity. The darkness does not overwhelm the artist or the viewer. It asks them to openly address their own fears and pain.

The artist originally installed these works in the crumbling decadence of Kongelejligheden, an abandoned eighteenth-century villa once used by the

Danish king. In the ruins of an empire that continues to haunt the landscape, repressed feelings and the threat of environmental destruction can be tapped into. Throughout the North there is an urgent need to address environmental violence openly, as painful as it may be. Norway has recently announced plans to begin oil exploration in the high Arctic. Mining is literally tearing apart Swedish towns as well as Saami reindeer territories. The same threats are appearing in the heart of Finnish Sápmi, in the Kevo Strict Nature Reserve, where permits for diamond exploration have been approved.

Lights On, Lights Off asks us to confront the anger that environmental degradation evokes, as well as the internal pain we all harbor. When we close our eyes to our own anger and fear, those emotions wreak havoc on us. By opening our eyes, we can redirect their power toward the fight for survival.

— DAVID W. NORMAN

I experienced my first transcendent visual event many years ago while driving along the Trans-Canada Highway in a pickup truck with my Grampa. I was five years old when the large shimmering yellow triangle suddenly loomed into sight on the roadside. It was standing on a burned black granite outcropping with a snarl of carbon-black tree skeletons surrounding it. The huge yellow triangle was stunningly beautiful and so vibrantly acidic that it seemed to phosphoresce under the sun. As we rounded the hillside and headed down to the Cutler Village Road, I saw several additional enormous yellow triangles arranged along the highway's verge, and as we passed, I saw that they were actually large piles of gravelly yellow powder.

"Sulphur," my Grampa said. "Poison."

Decades later, as a graduate student at York University, I learned that all Master of Fine Arts candidates must prepare both a thesis exhibition and a mid-length research paper to graduate. Anxious and uncertain, I fretted for days, wondering how my art and academic research could possibly coalesce. Finally, after a period of fruitless self-doubt I decided to just sit down and draw. At first, the images I drew came in unrecognized colors and shapes, so detached from my adult experience that I couldn't place them. Then suddenly one day it was clear. I'd begun to remember and was drawing by fingering through my childhood recollections for the visions of beauty and dread I'd seen on Highway 17. Over the next three months I completed seventy-eight small mixed-media pictures and decided to make the story of the sulphur domes my thesis subject. Later, as my research matured, I began to study the 1953 discovery of uranium in the Lake Huron region and its impacts on the Serpent River watershed near Elliot Lake, Ontario, thirty miles upriver from Serpent River First Nation.

Sulphuric acid is a key ingredient in the first step of the uranium refining process, when raw, broken uranium ore is tumbled for several days in a slurry of highly acidic water. Serpent River First Nation, Genaabaajing, situated on both the Canadian Pacific Railway line and the TransCanada Highway, midway between Sudbury and Sault Ste Marie on the north shore of Lake Huron, was an apparently ideal place to build some of the industrial and chemical infrastructure needed to efficiently refine the uranium being pulled out of the mines in Elliot Lake. So, in the mid-1950s, Noranda Mines, with the consent of the Canadian Department of Indian Affairs, built a sulphuric acid plant in the middle of Serpent River First Nation, adjacent to Cutler, Ontario, our village. Then (as now), our on-reserve population was small, between 250 to 300 souls, who had little to no input or influence on the corporate

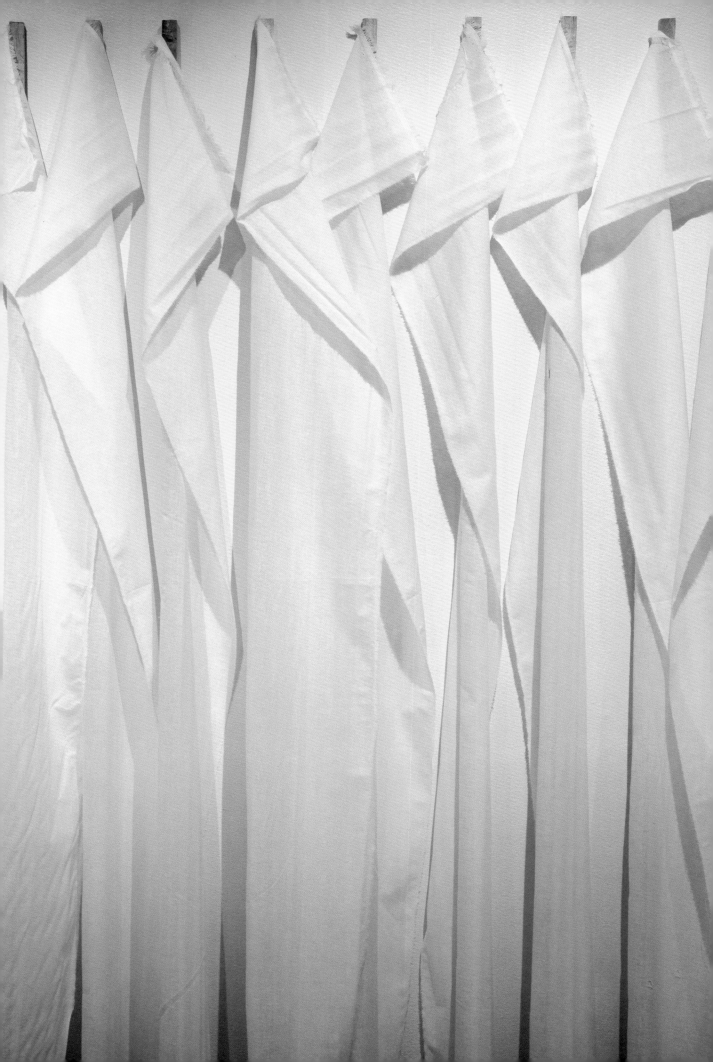

and governmental decision to locate a toxic chemical plant in our community or stockpile tons of sulphur in open drifts near our homes.

When the Cold War ended and the uranium futures market collapsed in the early 1960s, the mines were closed and the acid plant demolished, the rubble of its buildings bulldozed into the earth. But significant remnants of sulphuric acid remain in the groundwater, in the topsoil, blown by the wind, and burned into the cells of our bodies. Decades of protest, education, and legal action have so far failed to bring meaningful or effective (meaning permanent) remediation to the site.

As an artist I have revisited the subject of contamination, radiation, and the properties of radioactive chemical processes many times in the years since those first grad school days when I worried about writing a thesis. *Phenomenology* is an attempt to construct a model of a uranium atom using materials from memory and imagination. Ninety-two maple stakes are draped with strips of white gauze. Ninety-two is uranium's

atomic number and represents the ninety-two protons and ninety-two electrons in a uranium atom. As a sample of uranium slowly decays toward an inert state, its sensitive, unstable nucleus emits invisible ionizing particles in what may be described as the unseen motion of shivering waves.

To give *Phenomenology* a context I include this picture made in 1999, the first in a series of seventy-eight drawings collectively titled *Radiation and Radiance.* It and its brothers are the foundation of the video *Rooster Rock: the Story of Serpent River* (2002), and the exhibition S*tories from the Shield* that toured to several locations in Canada from 2001 to 2003. This drawing, *Cutler Ontario, a good location for a company to build a sulphuric acid plant*, is where my story began.

— BONNIE DEVINE

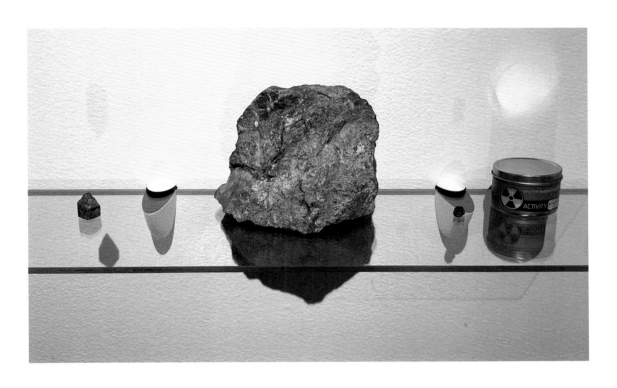

DETAIL: *Phenomenology*, 2015
Chunk of gneiss, 92 hardwood stakes draped in muslin, uranium sample, dimensions variable

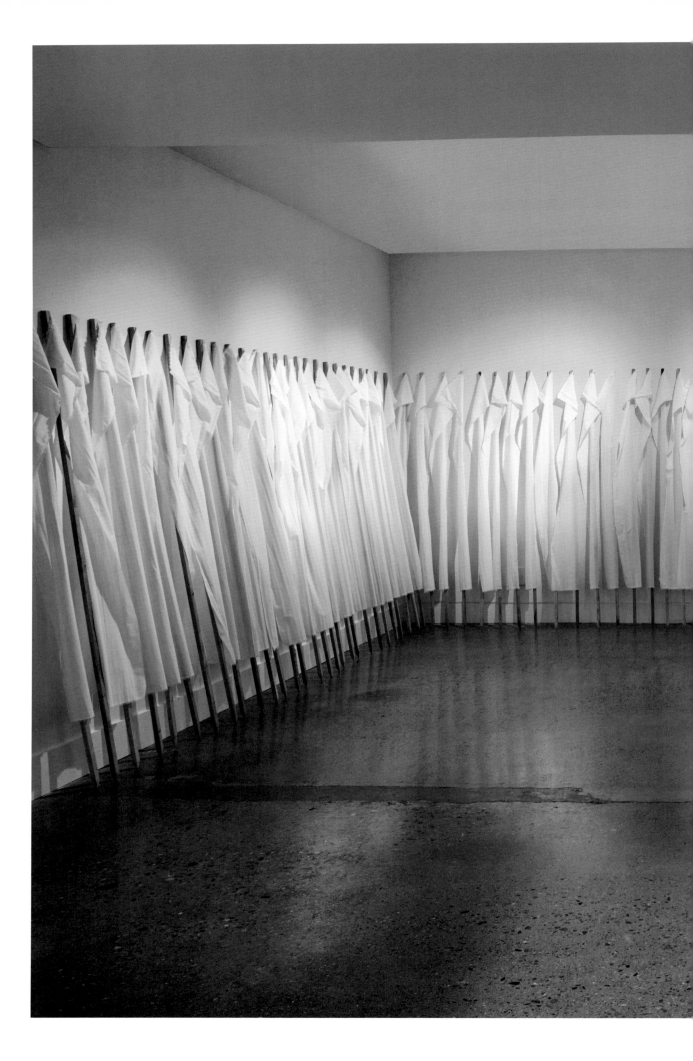

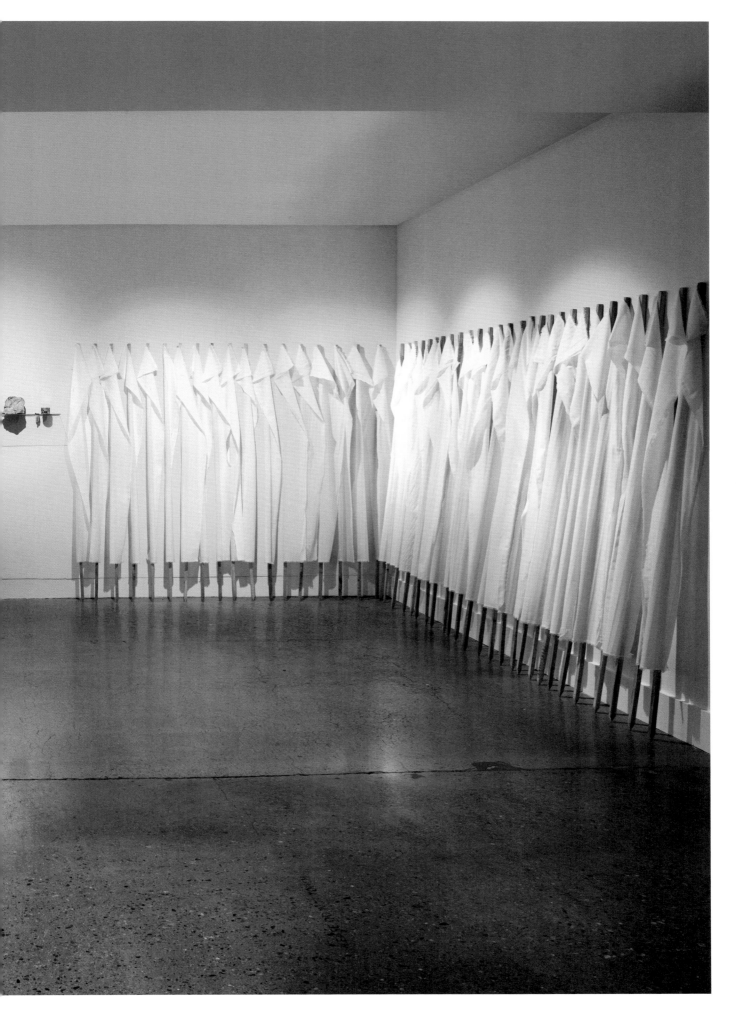

CARL BEAM
(OJIBWAY)

Sitting Bull and Einstein,
from the series *The Columbus Suite*, ca. 1990
Etching in black ink on paper, 31.5 × 48 inches
Carleton University Art Gallery, Ottowa, Ontario, Purchase 2003

The late Carl Beam, an Anishinaabe printmaker, featured the atomic bomb architect Albert Einstein several times over his career and in one striking image, *Sitting Bull and Einstein* (ca. 1990), we see the artist juxtapose photographic images of Einstein and Sitting Bull. Beam positions Sitting Bull on top of the picture plane to create an inversion of Western systems that would normally visualize the genius of Einstein on top. Instead we are asked to think of the genius of Indigenous ways of knowing that warn against the disconnected rationalism that Western science represents. Here spirit is stronger; in this image we are not vanishing. Sitting Bull assumes a "visual sovereignty" that destabilizes our common attributions of the coming of the Atomic Age.

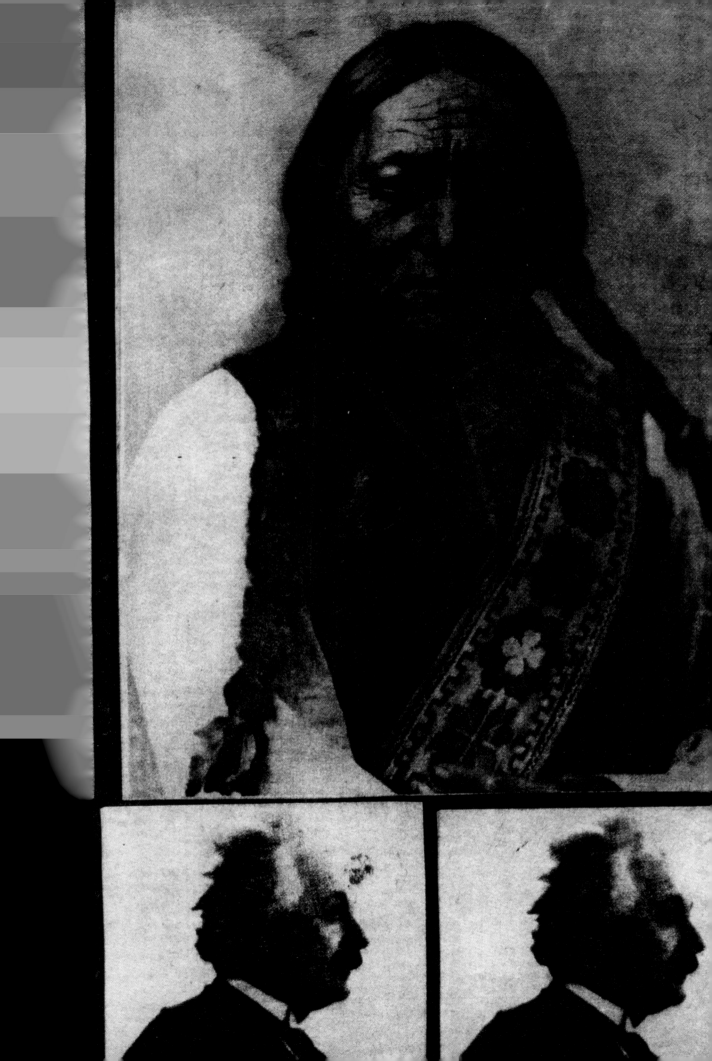

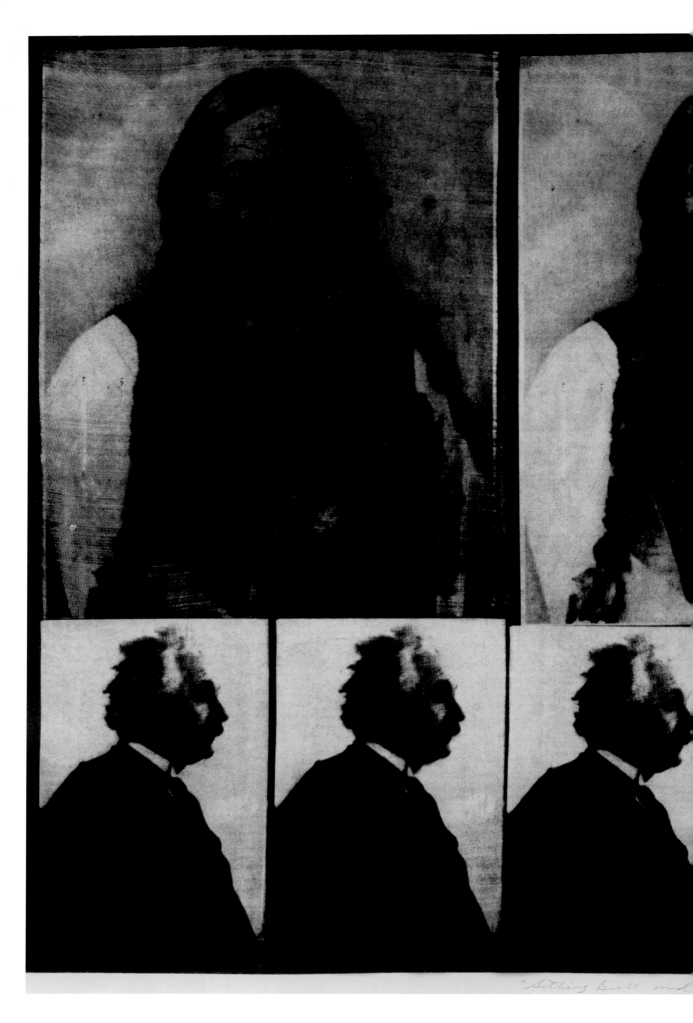

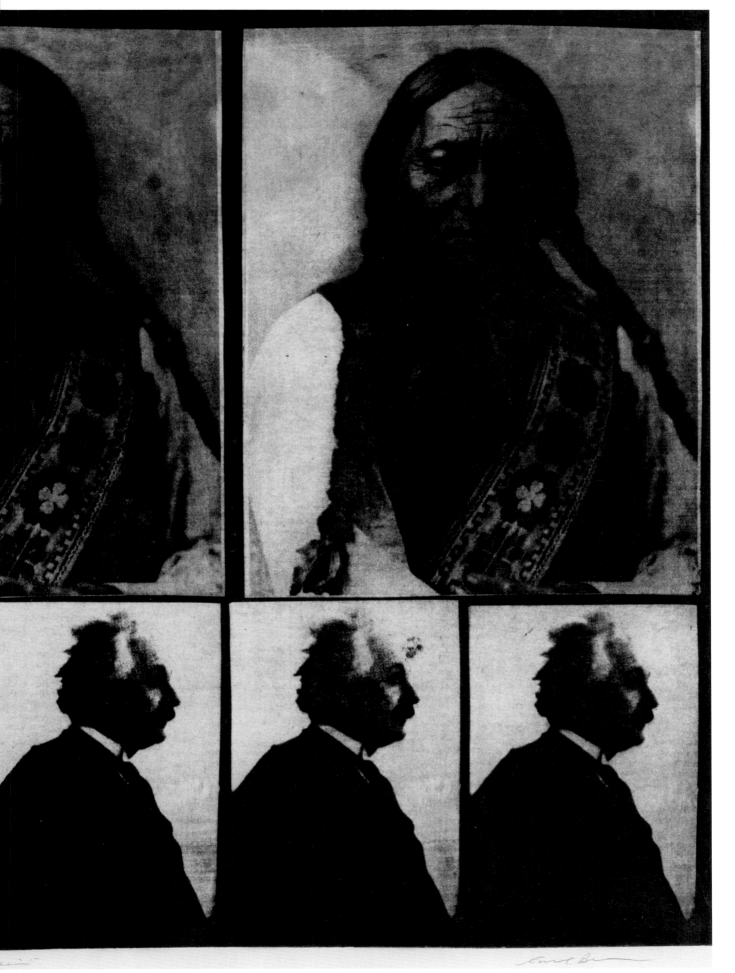

DAN TAULAPAPA McMULLIN
(SAMOAN)

Radiation Mat, 2021
Vinyl photocollage, 12 × 12 inches

Every man of my father's generation, in my very large extended family from Samoa-i-Sasa'e (Eastern Samoa or American Samoa), joined the military. My father's father, David McMullin, was an Irish-Jewish naval officer who married my grandmother and settled in American Samoa. My father, Samuel Sailele McMullin, Sr., like many young Samoan men, joined the US military after World War II, when the US Navy and many jobs relocated to Hawai'i. However, he was prohibited from going to officer's school because he was a naturalized citizen from American Samoa. Similarly, David kept his Jewish identity a secret because of US military anti-antisemitism.

My father was part of the Army Corps of Engineers and was involved in building the towns that were blown up in the atomic bomb sites in Nevada and the Southwest (New Mexico, I believe). He was told later that he would not be able to have children; he ended up having five children. (I used to think when I was a child that I was queer because of his involvement in nuclear testing!) He always felt bad about the animals that were tethered to the test sites. In doing this research, I think about my father often, while looking at the photographs. My father had a long career in the US military but retired to join the Civil Service. His last posting WAS at Fort MacArthur in San Pedro, California, where he was ordered by superiors to read statements condemning Martin Luther King, Jr., to the troops, which my father refused to do—he considered it against his Christian beliefs. He retired honorably as he was a Vietnam veteran. I helped care for my father in his last few years, and although he was against gay liberation, we became close again during those last days. He told me a lot about my family history, Samoa, and his life, including working on about a dozen atomic test bombing events in the Southwest.

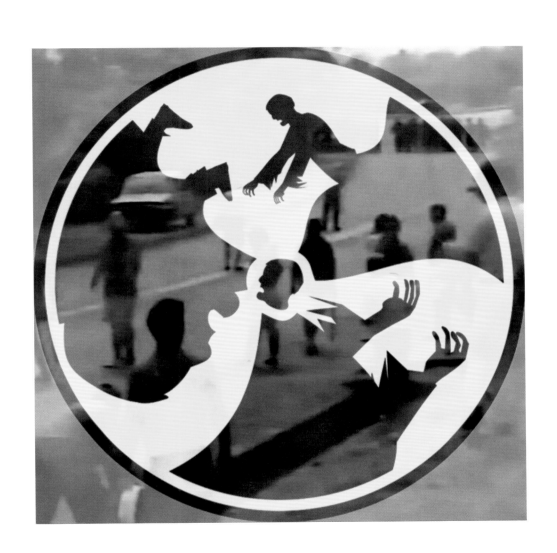

Te Mau Ata: Clouds, 2021
Photocollage and acrylic on canvas, 42 × 36 inches

McMullin's painting is titled *Te Mau Ata*, which is Tahitian for "The Gathering Clouds" or "The People of the Clouds." As in many Polynesian translations, metaphorical interpretations including clouds, signal the erasure of people as well as their environments. The artist combines a photo collage of images of Bikini women and men in forced migration from their islands alongside a controversial image of a cake in the shape of an atomic bomb being cut and served by Admiral Blandy and his wife in Washington, DC. Blandy was in charge of *Operation Crossroads* and other atomic tests in Oceania and was a central figure in propaganda films falsely portraying the displacement of Bikini islanders as voluntary. Also included is an image of Tahitian filmmaker, poet, and playwright Henri Hiro, who wrote in French and Tahitian. Working in the 1970s-1980s, Hiro led one of the first protests against nuclear testing in French Polynesia.

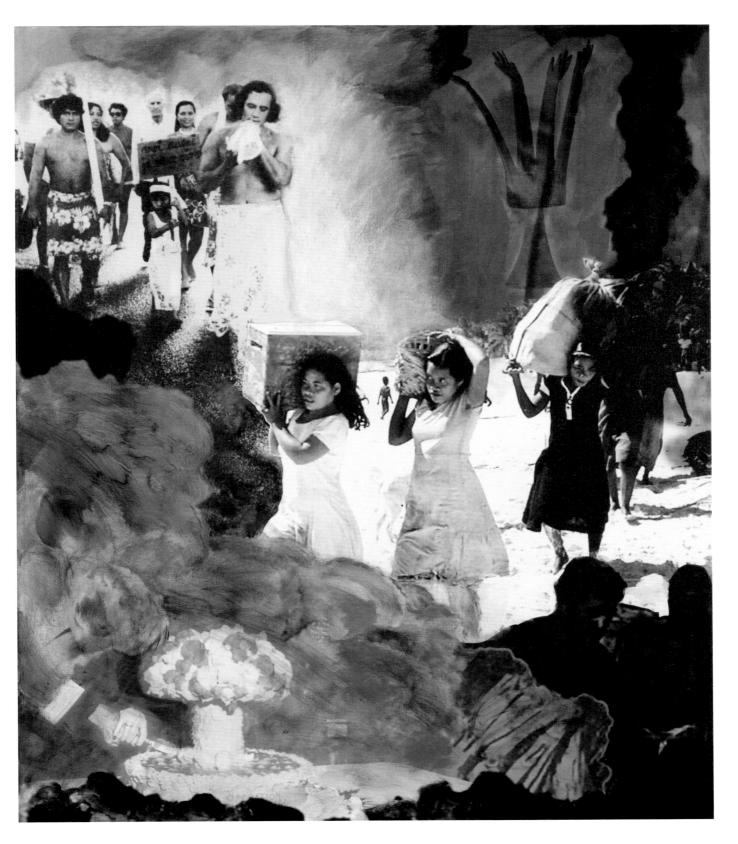

DAVID NEEL

(KWAKWAKA'WAKW)

Chernobyl Mask (Allusion to Bakwas, Nuclear Disaster Mask), 1993
Cedar wood, cedar bark, acrylic paint, 28 × 14 × 8 inches
Seattle Art Museum, Margot E. Fuller Purchase Fund, 97.55

The *Nuclear Disaster Mask* was created after I visited the major collections of Native American art at several public institutions, where I studied the work of the early Northwest Coast Native artists. It was my honor to hold in my hands masks that were carved a hundred years earlier; that experience allowed me to see the art through the eyes of the old masters. Traditionally, a Northwest Coast Native mask creates a character to symbolize a traditional story, an individual, or something as abstract as "cold" or the "north wind." The traditional dance masks were handed down within families and First Nations communities, and occasionally a new dance mask was created.

I learned a great deal from the early works, and I realized that in addition to "traditional" carvings, the artists I studied also created works that were inspired by people and events from their time period. I discovered portrait masks of people from that era, such as a portrait mask of a chief, a headdress frontlet carved to represent a chief's late daughter, and a mask representing a time of hunger. This

changed the way I viewed Northwest Coast Native art, and I began to carve masks which depicted contemporary people, issues and events.

In 1988, when I began creating masks about contemporary events and issues, my work was controversial. The popularity of Northwest Coast Native art was on the rise in the 1980s and '90s. There was little contemporary Indigenous art on the Pacific coast and almost no market to support it. There were a vocal few who believed that masks which depicted contemporary history, such as *Nuclear Disaster Mask*, had no place in the tradition of Northwest Coast Native art. I believe that it is the role of a Native artist to create work both contemporary as well as traditional. This is based on my early research and having seen the pieces that were made by the old masters.

Although this mask was carved some years ago, the relevance of the nuclear issue has not diminished. There have been a number of nuclear disasters—Chernobyl, Three Mile Island and Fukushima in

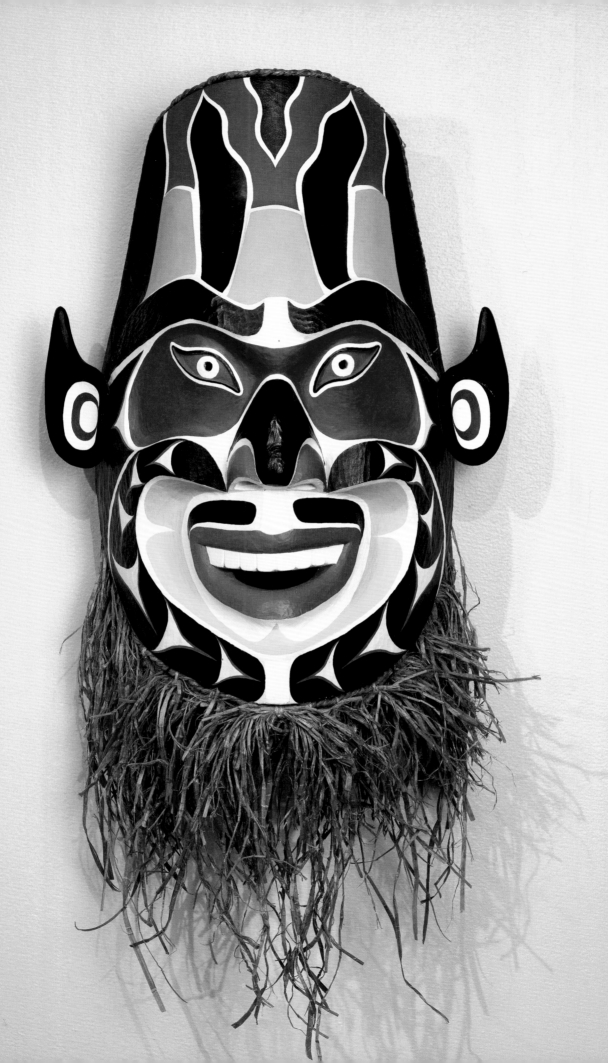

recent memory. I based this mask on the Bakwas, or Wild Man of the Woods, which is a character from Kwakwaka'wakw culture. He is the Chief of the Ghosts and he tricks people into eating his food, which may be disguised as a delicious salmon but is in fact grubs or rotten wood. Afterwards, his victims are trapped in the land of the ghosts. The forehead of the mask is inspired by the distinctive shape of a nuclear reactor cooling tower, and are also depicted in designs on the forehead. His countenance is mocking, almost demon-like, which symbolizes

the ominous nature of a nuclear disaster. While the topic is contemporary, I worked with the sculptural and design principals of Kwakwaka'wakw traditional art. Art and culture are alive and fluid; they do not stay stuck in time.

I believe that tradition is a foundation to build upon and not a set of rules to restrain creativity.

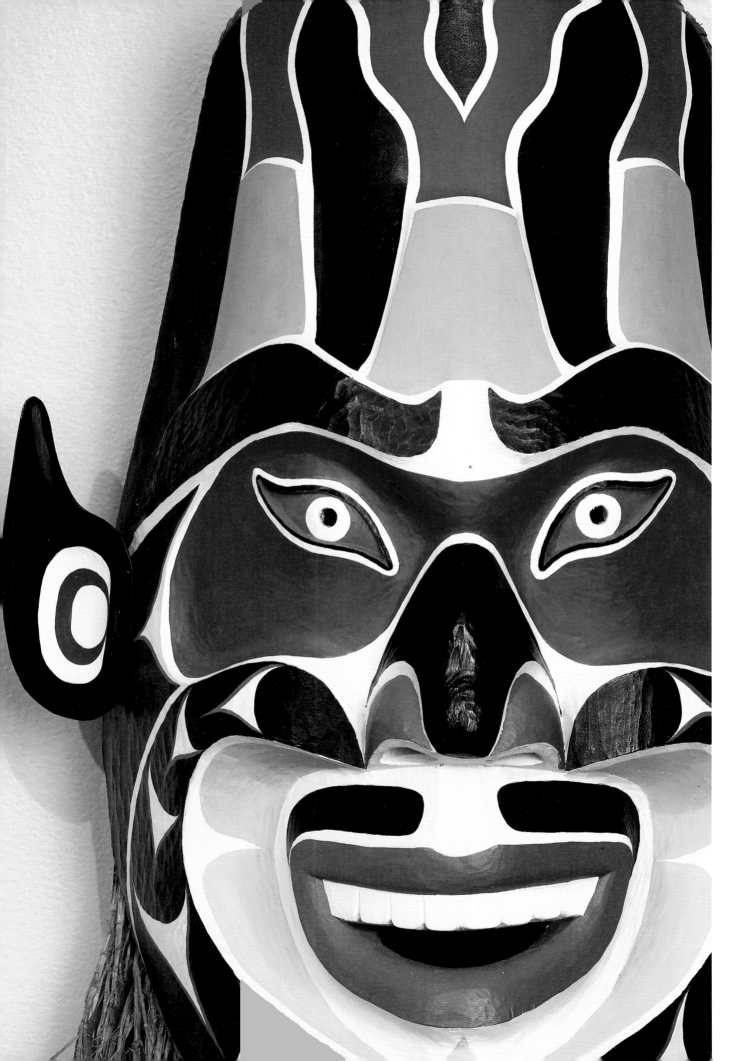

DE HAVEN SOLIMON CHAFFINS
(LAGUNA AND ZUNI PUEBLOS)

RADON DAUGHTER

Like most of my early childhood memories, many seemed to revolve around the sensations of water and earth colliding. The smell of damp earth after a rainstorm, watching water make its journey from the irrigation ditch down into my grandparents' garden or watching my twig boats float effortlessly into the tiny pools of water. For me, it was magical.

Those early memories of living with my grandparents and uncles in the village of Paguate were by far the very best. There was always something to do outside by just exploring our yard and garden.

This is how I became familiar with the Anaconda Jackpile uranium mine.

The majority of my relatives worked there, including my dad. From a child's perspective, the mine resembled a giant cave or anthill. To me, it consisted of various layers of colorful sand with huge rocks where a mythical dragon lived beneath the ground. In reality, this dwelling was once considered the world's largest open pit uranium mine. It was also located less than 1,000 feet away from the village of Paguate.

The Anaconda Company's Jackpile-Paguate uranium mine opened in 1951 and closed in February of 1982—more than thirty years of mining. More than 400 million tons of material were moved, including twenty-two tons of Ore. The mine also consisted of three major pits, several underground mines, and mine waste dumps.

However, due to economic turmoil, the mine ceased operations and a request for reclamation was ordered in 1980. The mine closed.

DISTURBING THE DRAGON

As I played outside my grandparents' house, I would often hear a loud siren blow. This was the warning of an impending blast from within the mine. Some folks would start to close their doors, shut their windows, cover up dishes, and so forth.

Usually, I'd be outside, standing against the wall and waiting. Then—all of sudden, BOOM!! The earth beneath my feet shook. And I'd look toward the mine; a big billowy cloud of grayish-yellow dust rose into the sky. It was if the Dragon took a deep breath and exhaled. . . .

Depending which way the breeze was blowing, the dust would travel over. And in our case, it would settle over the village.

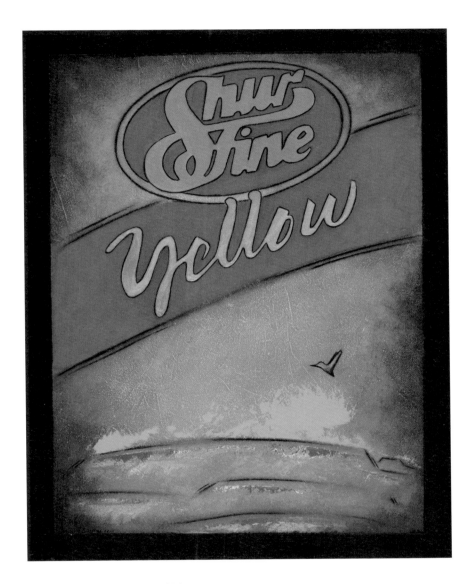

ShurFine Yellow Cake, 2019
Acrylic on wood panel, 10 × 8 inches

THE DRAGON SLEEPS

For many years after the mine closed, I began to notice how many people were being affected by the mining. People who were once healthy and strong became ill with cancer and other health issues. My grandpa would be the first in our family to develop cancer, then my grandma, next my uncle. So many questions and tears but not enough answers.

In 1998, I lost my only son Skye at the age of two years old due to severe health issues. Within the same year, my daughter Ryan was born. Later, she would be diagnosed with autism. The untimely passing of my son was so devastating. My daughter and I had to try and find a way to rebuild our lives. Maybe painting would be the way, again? Maybe we could tell our story?

As for me, I was always ill as a child. It would be several years till doctors would discover I had congenital cervical dystonia. There is no cure for dystonia. There is no cure just yet for my Ryan's autism.

Three years ago, I spent almost eight months in the hospital due to an intestinal disease.

After numerous surgeries, an ostomy bag, and depression, I thought to myself, maybe all these health issues are just random? Like the stars in the night sky. . . unfortunately, they were not.

I often look back to when my grandpa was governor of Laguna in the 1950s.

The weight on his shoulders must have been immense. The governor and the council would later decide if mining near the village of Paguate would be the opportunity the Pueblo needed to survive. Years would pass, many blaming my grandpa for all the land and health issues. And yet, I would also learn, it takes the council to give the okay. It's not just one person; all councilmen from each village must vote in order to give their say.

My grandpa also worked in the mine; he developed cancer and passed away. It was one of the worst times of my young life.

Sometime later, I would learn of stories about how children from the village would go to my grandpa's house and he would cook for them. He was feeding children who didn't have enough to eat at home.

Maybe the mine was a way of keeping food on the table for everyone despite the circumstances? Maybe he wanted more for the people of the Pueblo? Maybe he wanted everyone to flourish? I imagine it wasn't an easy decision. But then, it is not easy to watch one's own people suffer and go to bed at night hungry.

I believe his heart was in the right place.

Sometimes everyone must make decisions based on what is good for the general well-being of a family. The Pueblo of Laguna was his family.

Food on the table, a roof over our head, and a fire in the stove. At the end of the day, you know in your heart you have done your best with empathy and kindness.

And so, the dragon sleeps deep beneath the Earth, once again. Never to reappear.

Uranium 238.029, 2020
Acrylic on canvas, 8 × 8 inches

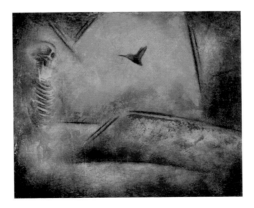

Facing Mortality, 2019
Acrylic on wood panel, 5 × 6 inches

GUNYBI GANAMBARR
(YOLŊU)

Gapu, 2017
Incised rubber (conveyor belt), 11.29 × 3.02 feet (344 × 92 cm)
Art Gallery of New South Wales, Sydney, Australia
Purchased with funds provided by Rob and Jane Woods, 2017

Gunybi Ganambarr is a maverick and the originator of the "Found" movement at Yirrkala and across northeast Arnhem Land. In response to a policy of his art center that artists must only employ materials derived from the land, Ganambarr began to use non-traditional mediums such as rubber, aluminum, roofing insulation, and galvanized iron he collected from Country to depict land and Country. This innovation speaks to ideas that extend beyond traditional Yolŋu art, which reflect Yolŋu cultural worldviews in groundbreaking and unconventional ways. He is mindful of his cultural obligations, operating only once he receives narrative permissions from his Elders.

In *Gapu*, Ganambarr discusses the major impact that mining has had on communities in northeastern Arnhem Land, particularly citing the Gove mine which was established on the Gove Peninsula in 1971. The work, an old Rio Tinto conveyor belt which has literally transported the riches of Country away, has been incised with Ŋyamil clan designs for *gapu* or freshwater. The knowledge referred to by this imagery is deep in complexity and secrecy. What Ganambarr does share is Yolŋu responsibility to and ownership of Country—highlighting rights that have been eroded as the surface of Country itself has been removed.

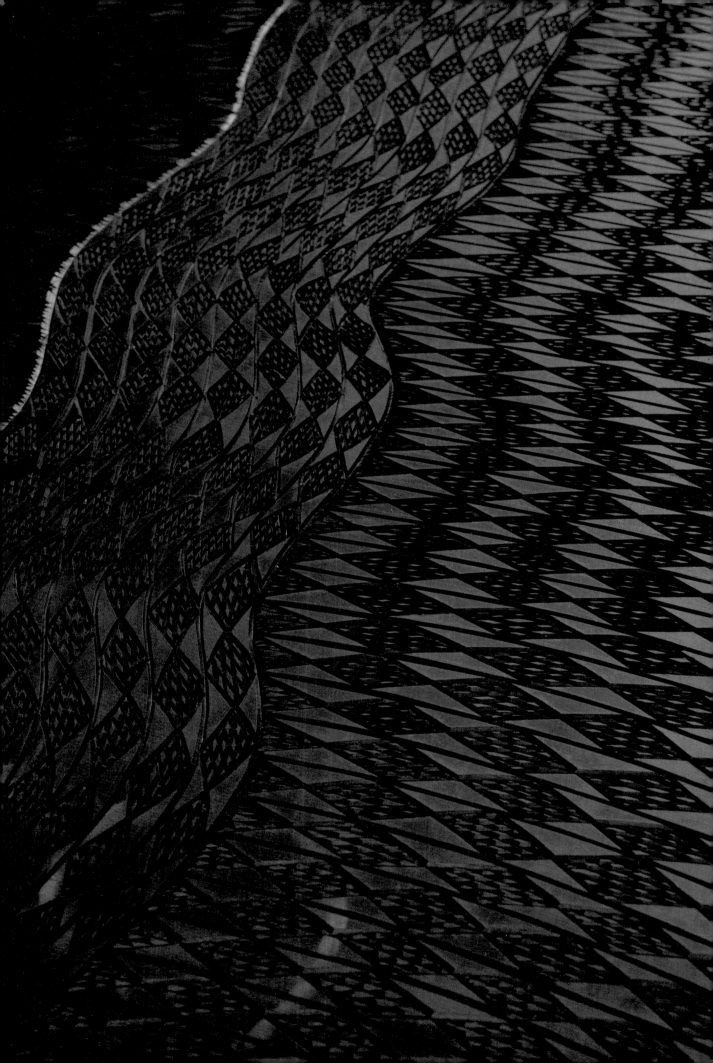

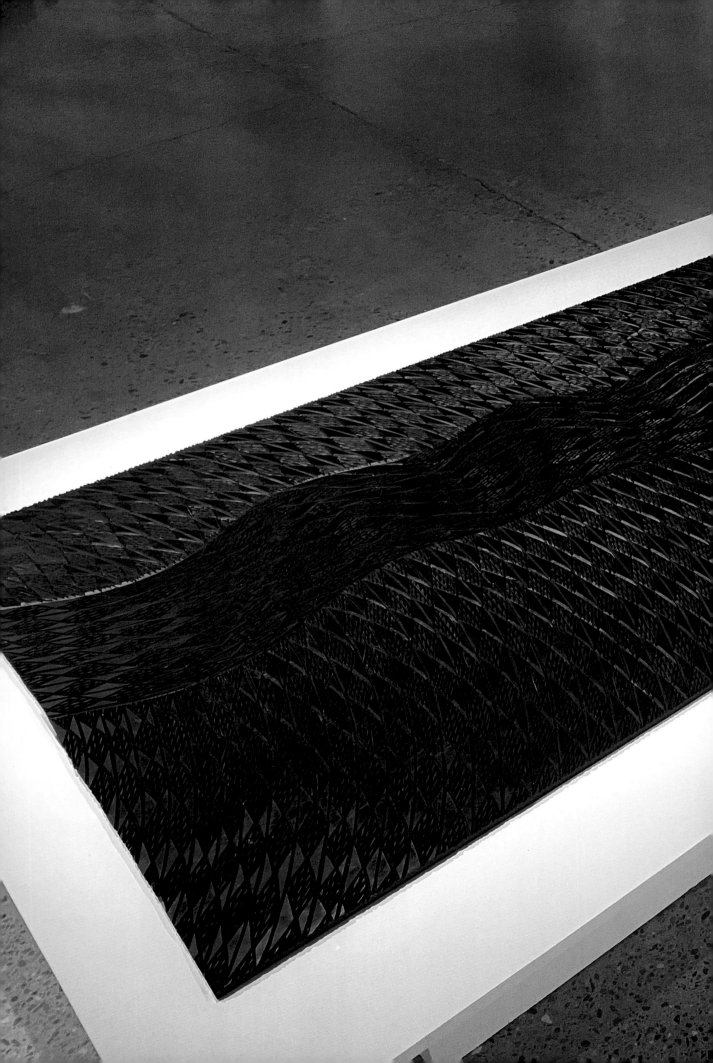

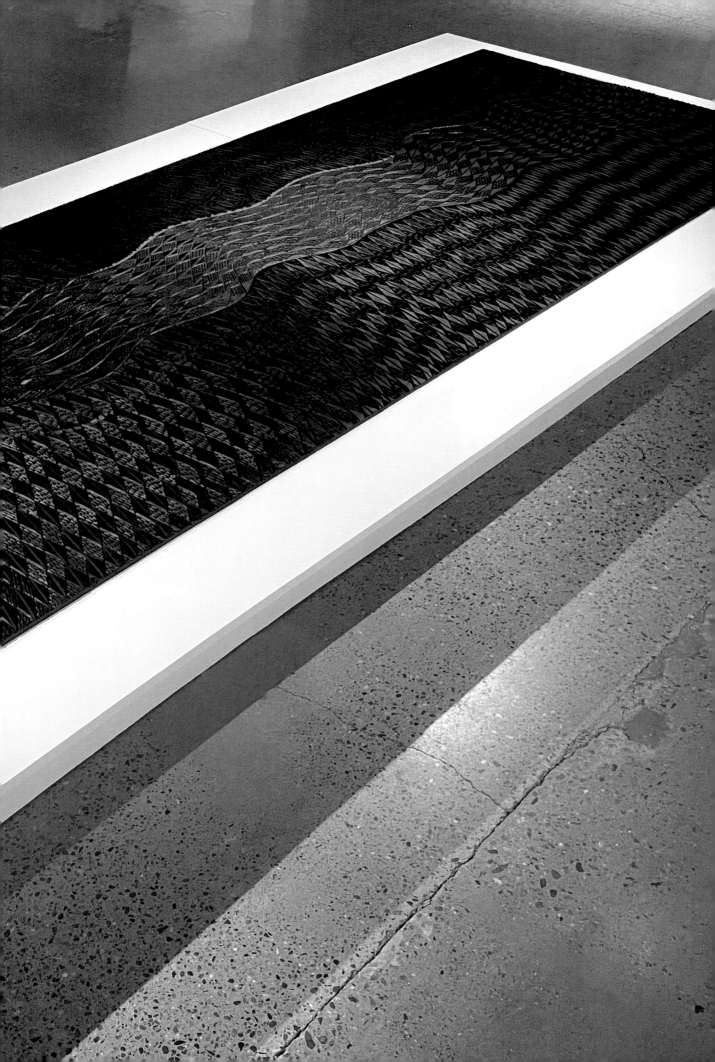

HILDA MOODOO AND KUNMANARA QUEAMA
(PITJANTJATJARA PEOPLE)

Destruction I, 2002
Synthetic polymer paint on canvas, 46.85 × 38.66 inches (119.0 × 98.2 × 3.0 cm)
Art Gallery of South Australia, Tarntaya (Adelaide), Australia
Santos Fund for Aboriginal Art, 2002

Hilda Moodoo and Kunmanara (Jeffrey) Queama first came to prominence for their land rights activism in the 1970s. Following the return of most of Maralinga Tjarutja lands (former atomic bomb test site) to Anangu Traditional Owners in 1984, both Moodoo and Queama became instrumental in the move to return Anangu to Country. They were founding members of the Oak Valley community, established 150 kilometers northwest of Maralinga.

Moodoo and Queama began to evidence their innate connection to Country through painting in 2001, expressing their identity as Pitjantjatjara peoples who were effectively banned from their traditional lands. Here, their painting alludes to British nuclear tests: Operations Buffalo (1956) and Antler (1957) and the mushroom cloud. While not the first Aboriginal artists to paint the cloud—this was likely Yorta Yorta artist Lance Atkinson—they were the first to present the cloud in the unique and recognizable "dot" painting style, a technique belonging to people from the Desert regions.

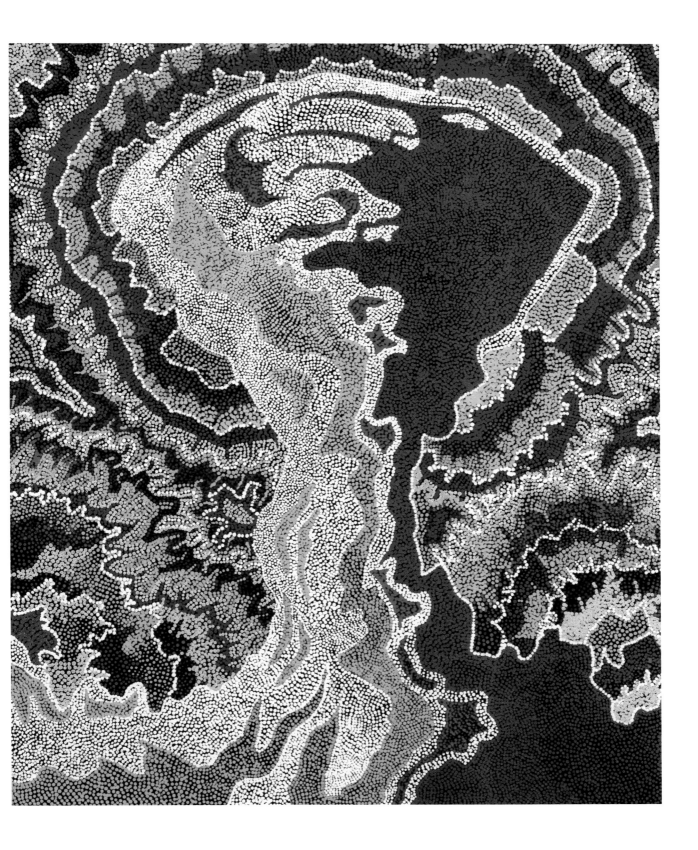

IVINGUAK STORK HØEGH
(INUIT)

DETAIL: *Sussa manna aserunngikkaluarutsigu (We don't have to destroy this area)*, 2020
Digital photocollage, 42 × 42 inches

Ivinguak Stork Høegh exaggerates and visualizes the absurdity of uranium mining in the mountain of Kuannersuit. The works on view are a part of the *Qaartorsuaq (Big Blast)* series. If uranium extraction happens, it will change the area and the mountain forever. The enormous explosions in Stork Høegh's works also refer to the deadly force uranium has when used in nuclear weapons in wars. The children in the foreground are borrowed from historic photographs— combining the old and new is both about playfulness but also about connecting the past, present, and future. What was done many years ago affects people today, and what is done today will affect the future. The children in her photocollage are crying, and people are leaving because they are scared about the disastrous consequences of uranium mining. The motorcycle gang in the background appears like a threatening invasion of the area of Kuannersuit by outsiders.

The title *Sussa Maanna Aserunngikkaluarutsiguk* is borrowed from the chorus of the song "Uulia (Oil)" by the Greenlandic singer and songwriter Nive Nielsen. The song was written in protest not only to uranium mining but as a common plea for us to stop destroying nature. A direct translation would be, "What if we just stopped destroying this place," and continues, "What if we just stopped destroying this land."

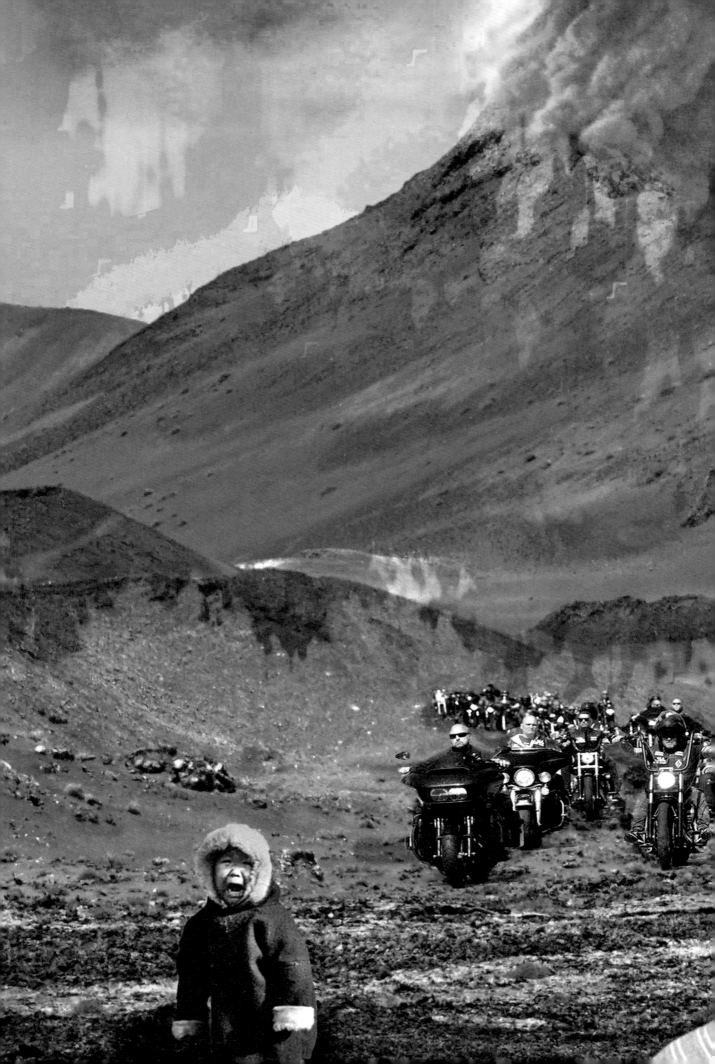

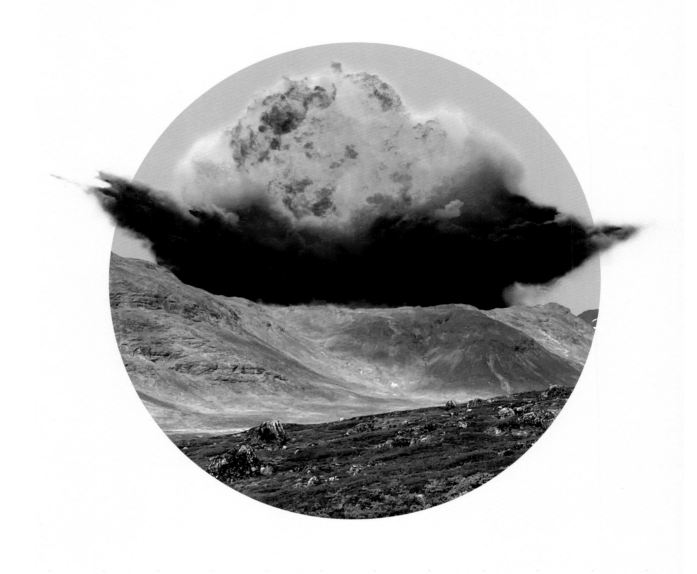

Qaartorsuaq (Explosion), 2016
Digital photocollage, 42 × 42 inches

Sussa manna aserunngikkaluarutsigu (We don't have to destroy this area), 2020
Digital photocollage, 42 × 42 inches

JERREL SINGER
(DINÉ)

A Warning Ahead, 2017
Oil on canvas, 40 × 30 inches

A Warning Ahead, with its surreal colors and intense cloudy sky, is a mesmerizing landscape. However, a radiation hazard sign in the distance signals there is something wrong with this eerily beautiful scene. Singer painted this landscape to create awareness about the dangers of uranium mines on the Navajo reservation. The artist grew up in Cameron and Gray Mountain, Arizona, near more than 100 abandoned uranium mines. He started his artistic career when his father became gravely ill with cancer and died two years later. Singer's father was exposed to radiation from uranium mines on the Navajo Nation. Singer's family and neighbors have also been exposed to contaminated wind from nuclear tests in Nevada and Utah. As a result, he lost several aunts and uncles. Singer explained, "This is where we grew up and where we played. That land was our life source and now we can't go back there."

JESSIE KLEEMANN
(INUIT)

Arkhticós Doloros, 2020
Video performance and poem, 10:00 minutes

Artist statement:

This is a performance at an area known as the Blue Lake on top of *Sermeq Kujalleq* Glacier, near Ilulissat on June 19, 2019. I was invited to perform at a workshop on climate change called At the Moraine—Envisioning the Concerns of Ice organized by Amanda Boetzkes and Jeff Diamanti.

In my own performance art practice I utilize whatever my body needs to expressitself both as a directed emotion coming from its own memories, but also from mythology. I explore through layers of different movements, substances, poetry, or themes, such as the *Sassuma Arnaa*, seal blubber, or sea weeds. I can then appear in the work through several repetitions until it shows something new or loses its inherent meaning. I let my body take over and I ask what it should do to me and to the space. What relevance do the myths have, and are we able to let them speak?

In the case of the performance at *Sermeq Kujalleq*, the elements had their own say: the wind, the immense Arctic light, the melting ice and oozing cryoconite from the depths of the ice all the way to the moraine underneath. What is the reality of the melting of our Arctic, *Issittup aakkiartornera*? As the ice sheet melts and the planet faces human migrations fleeing war and famine from the subarctic regions, we still don't know how to let it speak to us. *Arkhticós Doloros* means that we are all in it: it is my pain, it is the Arctic in pain, I am the pain, the Great Polar Bear is in pain right now.

Related to the poem "Arkhticós Doloros":

I know the spelling seems odd; the word Arctic is widely known as it is written so often. But by choosing the spelling quite deliberately as Arkhticós, I gesture to a form of word play that comes from our language and history. The word Arkhticós is comprised of the Greek word *Arktikos*, meaning Great Bear, the constellation in the northern sky. By adding an "h," there is another gesture to *khronos*, or time. It seems that we do not know in what times we are all living. Yet our Arctic had its own time long before humans. I call it the dreaming time. I am a *kalaaleq*, an Inuk from Greenland. I write about dreamtime but also about the time of memory. My languages are somewhat erratic in the written state. Yet I write in the forms of poetry that we as Kalaallit Inuit have used for centuries. I honor that by letting the words and languages change and multiply in various directions. Anyone who knows of Inuit mythology will recognize this practice. I cannot write as another (*qallunaaq*) which is of course a contradiction as I write these lines. *Qujanaq*!

136

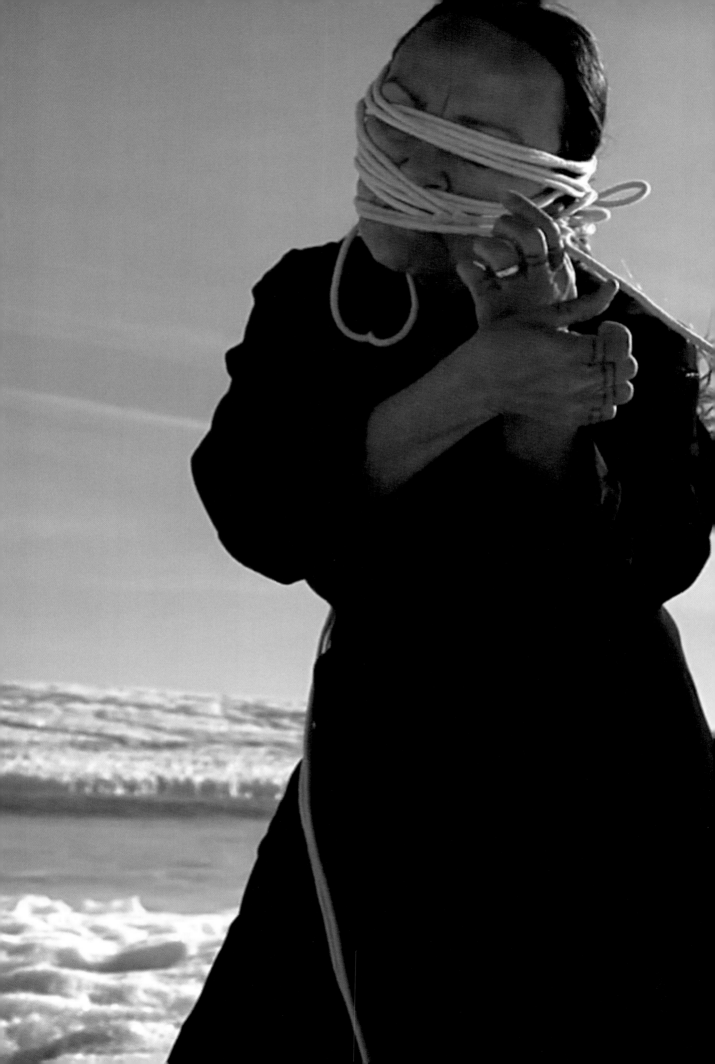

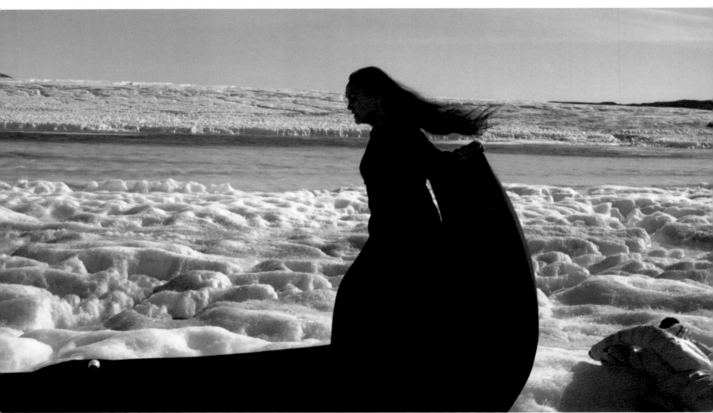

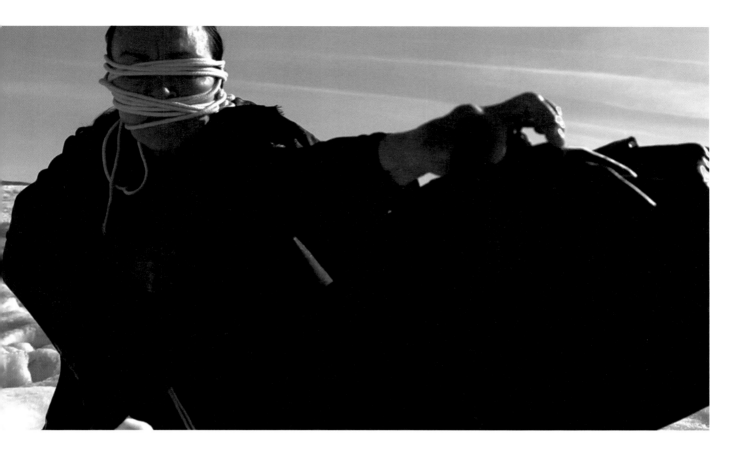

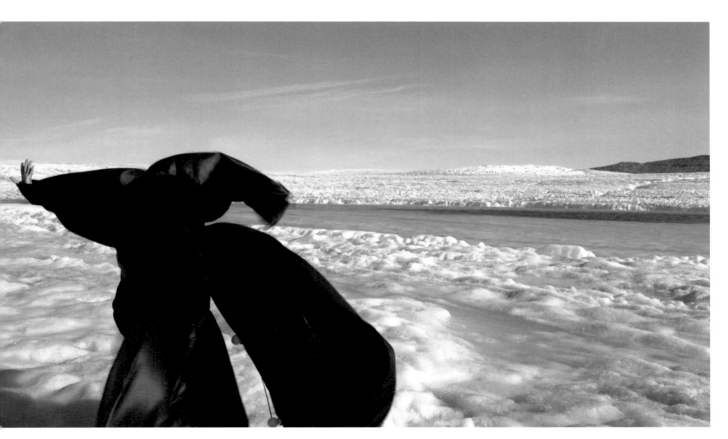

JOY ENOMOTO (KANAKA MAOLI/CADDO) AND NO'U REVILLA (KANAKA MAOLI)

Nuclear Hemorrhage: Enewetak Does Not Forget, 2017
Watercolor and thread, 16 × 12 inches
Collection of Brandy Nalani McDougal
-

This work is a reflection on the nuclear violence that remains resolute in the memories of the Marshallese, embodied in the absurd solution to containing nuclear waste on Runit Atoll. Created in 1979 as a temporary measure, the 350-foot-wide cracking concrete cap over the radioactive-waste-filled bomb crater hides 111,000 cubic yards of contaminated soil and is referred to as "The Tomb" by the islanders. On the low-lying island, it is vulnerable to inundation from rising seas, a toxic time bomb leaching plutonium into surrounding waters.

The ring of green represents the hope of restoration and the memory of what existed. The dome appears to be built by the sea fan whose flat forms resemble a network of nourishing blood vessels. Branching from a stem anchored at the bottom, its structure mimics a placenta, the body's nourishing organ between old and new growths.

NUCLEAR HEMORRHAGE IS ACCOMPANIED BY BASKET
for Kathy

She brings her host a basket:
 earrings, mats, testimony

 This basket, she says, is medicine.
Some may ask: what is a basket to a bomb?
Why bring medicine when they send ships
 bombing
 their laps
 to jellyfish

They didn't know what to call them, she said.
They didn't know the name.

 this ocean
 an open wound

 but who gives a damn
moonlight scorched from wombs
 who gives a damn
 who gives a damn
 who gets to damn who

 She brings her host a basket
Then, bone by bone
 her low tide lips
 reveal the names
 her gods & wayfinders
 her mother & country
 her island sea

 This is a basket of names,
 a basket of stories.
For afterbirths of fallout—
 war-petalled & sacred-starving,
 her story is the medicine we ache for.

—NO'U REVILLA

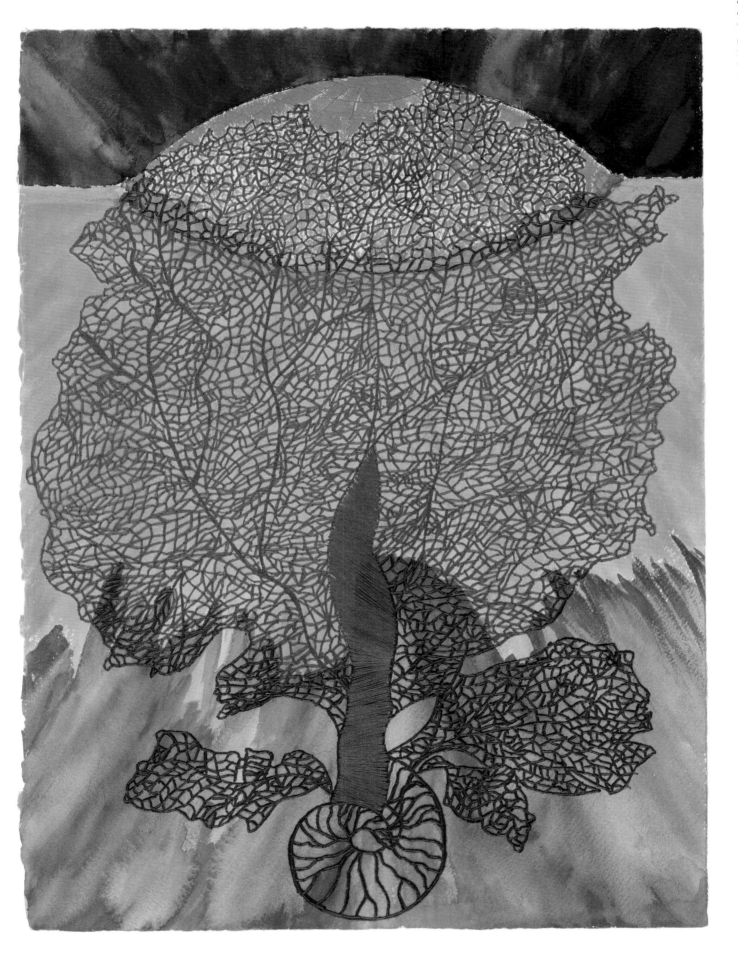

KATHY JETÑIL-KIJINER (MARSHALLESE-MAJOL) AND DANIEL LIN

ANOINTED, 2017
Video, 6:08 minutes
Written and performed by Kathy Jetñil-Kijiner (Marshallese-Majol)
Directed by Daniel Lin

Marshall Islander poet and activist Kathy Jetñil-Kijiner's video poem *ANOINTED* explores the nuclear testing legacy of the Marshall Islands through the legends and stories of Runit Island. The video documents the imperfect clean-up attempts after nuclear disasters, such as the detonation of the first hydrogen bomb on the Enewetak Atoll, which allowed the United States to temporarily step ahead of the Soviet Union during the Cold War's nuclear arms race. Overall there were forty-three nuclear tests conducted at Enewetak from 1948 to 1958. The resulting nuclear waste was capped with concrete in a hazardous eyesore on Runit Island, known as "The Tomb." The concrete dome is beginning to leak, contaminating the water and marine life. Most of the forty-island chain is still uninhabitable due to the remaining radioactivity. *ANOINTED* was directed by Daniel Lin as part of the Pacific Storytellers Cooperative Project of PREL.

After WWII the United States tested 67 nuclear weapons in the Marshall Islands.

Two decades after testing ended, contaminated waste was collected and dumped in a crater on Runit Island in Enewetak Atoll.

KATHY JETÑIL-KIJINER (MARSHALLESE-MAJOL)
MUNRO TE WHATA (NGĀ PUHI)

History Project: A Marshall Islands Nuclear Story, 2018
Animation, 3:45 minutes

This graphic adaptation has resulted from a rich creative collaboration between Marshallese poet Kathy Jetñil-Kijiner, Maori-Niuean artist Munro Te Whata, Edinburgh University academic Michelle Keown, and Island Research and Education Initiative (iREi), a non-profit publisher based in Pohnpei. The project began when Keown came across a YouTube recording of Jetñil-Kijiner performing her poem "History Project" during the Poetry Parnassus event held in London during the 2012 Olympics. The event was intended to bring together one representative poet from each of the 204 nations competing in the Olympics, and Jetñil-Kijiner represented her country, the Republic of the Marshall Islands (RMI), by drawing the world's attention to the legacy of US nuclear testing in the islands.

Following the US atomic bomb attacks on Hiroshima and Nagasaki in 1945, which resulted in Japan's surrender as one of the "Axis" powers against which Britain, the US and other allies fought during the Second World War, the US took over many of Japan's former Micronesian territories, including the Marshall Islands, as a "Strategic Trust Territory" mandated by the United Nations. This allowed the US to use the Marshall Islands as a site for multiple nuclear tests during the Cold War, when the US competed with other large nations such as Russia (formerly known as the USSR) in the race for global dominance in the field of nuclear weapons technology.

Chiyoko is 68 year old
physically handicapp
came from their mot
40 years old, but he
with a blister on his
for treatment. He w
had never seen a ca
born with a lower
gone through num
ose nuclear vict
posure

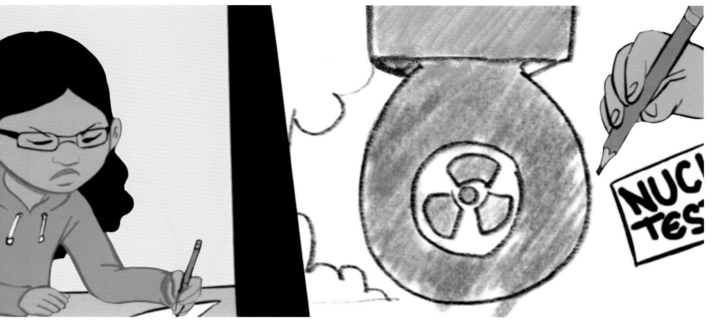

KLEE BENALLY
(DINÉ)

Poise/End, 2017
Virtual reality video (8:25 minutes), sculpture, headset,
Headset and stand: 36 inches tall

This immersive, cinematic VR video allows the viewer to experience lands contaminated by abandoned uranium mines on Navajo Nation, and to follow personal stories of Indigenous Peoples impacted by nuclear colonialism, and ultimately to witness how deadly the nuclear fuel cycle is.

In his artist statement, Klee Benally (Diné) explains, "We are *Poise/End*. Though we have faced nuclear colonialism and the extreme poisoning of our land, water, and bodies, we still maintain our dignity and *hózhó* (balance). We are not victims, but survivors who continue to resist and fight for Mother Earth and our future generations. *Poise/End* is an immersive detox from nuclear violence."

KOHEI FUJITO
(AINU)

The Singing of the Needle, 2021
Iron, acrylic, deer skull, 82.8 × 74.4 × 82.8 inches

2011.3.11.
Fukushima Daiichi Nuclear Power Plant
Meltdown

Frightened by the direction of the wind, I felt
helpless and couldn't do anything, so I closed
the thin curtains throughout the house.

Nuclear waste that cannot be processed
continues to increase.

—KOHEI FUJITO

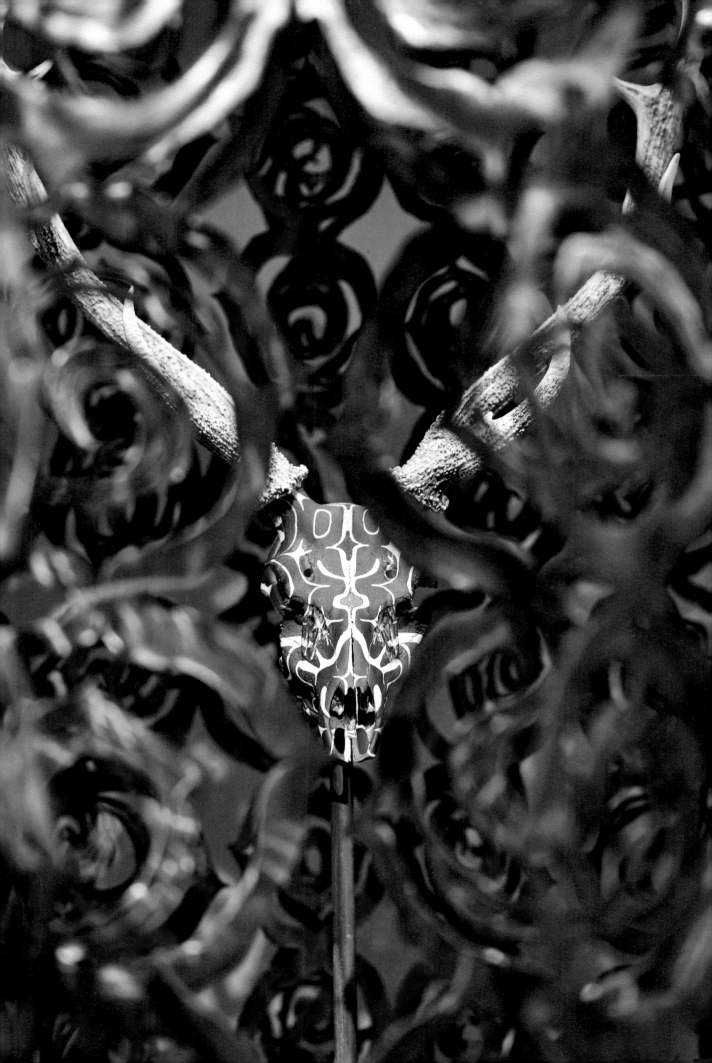

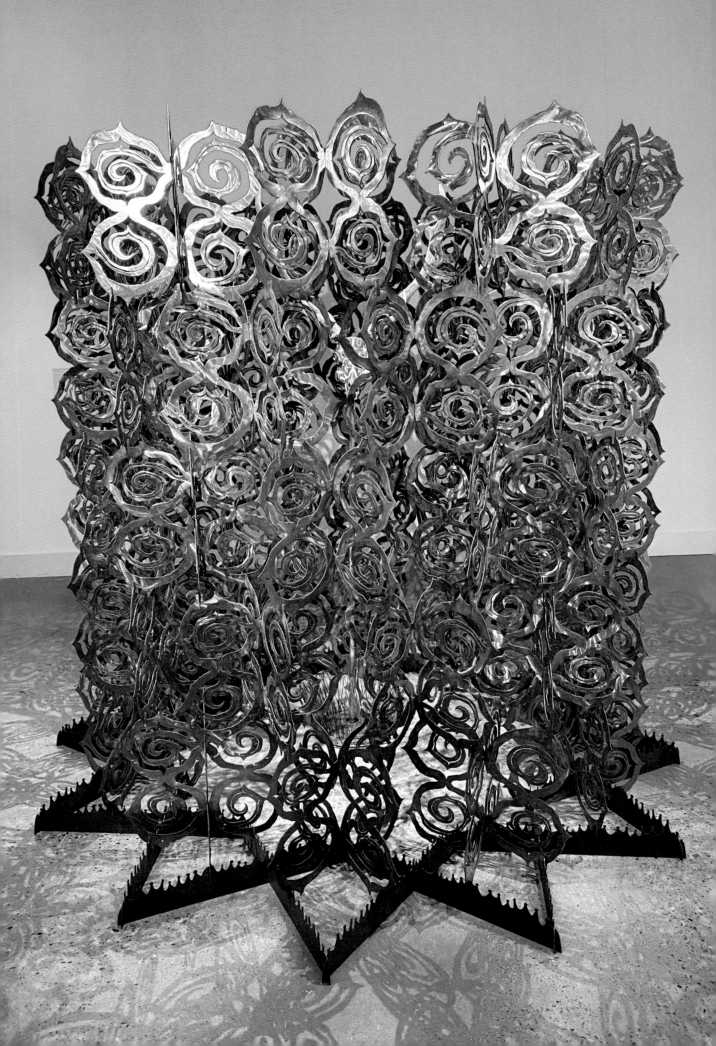

KUNMANARA (KARRIKA BELLE) DAVIDSON
(PITJANTJATJARA)

Maralinga Bomb, 2016
Acrylic on canvas, 48.31 × 39.96 × 1.30 inches
Australian War Memorial, Kamberri (Canberra), Australia, purchased 2016

One of the recurring subjects depicted by Kunmanara (Karrika Belle) Davidson is her own experience of the British atomic weapons testing program. Davidson often depicted Country immediately after an explosion, embedding within the landscape Anangu, who immediately suffered sickness or died due to radiation fallout. She often painted the rockholes located alongside her bush home of Wilkurra, which was where she and her young son were holidaying when caught on Country during a bomb blast. *Maralinga Bomb* features circular shapes in green that take the form of windbreaks set up to protect Anangu from gales and puyu, the poisonous black mist. Within these forms are people—some of them sick, some of them dying. The middle and lower section of the work features dazzling fields of red and brown dots, identifiable as the spot fires that burned on Country long after an explosion.

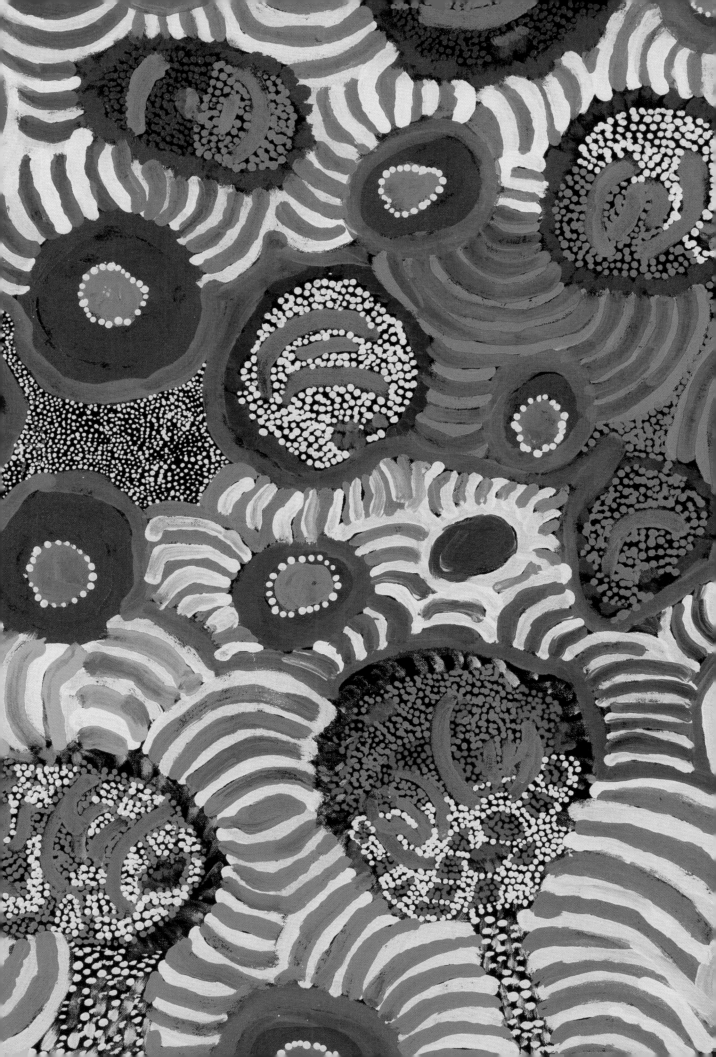

MALLERY QUETAWKI
(ZUNI PUEBLO)

Extraction & Remediation, 2020
Diptych, acrylic on canvas, 16 × 20 inches each

Mallery Quetawki's diptych *Extraction & Remediation* (2020) chronicles uranium mining on Indigenous lands from the early 1940s to recent clean-up efforts of contaminated sacred sites. Her petroglyph drawings on the left part of *Extraction* represent ancient customs and knowledge, which collide with the modern world, symbolized by a circuit board pattern. The uranium vein in the ground has a petroglyph-like design, "as it is meant to 'stay in the ground,' and further along it escapes the ground, signifying extraction and causing the upper environment to become contaminated as the flowers wilt into radioactive symbols," Quetawki explains. The *Remediation* section comments on the need for blending modern science with Indigenous customs and knowledge. She says, "when these ideas work in tandem with one another, we can begin to heal our lands and our people. Our Indigenous ways of life need to be heard and recognized in order to work with current clean-up efforts on our contaminated soils. Sacred sites will always remain sacred and so will our stewardship to the lands in which we were all birthed."

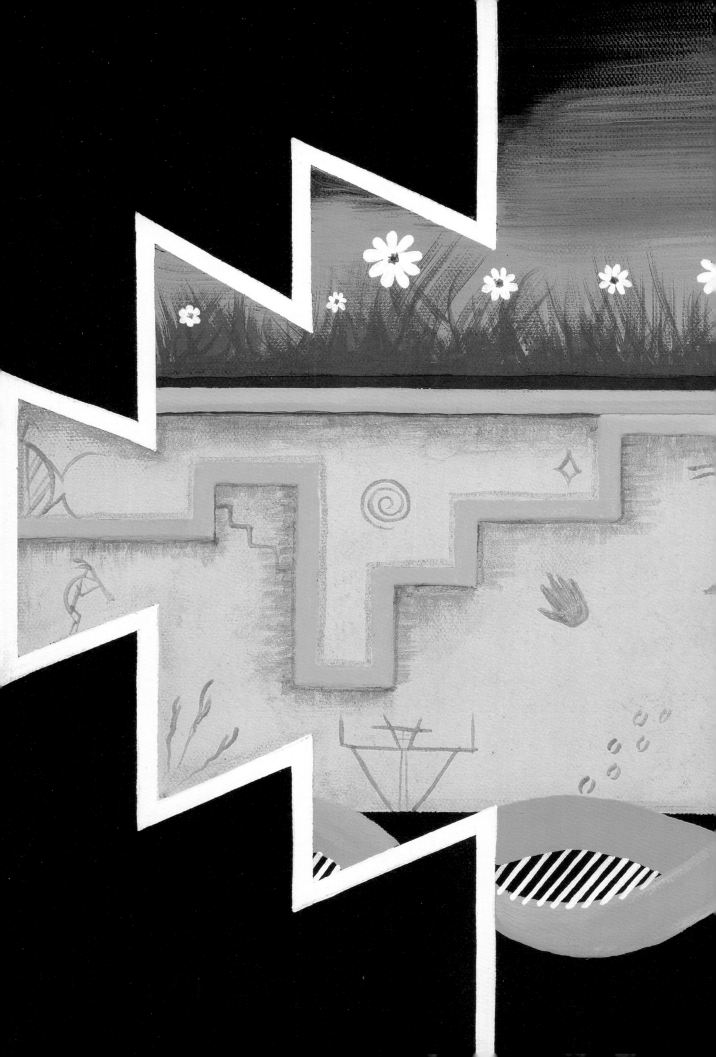

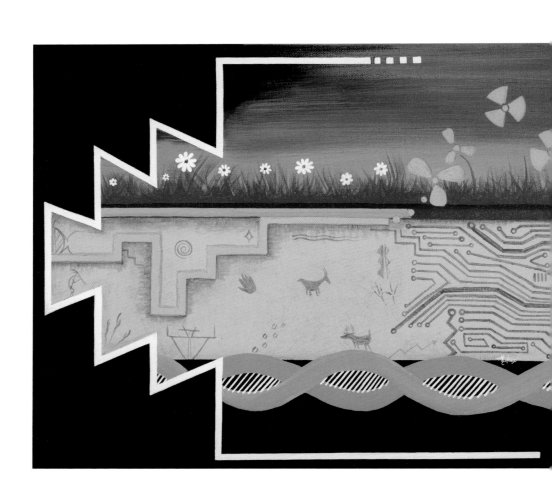

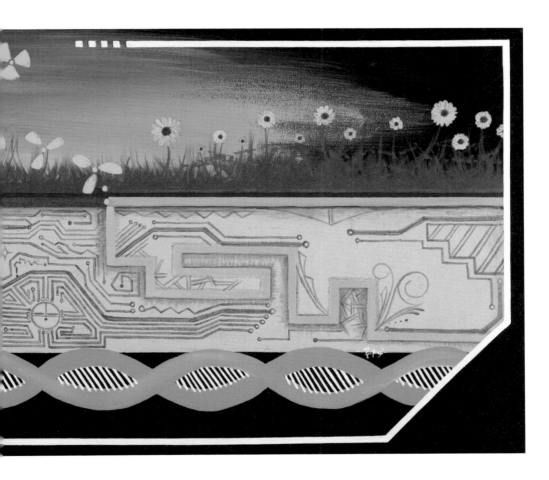

MARIQUITA "MICKI" DAVIS
(CHAMORU)

Pacific Concrete: Portrait of Christian Paul Reyes, 2019
Mixed Media, photographs, postcard stand, fabric, guafak
Dimensions variable

In the summer of 2018 I traveled home to Agat, Guahan, and took on the responsibility of caring for our family's photo archive. *Pacific Concrete* is a project that was born from the North Korean missile crisis of 2017, when US leaders on the continent assured their constituents that they would be safe should the missiles launch, because they would be aimed "in the Pacific." I was deeply troubled by the vagueness of this mark, as though the destination had no form, no life, as though Guahan was nothing more than a military target. I knew then that I wanted to make an effort to share the life of my family in hopes of adding to the specificity of "the Pacific," and of making the Pacific concrete.

I discovered a series of photographs of my late uncle Roland and his wife, my auntie Rose. We see their love for each other, for their first son Michael Rodney, and the highly anticipated birth of their second son Christian Paul, who was born with congenital tumors. We also see the tenderness and clarity of these parents for their newborn child. Christian Paul Reyes was only with us for a short time, but the love that his family gave him continues to this day. I remember him very clearly as a child, and later when his father would speak of him he would never refer to him in the past tense. He is present then, as he is today.

OKI (AINU)
AND RANKIN TAXI

You Can't See It, and You Can't Smell It Either, 2011
Video, 4:28 minutes
Producer: OKI (Ainu)
Lyrics: Rankin Taxi
Video: Takahiro Morita FESN
Music: OKI Dub Ainu Band

Japan reggae artists MC Rankin and
OKI Dub Ainu Band deliver a cautionary
message about radioactive material
through this song and music video *You
Can't See It, and You Can't Smell It Either.*

PAT COURTNEY GOLD

(Wasco/Warm Springs)

Sturgeon Basket, 2005
Jute warps and cotton wefts, iridescent threads
Ca. 6 × 3.5 × 3.5 inches
Michigan State University Collection, East Lansing, MI

Pat Courtney Gold (Wasco/Warm Springs) uses customary weaving techniques as a response to radioactive poisoning. Her *Sturgeon Basket* is woven in the shape of a "sally bag," a Columbia River Plateau (Oregon) basketry style, characterized by a cylindrical shape and used to carry and store foods, medicines, and personal items. Consistent with Wasco sally bag conventions, the design features a ground, skyline, and abstract patterns inspired by ancient petroglyphs from the area. The main motif consists of five sturgeons, fish honored by Pacific Northwest tribes for their strength, size and longevity: they can grow larger than ten feet, weigh more than 1,000 pounds, and live approximately 100 years. The bottom-most sturgeon is laced with iridescent synthetic threads, which, according to Gold, represent radioactive isotopes from the Hanford Site, a nuclear facility whose waste has contaminated the Columbia River system during the pastseven decades. As a result, sturgeons, a traditional food source for area tribes, are suffering from deformations and toxins.

To the left and right of the fish column, there are three columns of water. The bottom of the basket has a circular target design in red, white, and blue cotton yarn.

SOLOMON ENOS
(KANAKA MAOLI)

Illustrations for *Jerakiaarlap (graphic adaption)*, 2018
Oil on paper, 12 × 8 inches each

Two works by the Honolulu-based artist reference the Bikini Atoll community that has been subjected to forced migration. They are from the graphic adaptation titled *Jerakiaa-rlap*, the "point of no return" in Marshallese. This project was created in collaboration with activist poet Kathy Jetñil-Kijiner in Majuro and Professor Michelle Keown at the University of Edinburgh.

These panels, excerpted from the ending of *Jerakiaarlap*, posit the futuristic return of Marshallese to their islands now transformed by biotechnology. An immense garbage mound is towed to transform the waste material into healthy soil. A gambling game is played with sinister cards bearing female death heads, a reference to "slow violence" that is temporally distanced and thus disassociated from the inciting trauma. A jaundiced landscape presents two suns simultaneously: our solar system's sun and the fireball of a nuclear explosion with a solitary human figure caught between.

WILL WILSON
(DINÉ)

Mexican Hat Disposal Cell, Navajo Nation (from the series *Connecting the Dots*), 2020-2021
Triptych, drone-based digital photographs, ca. 44 × 110 inches total
Collection of the artist

EXCERPTED FROM AN INTERVIEW WITH
JENN SHAPLAND, FEBURARY 24, 2021

Drones are an amazing new tool empowering normal folks to be able to image the world in a new way, and it is a particularly useful solution for photography on the Navajo Nation. It can be very difficult to understand the structure and scale of some of these abandoned mines and disposal cells from the ground. It is hard to make a captivating picture that will draw people in. Drones give you the ability to shoot from a different vantage point. The world is transformed when you are able to take pictures from 100 to 1500 feet above the ground. You can see things on a much grander scale. The images I chose for this exhibit show how close some of these sites are to communities.

The triptych included in *Exposure* features the Mexican Hat Disposal Cell from about 1500 feet, and then from about 700 feet. As I was flying over the disposal cell, I noticed this small, strange shape in the middle of the giant field of river rock.

There's a plaque out there in the middle of the disposal cell. It's this strange memorial to this place and its toxic legacy. It's dead smack in the middle of the cell, so you'd have to climb over the fence and walk to the center of the cell to get a photograph of it. It talks about the disposal cell, when it was completed, and what is buried there. It states, "Mexican Hat, Utah. Date of closure: July 20, 1994. Dry tons of tailings: 4,400,000. Radioactivity: 1,800 Curies. RA-225." With the current debate around monuments and what gets raised to the level of remembrance, it's interesting to me to think about how this place is memorialized. That's the other amazing thing about the drone—I don't have to expose myself to the radioactive contamination while making the photographs.

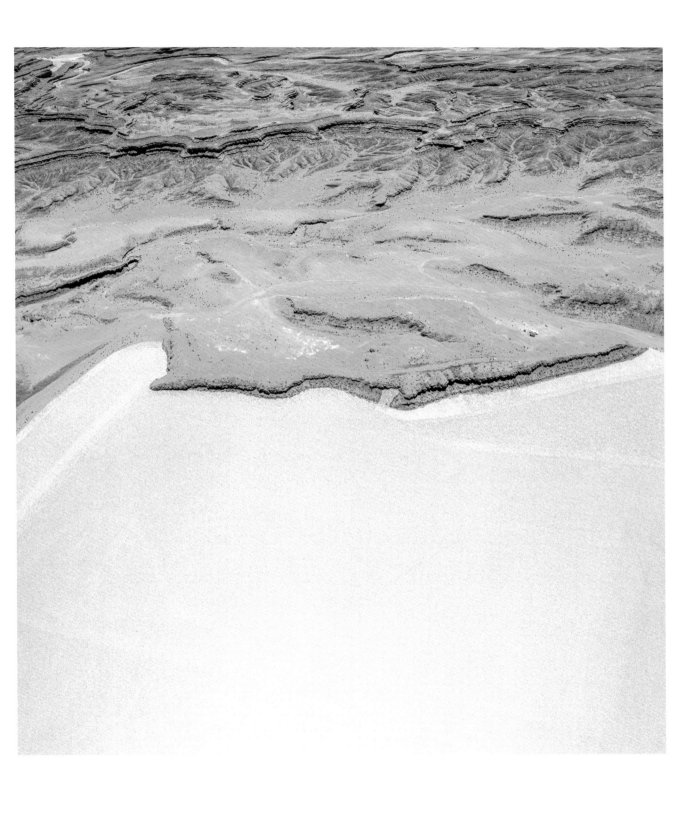

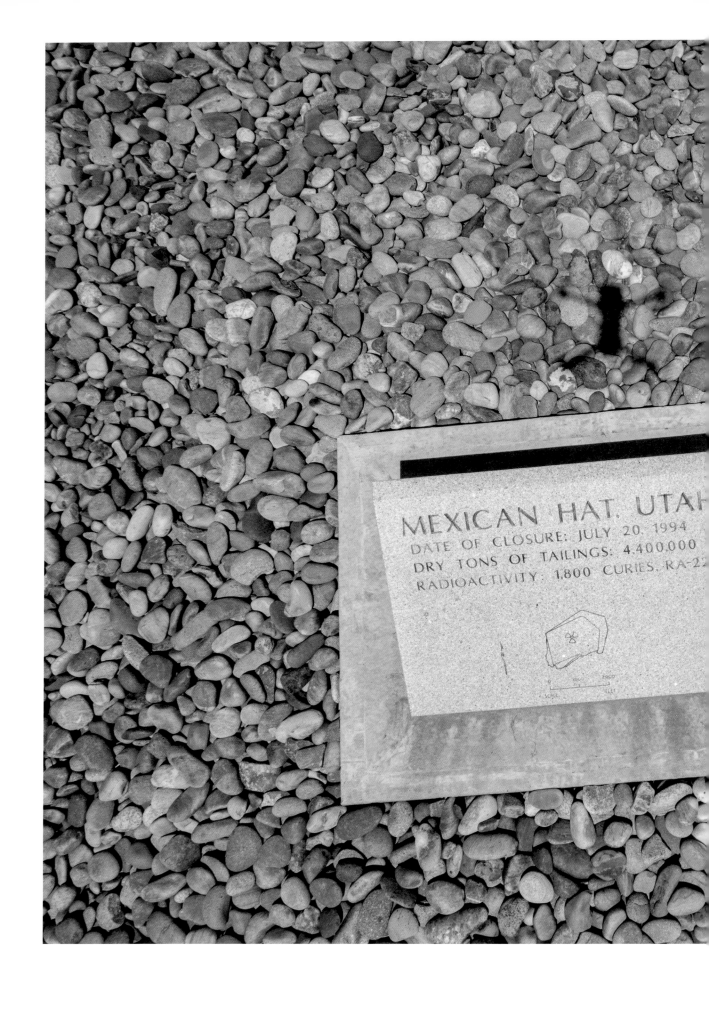

MEXICAN HAT, UTAH
DATE OF CLOSURE: JULY 20, 1994
DRY TONS OF TAILINGS: 4,400,000
RADIOACTIVITY: 1,800 CURIES, RA-22

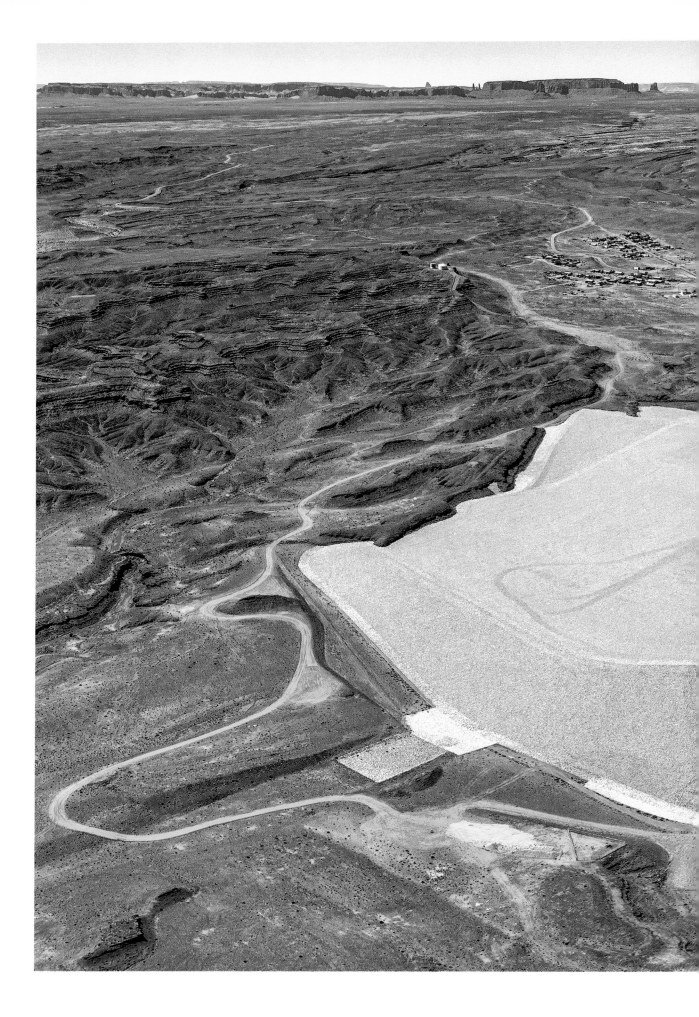

YHONNIE SCARCE
(KOKATHA/NUKUNU)

Nucleus (U235), 2021
4 glass bush plums (#11-14 in the series)
Ca. 9.84 –11.81 x 9.84-11.81 × 13.8 h inches each
4 metal carts, 16.5 × 20.9 × 34 inches each
Courtesy the artist, THIS IS NO FANTASY and Dianne Tanzer Gallery, Narrm (Melbourne), Australia
Glass blowing with assistance from Kristel Britcher, Jam Fantasy, Tarntanya (Adelaide), Australia

**EDITED AND CONDENSED
FROM AN INTERVIEW WITH ERIN VINK**

I've previously visited sites of genocide, internationally as well as here in Australia, and usually you get a sense of the energy that has been left behind. I've visited concentration camps and places similar to that and you can really feel the sorrow. Whereas at Maralinga, there is nothing there. It's weird and you feel nothing. It feels like all the Old People, or even just the energy from the land—from Country there—have just up and left. There's a lot of stillness. There's no good energy there. It's quite flat. I didn't even feel any sort of emotion, which I normally do—I try to tap into that. I guess that's the whole story of the nuclear test there and at Emu Field as well. That radiation killed off a lot of things. It is coming back, slowly, but I found it really interesting, my response, and every time I go back I still feel the same. I'm still drawn to that place and it's become an old friend, or it seems to be hanging around quite a lot in my head. I tend to want to be around it and visit as much as possible. That's like my birthplace of Woomera too—I keep wanting to go back even though there isn't much out there.

I think initially I was trying to create a visual representation from memory and from the stories that I had heard firsthand. And while you read about what you read about, such as what people saw and what they felt when they saw it, it was so important for me to create *Thunder Raining Poison* (2016), *Death Zephyr* (2017), and *Cloud Chamber* (2020) so that people could get a sense of what was coming towards those people who were out on Country when the testing took place. Also, my cloud works were about understanding that it wasn't always that first explosion that caused damage— instead it was from those clouds that traveled all over the place and across the state of South Australia. They traveled quite vast distances in many shapes and forms, so it was important to reference that.

I use the symbol of the yam often to represent the deceased. You see that in a lot of my works—particularly burial grounds or memorial works. I felt like the yam was a really great food symbol to represent us. Also, the yam shape I made were pieces of glass that I could suspend easily because they have an opening at the top—not always though—but they

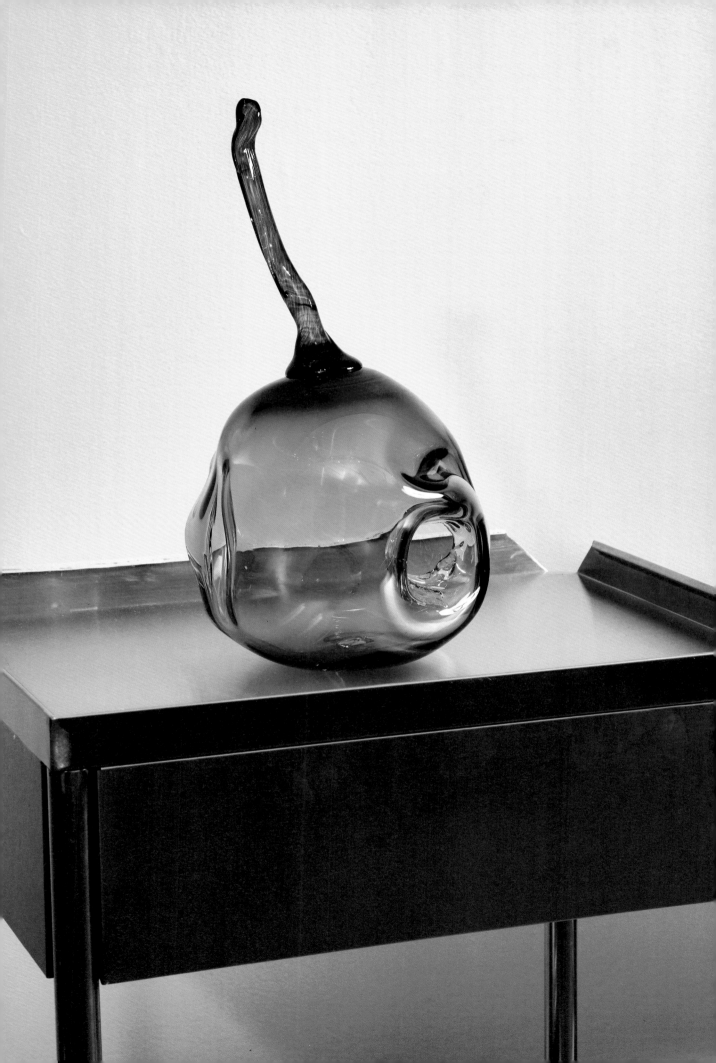

seemed like something that was quite perfect to represent something that was falling or rising out of the sky.

For me particularly, knowing that there are Aboriginal people that disappeared during that ten-year time frame—that period when bombs were even happening at Emu Field as well—that's what needs to be talked about. I find too that Emu Field is not really talked about as much as Maralinga, and yet it was the first mainland-based test site. Those tests were as detrimental to Aboriginal people as the ones at Maralinga were. Emu Field is further up in South Australia than Maralinga so clouds traveled far distances into the Northern Territory, causing damage there too. It's important to note it wasn't just one place—there were other bombs exploded as well at the Montebello Islands, even before Emu Field. I feel like the British and Australian Governments were always sniffing around for the next big thing or next big place to do something bigger, the grass is always greener, something like that. Even with my own reflection on the information and from the stories that I've heard, for me the hardest thing is that those nuclear tests happened when Aboriginal people were not considered citizens. I feel there were a lot of Aboriginal people who were killed because of these tests and because they weren't recognized as people, the government got away with what they were doing because we weren't important enough to be counted! Those stories are important, so I'm working on an ongoing project to recognize everyone's experiences. The more I speak to people the more willing they are to talk about it. I think if you show that you have some sort of history related to those tests, then they are more willing to share their own stories for others to learn.

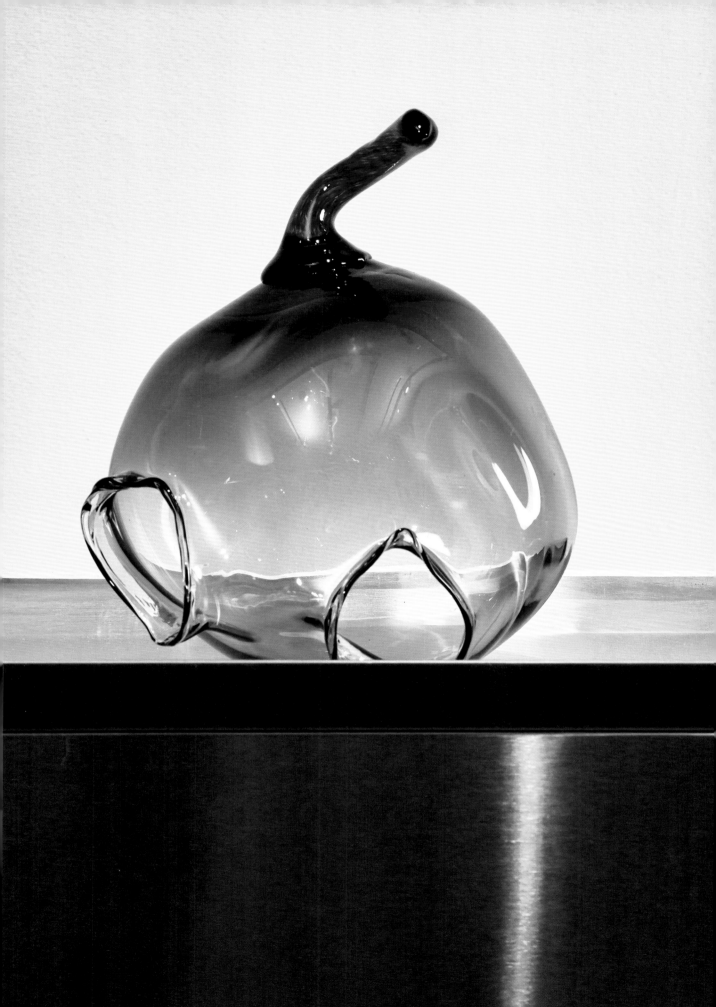

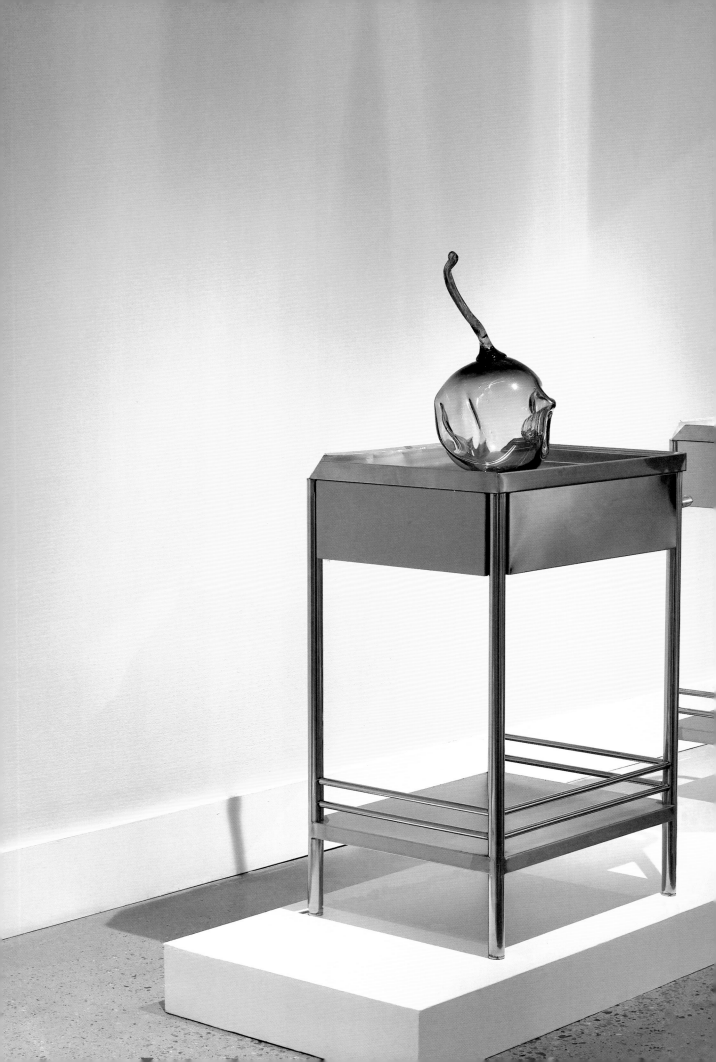

TEXTS

POISON REIGN: AUSTRALIA'S TOXIC NUCLEAR LEGACY

Erin Vink (Ngiyampaa)

Assistant Curator of Aboriginal and Torres Strait Islander Art, Art Gallery of New South Wales

"KUKA PALYA! NGURA WIYA!" ("You can hunt here, but you can't make a home!") reads a small warning sign written in Pitjantjatjara text. Some 1200 kilometers northwest of Tarntanya (Adelaide), South Australia, this sign stands at a dusty, former atomic weapon test explosion site in an area known as Maralinga, within the Anangu Pitjantjatjara Yankunytjatjara (APY) Lands. To Anangu,[1] this Country[2] was once rich with spinifex grass, mulga, and *malu* (young kangaroos). However, in the wake of the devastation caused by the British atomic weapons testing program that was carried out on Australian soil from 1956–1963, what now exists is only the dead, irradiated land, where nothing much remains.

The English language has never proven to be adequate in communicating the nuances of Aboriginal and Torres Strait Islander people's spirit and culture. Where the translated Pitjantjatjara sign hints only that Anangu cannot return "home," to Aboriginal people it speaks of the violent separation and removal of Anangu from their lands, culture, and heritage. Like many First Nations people, Aboriginal and Torres Strait Islanders believe our land is sentient, and we are inextricably intertwined with it. Thus, what the translation fails to tell non-Indigenous people is that Anangu can never go back home, they can never again sleep on this land, or feel the beautiful red sand between their fingers and toes. They can never again be energized by this place that is part of their heart and soul.

As I write on the unceded sovereign lands of the Gadigal of the Eora Nation (Sydney, Australia), and in a year following apocalyptic Australian bushfires and a global pandemic, there is a growing awareness among the general Australian population that we live amongst other creatures and on an environmentally fragile planet. This is especially true of the Aboriginal artists who make up the Australian contribution to *Exposure: Native Art and Political Ecology*, as they are inherently aware of how one's actions and interactions with landscape can shape the world around us. Speaking about the nuclear atrocity that was the British atomic weapons testing program, along with Australia's history of nuclear mining, their works make a significant contribution to the Australian art ecosphere. Their creative endeavors also powerfully tell that if we are to live through this changing world, caring for Country and our spirit must become a priority.

//

The particular history of Australia's atomic identity began in 1950 when the British government, committed to making their own atomic bomb, secretly approached Robert Menzies, then Prime Minister of Australia, on November 16 requesting permission to undertake nuclear weapons testing at the first of three locations: the Montebello Islands.[3] This request to Menzies was made following the United Kingdom having been denied use of Commonwealth soil by the Canadian government, and following their failure to collaborate with the United States of America on their atomic weapons. Menzies agreed to testing without any discussion between Cabinet, nor the entire Parliament.[4] At Montebello they exploded three large-scale nuclear weapons as part of Operations Hurricane (1952) and Mosaic (1956), with Menzies assuring Parliament the day after the initial testing that "no conceivable injury to life, men or property could emerge from the test."[5]

Attention soon shifted to the A̲nangu Pitjantjatjara Yankunytjatjara Lands, and the British exploded two major weapons at a place called Emu Field under Operation Totem (1953), and then seven major bombs at Maralinga as part of Operations Buffalo (1956) and Antler (1957). Combined with hundreds of smaller test explosions across the three locations, these major trials explored the mushroom clouds and investigated a diverse range of atomic weapon designs and explosive yields, resulting in the first operational British nuclear weapon. The first was called Blue Danube, similar in shape to the atomic bomb that the Americans dropped on Hiroshima and Nagasaki. The second was named Red Beard, a smaller and more tactical nuclear weapon.

//

Because the British atomic weapons testing program was so secretive and deadly, it remains at the heart of discussions around Australia's nuclear problems, and it is here at Maralinga that several of our Aboriginal artists' stories begin. One is Pitjantjatjara artist Betty Muffler (b. 1944), who was a young girl at the time of the testing. Today she is considered a *kungka* (strong woman) and, as a *ngangka̲ri* (traditional bush doctor), she is regarded throughout the Lands for her healing practice. Escaping the black mist or *puyu* that fell on Country and contaminated land with radiation, she and her surviving family relocated to Pukatja (Ernabella), before she moved on to the Aboriginal community of Indulkana. She continues to live and work there, painting out of Iwantja Arts Centre— an entirely Aboriginal owned and directed art studio. It is also the shared studio space of renowned Aboriginal artists Vincent Namatjira, Kaylene Whiskey, Alec Baker, Peter Mungkuri, and Tiger Yaltangki.

Although Muffler began painting and exhibiting in 2014, she did not begin painting prolifically until 2017. That same year she produced the illuminating work *Ngangkari Ngura (Healing Country)* which won her the 2017 emerging artist prize at the Telstra National Aboriginal and Torres Strait Islander Art Awards. This work, now in the collection of the Australian War Memorial, Canberra, captured in explicit detail the devastation caused by the atomic weapons testing program to her Country, along with places of healing. In this work, she goes as far to reflect on how her own father died from sickness following his immediate return to irradiated Country. At the time of painting, Muffler included dark areas on this canvas, to signify the dead or dying land. She noted that, because Country is sentient, it holds the trauma of her father and other ancestors who came to their demise at this place.

Muffler has since made a significant thematic departure from this celebrated 2017 work, and her practice has come into its own over the past four years. Rather than focus on the environmental destruction of Country and the hurt experienced by Anangu, she instead presents works that piece together stories of her Country, bringing out the hidden and unwritten stories of her Land and *ngangkari* practice, to explore what it means to heal. She uses her own voice and experiences to portray the landscape she inhabits, to celebrate the passages of culture and to remind us that memory is not linear.

In a 2019 work also titled *Ngangkari Ngura (Healing Country)*, drawn from the collection of Bérengère Primat, Muffler presents her experiences as a *ngangkari*, traveling through the Lands offering healing to people and Country. Viewing this work as a nocturnal topographical map, the work shows *tjukula tjuta* (many rockholes) and the kapi (water) that flows through her Country. *Ngangkari* are said to control the weather, to bring rain, and here Muffler has laid down a brilliant white, indicating the flow of water from one rockhole to the other. Across the canvas the water flows, filling up rockhole from top to bottom, the movement echoing the energies of Country that flows from people to place. This energy is invisible to all but the *ngangkari*, as only they can see spirits and feel the power of place. Muffler says, "I really like my *ngangkari* work. . . . It makes me happy to know that I'm helping people—I know it's a really important job."[6] *Ngangkari Ngura (Healing Country)* thus is both a reminder of how we ended up "here" and a forced prompting for mankind to consider how we treat one another. Muffler in no uncertain terms reminds us to reflect on our history, even if it is uncomfortable to do so.

Another Pitjantjatjara artist who created visual documents about Maralinga and the Anangu experience was Kunmanara[7] (Karrika Belle) Davidson (ca.1942–2017). She was born near Papulankutja (Blackstone) in South Australia, but as a young girl grew up at Warburton Mission following the death of her mother. At Warburton Davidson

learned to read and write, and she had fond memories of her time there. However, many Aboriginal children who were removed from Country and their families do not share this same positive experience. Often under the pretense of missionary work, the then South Australian Government utilized conditions brought about by the atomic weapons testing program to control the location and movement of Aboriginal people from the Desert regions, thus allowing the regulation of blackness.

In *Maralinga Bomb* (2016), Davidson depicts a time when, while camped in the bush near Warburton Mission with her young son and other Aṉangu, a nuclear test was detonated. She and others became immediately ill and were collected by Mission patrollers and taken back to Warburton. Here we see Davidson's memory unfold across the canvas with circular shapes detailed in green taking the forms of windbreaks originally set up to protect people from the post-bomb winds. Within these windbreaks are small, fine dots, representing people—some of whom are sick and dying. There is an ebb and flow to the work, and Davidson's masterful patterning of brown and red indicates the sparks of fire that caught on spinifex grass, that flamed into black, ruined remains. Of her work, Davidson recalled, "They [Aṉangu] were all going down to the rock hole. I was a sick one. I had my first boy. It was a holiday. Smell went over when we got there. Big cloud. Winds come in from the south. Some people dying, some people got medicine. The kids were dying, girls, children, men, women. This is the real story from the bomb: how we got sick."[8]

Pitjantjatjara collaborators Kunmanara (Jeffrey) Queama (1947–2009) and Hilda Moodoo (b. 1952) also ruminate on the lack of Aboriginal land agency during the weapons testing program by giving form to the mushroom cloud that forced them to evacuate their lands. Mesmerizing and multi-layered, the landscape comes alive in *Destruction I* (2002) with the lingering smoke and debris swallowing up an Aṉangu land- and skyscape, and indeed the canvas itself. *Destruction I* was included in the 2002 exhibition *Desert Oaks* in Tarntanya (Adelaide, Australia), and added Queama and Moodoo's voices to a community collective that came into being due to their dispossession. This community, named the Oak Valley community, is a group of Pitjantjatjara people who returned to Country in the mid-1980s, to which both Queama and Moodoo are recognized as community founders.

While they were not the first Aboriginal artists to paint the Maralinga mushroom cloud—that was probably Kamilaroi/Yorta artist Lance Atkinson—Queama and Moodoo's painting was one of the earliest presentations of the cloud in the unique and recognizable "dot" painting style, a technique belonging to people from the Desert regions. And nearly twenty years since this painting was completed, we find many Aboriginal artists still turning to this imagery of the cloud, including Waanyi artist Judy

Watson, or Dunghutti artist Blak Douglas. Perhaps because the nuclear atrocities were so unfathomable, artists continue to return to the mushroom cloud to understand the magnitude of destruction, along with its lingering effects still experienced by Aboriginal people in the present.

//

There are Aboriginal artists in *Exposure: Native Art and Political Ecology* who come from across the Desert regions and Arnhem Land, utilizing beauty and aesthetics to arrest viewers, to challenge nuclear colonial paradigms and narratives specific to their people. One such person is contemporary glass artist Yhonnie Scarce (b. 1973), who regularly produces works that comment on the devastating effects of nuclear colonialism within Australia, testifying to the trauma enacted on Aboriginal people and communities, including the government control and dispersal of South Australian Aboriginal people during the 1950s and 1960s.[9] As a Kokatha and Nukunu woman, Scarce has familial connections to the Country around Maralinga through her maternal grandfather. She was born at Woomera in 1973, a town that was drawn up only thirty years earlier to house the British and Australian Defence Force personnel who were working within the vast militarized zones.

Scarce is known for her ambitious glass installations, such as *Thunder Raining Poison* (2015), *Death Zephyr* (2017), and *Cloud Chamber* (2020). In these works, that poisonous black mist or puyu that fell on people in Country becomes clouds of small glass bush yams, delicately suspended. Rain is normally a welcome sight in the desert; however, following the bombings, the puyu caused sickness and early death for many. One case was that of Yami Lester, a Yankunytjatjara man who, despite medical treatment, lost his eyesight soon after being exposed.[10] For Scarce, she speaks of it as "a death cloud, with a mouth and jaw. . . it would have swept along close to the ground and engulfed people."[11]

For this exhibition, Scarce was commissioned to produce four new works that focus on the form of the bush plum, a food staple once frequently harvested by Aboriginal people. *Nucleus (U235)* (2021) sees four bush plums (numbers 11–15 in the series) perched on top of tables, with each plum representing a person, an individual life lost. Declan Fry wrote of the works that each were "pocked with apertures and openings, topped by umbilical-cord-like stems. Some of these holes are faintly burnished black, as if they had imploded outwards, their bodies wrinkled with wound-like crevasses."[12]

There is an ethereal quality to *Nucleus (U235)* that sits in noticeable contrast to what the work itself reveals. Perhaps it's how the material is made, forged in fire, that makes Scarce want to interact with this medium—the conditions too are reminiscent of the

crystallization of desert sand due to the nuclear tests. Or perhaps it is because the bush plum can exist in a flash of suspended animation, the plum itself becoming a person held within a moment of destruction. The plum, while beautiful, therefore brings with it a sense of foreboding, becoming a literal monument to the dead.

A breathtaking major work that reveals what happened at Emu Field and Maralinga is the collaborative installation *Kulata Tjuta* (2017), which features some 550 suspended *kulata* (spears) and floating *piti* (coolamons), originally realized at the Art Gallery of South Australia in 2017 for Tarnanthi: Festival of Contemporary Aboriginal and Torres Strait Islander Art. Forecasting fragility, the installation draws on the collective knowledge and experiences of Anangu who experienced the atomic weapons testing program, and accompanying the *kulata* and *piti* is video footage of the artists recalling these events. Willy Kaika Burton explains that, "with this artwork, we say a prayer for the ones who were lost from the Black Mist, the bomb test. . . . We are with you and we are proud."[13]

Like Scarce's work, one might feel that *Kulata Tjuta* is an inert moment of suspense, where the form could shift or change at any moment. Referred to as *kupi kupi* (a mini tornado) the form of the kulata becomes a weather phenomenon that can often be seen across the Lands. For Anangu, the wind associated with this movement is of extreme cultural significance. According to the APY Art Centre Collective, "the winds mark the passing of the most senior and significant Anangu Elders [and] it can be a warning to Anangu that danger in Country is approaching."[14] One can imagine that this wind tornado has just been generated following a blast, and that past Elders are warning Anangu to get away, to escape this place and hide.

If the works by these Southern Desert artists serve as a reminder of the trauma caused by the mushroom cloud and the *puyu* that followed, then Daymil artist Gunybi Ganambarr's (b. 1973) work *Gapu* (2017) speaks to the failure of the Australian Government to decolonize its nuclear self. Since the atomic weapons testing program ceased in 1963, mining for uranium has become a significant industry in Australia—in fact, we are now the world's second largest producer. First mined in Australia's "Top End" in the late 1970s, the government commonly extinguished the native title rights of Aboriginal and Torres Strait Islander peoples in favor of mining and pastoral companies. Here we are privileged to hear from Ganambarr, whose work directly references the major impact that mining has had on his Country in northeastern Arnhem Land. Ganambarr reclaims an old conveyor belt, an object that has literally transported the riches of Country away, intricately incising it with the clan designs of his people. What remains are remnant marks of white chalk that hint at this destructive relationship to industry.

At the heart of Ganambarr's practice is an exploration of Country: how it is owned, how it is shared, and how it is utilized. That our culture is both 65,000 years old and immediately young, Ganambarr's detailed incised designs become both an act of contemporary artmaking but also a symbol of something that has been firmly attached to place since time immemorial. The markings denote ownership of and responsibility to and for Country, along with symbolizing the rights of his people that have been eroded as the surface of Country itself has been removed. The diamond design in *Gapu* relates to the meeting of fresh- and saltwaters around Gängan, known as Gulutji. Barama (the great Ancestral being for the Yirritja moiety) emerged from the water at this location and established Yirritja law. As such, since this time it has been an important meeting place shared by Yirritja clans (the Yirritja moiety together with the Dhuwa moiety forms a duality system that keeps all past, present, and future life in balance) for ceremony and social activities, such as fishing. It and other sacred sites across Australia are at direct risk of damage due to mining and the extraction of Country's riches.

//

Anangu Elder Keith Peters's words, "Enough is enough! They've [the Government] damaged our Country and we've seen that before! We are not going to have this disaster again!"[15] serves as a message to all Australians that our First Nations people have had enough of the casual violence, rape, and pillaging of Country. If we as a nation still cannot comprehend the events and direct results of the atomic nuclear weapons testing program from seventy years ago, how can we now comprehend the damage we are inflicting to Country as we travel down this new nuclear path?

Many of the First Nations artists presented in this exhibition are not only aware of the instability of nuclear energy, but they anticipate and exaggerate it within their works. As viewers move through the Australian contribution to *Exposure: Native Art and Political Ecology* they encounter diverse visual languages that reveal Aboriginal Australian experiences of displacement, dispossession, and slow violence that have long been excluded from the accepted narrative. At the heart of this conversation are the voices of survivors, from Australia's Pitjantjatjara, Yankunytjatjara, Kokatha, Nukunu and Daymil people. Let us hope that these artists, and those yet to come, reveal this intimate history that will teach vital lessons on the treatment of our planet and her Indigenous peoples. It is impossible for us to know, while poised on the precipice, whether we have ultimately caused irreparable and irreversible damage.

Endnotes

1. Anangu means "people" in Pitjantjatjara. It is the term used to refer to people from this region, that being the Western and Southern Desert regions.

2. For Australian Aboriginal people, Country is a capitalized word. It reflects that it is a sentient being and that the term encompasses more than just creeks, hills, rock outcrops and waterholes. Country includes all living things, seen and unseen. It includes people, animals, but also weather, seasons and Ancestors that have existed in place since time immemorial.

3. Australian Parliament House, Senate and House of Representatives, *Debates* 191 (1 May 1947): 1832.

4. Australian Parliament, *Debates*, 1832

5. Australian Parliament House, House of Representatives, *Debates* 1 (16 October 1953): 1510.

6. Betty Muffler, "Ngangkari Ngura (Healing Country)" artwork certificate, 2018. English translations supplied by Iwantja Arts, 526-18.

7. "Kunmanara" is a Pitjantjatjara word meaning "no name" and replaces Anangu people's Christian name when they pass away. This is done out of a practice called Sorry Business, to respect that person and their family during mourning. In the case of artists, the families of deceased sometimes give permission for their first names to be written in brackets.

8. Kunmanara (Belle Karrika) Davidson, *Maralinga Bomb* artwork certificate, 2016. English translations supplied by Papulankutja Artists, sourced from Australian War Memorial, https://www.awm.gov.au/collection/C2144666

9. Erin Vink, "The Australian War Memorial and collecting Aboriginal art in a Moment," *Art Monthly Australasia* 325 (Spring 2020): 86-89.

10. Mattingley, Christobel, ed., *Survival in our own land:*

"Aboriginal" experiences in "South Australia" told by Nungas and others (Adelaide, 1988), 92

11. Scarce, as quoted in Jane Ure-Smith, "Heat and dust: art inspired by Aboriginal identity and nuclear explosions," *Financial Times*, May 8, 2020, Accessed 1/10/2020, https://www.ft.com/content/342e771c-82ff-11ea-b6e9-a94cffd1d9bf

12. Declan Fry, "Looking Glass," *The Saturday Paper*, Dec 5, 2020, Accessed 1/03/2021, https://www.thesaturdaypaper.com.au/culture/art/2020/12/05/looking-glass/160708680010811#hrd

13. Willy Kaika Burton, "The Kulata Tjuta Project, Supported by APY Art Centre Collective," in Nici Cumpston, *Tarnanthi* (Art Gallery of South Australia, Adelaide, South Australia, 2017), 42.

14. APY Art Centre Collective, *Kulata Tjuta*, accessed 26 October 2020, https://www.apyartcentrecollective.com/kulata-tjuta

15. Keith Peters, "Indigenous Voices," *UNLIKELY, Journal for Creative Arts* 5, accessed 2/10/2020, http://unlikely.net.au/issue-05/indigenous-voices

CEDING THE MUSHROOM CLOUD

Kōan Jeff Baysa, MD

Flashback. 11:08 PM, 9 July 1962. My father had just woken me and I joined him standing and staring at the sky out of the large dining room window of our home in Hawai'i. In silence, the sky erupted in an instant with a green-gray flash that backlit the clouds then faded. I trudged back to bed with no idea that what I had just witnessed was the flash of the largest nuclear fusion test ever conducted in outer space: Starfish Prime, a nuclear test conducted by the US that was launched from Johnston Atoll, 900 miles from Hawai'i then detonated 250 miles high in the atmosphere.

8:07 AM, 13 January 2018. An alert was issued of an incoming ballistic missile threat to the Hawaiian Islands. Recent saber rattling of nuclear threats from North Korea put Hawai'i and Guam, a US territory since 1950, squarely within striking distance. It was ultimately a false alarm, but nonetheless Pacific Islanders, especially older Marshall Islanders, numbering among the roughly 15,000 individuals, many of whom were pushed to migrate to the Aloha State, cringed as the specters of radiation sickness, malformed babies, and cancers from downplayed radiation exposure loomed in their memories and fears were kindled anew.

Nuclear bombs release their energy in the form of a blast, a fireball, visible light and radioactive ionizing rays. The latter is invisible, but the carcinogenic and teratogenic aftereffects are tragically and painfully visible. The arts also make radiation visible with their impact via visualizations, symbologies, and the written and spoken word. The persistence of art ensures that the information disclosure and powerful messaging of radiation dangers are carried into future generations, especially given that the half-life of plutonium-239 is 24,000 years.

My curatorial approach for *Exposure: Native Art and Political Ecology* was not to lay out a comprehensive history of nuclear testing in the Pacific Ocean. Instead, the intent was to elucidate the settings that gave world powers, like the US and France, essentially *carte blanche* to conduct nuclear capability testing in the Pacific, the American Southwest, and Algeria and French Polynesia, respectively. Weather patterns guided radiation-laden

clouds to disperse their contaminated contents to the Cook Islands, New Zealand, Niue, Fiji, Tokelau, Tonga, Tuvalu, and the northern islands of the Hawaiian chain.[1] Nuclear testing in the Pacific was accomplished remarkably without conscience or consequence for an extended period of time through the promotion and enhancement of colonialist attitudes that devalued and dehumanized Native peoples.

The history of nuclear testing is the history of nuclear colonialization. Tongan scholar Epiloi Hau'ofa stated, "certain kinds of experiment and exploitation can be undertaken by powerful nations with minimum political repercussions to themselves."[2] This was justified by the erroneous perception and promotion of the Pacific, a place so distant from the Western centers of power that it was comparatively "empty" of people, on "islands in a far sea," and the "hole in the doughnut" of the affluent Pacific Rim.[3] Britain, France, and the US all minimized the risk of international scrutiny by undertaking their nuclear tests in sites over which they had colonial jurisdiction.[4]

In 1956, Merril Eisenbud, director of the US Atomic Energy Agency's health and safety laboratory, explained that Utirik Atoll in the Marshall Islands "was an ideal research site for getting a measure of the human uptake when people live in a contaminated environment . . . While it is true that these people do not live . . . the way Westerners do, civilized people, it is nevertheless also true that these people are more like us than mice."[5] Further, shortly after the tests took place, under the guise of humanitarian aid, the people of Rongelap, Ailinginae, and Utirik were enrolled as human subjects in Project 4.1, a US scientific study of the effects of radiation on human beings.[6]

The artworks included by Indigenous artists of the Pacific provide lenses with which to view these attitudes and injustices brought against Native communities and the irrevocable devastating sequelae and environmental disasters that ensued. Moreover, the works selected by my co-curators are not isolated, but interconnected. In 2018, Marshall islander Kathy Jetñil-Kijiner collaborated with Aka Niviana, a climate change activist and poet from Greenland, to write a poem about climate change in their respective homelands. "Rise: From One Island to Another" links the melting icecaps and rising sea levels on similarly affected but disparately located areas on the globe.

From 1946–1958, the US conducted sixty-seven nuclear tests within the Marshall Islands, twenty-three of which took place on Bikini Atoll. Residents initially believed that their serial displacement to neighboring islands would be temporary. In 1972, more than 100 people moved back to Bikini after the United States declared the island to

be "radiologically safe." Laboratory tests in 1978, however, indicated that the returnees had ingested unacceptably high levels of caesium-137 and strontium-90, and they were again evacuated from the island.[7] They were shielded from the fact that their homeland would be uninhabitable indefinitely, given the half-life of the plutonium-239. The nuclear fallout ash drifting down from the sky resembled snowflakes, and children unknowingly played in them, some ingesting them. Immediate symptoms of radiation poisoning were skin lesions, hair loss, and vomiting. Long-term generational health problems include thyroid tumors, leukemias, pregnancy complications with miscarriages and stillbirths, as well as infants with profound developmental delays and severe congenital anomalies who were described as ultimately nonviable "jellyfish babies" because of their translucency and incompletely formed musculoskeletal systems. These malformed fetuses and infants, described as chimeric visualizations of pelagic invertebrates, appear in "Monster," Jetñil-Kijiner's antinuclear poem.

In 1986, the Compacts of Free Association (COFA) was made between the US and three Micronesian nations that allowed citizens of these nations to enter the US freely and to work. This prompted Marshallese to migrate to Hawai'i and the mainland, but as the newest immigrants placed lowest on the socioeconomic ladder, they encountered racism and discrimination. Marshall islanders are still living in near-permanent exile, comprising 76 percent of the homeless population in Hawai'i.[8] The Marshallese are still waiting for the US to atone for the environmental and socioeconomic damage resulting from its military exploitation of the islands across generations.

The Marshall Islands has also taken the global stage in advocating for the compensation of nuclear weapons victims through the voice of Jetñil-Kijiner, the Marshallese firebrand eco-activist and performance poet. The spoken word artist highlights the Gordian knot formed by the interconnected issues of nuclear imperialism, forced migration, climate change, racism, and sequelae of Native peoples. *History Project: A Marshall Islands Nuclear Story* (2018) exists as an animation and a graphic adaptation, a rich collaboration between Jetñil-Kijiner, Edinburgh University academic Michelle Keown, Maori-Ninuean artist Munro Te Whata, and PREL (Island Research and Education Initiative), a nonprofit publisher in Micronesia. The exploration of the nuclear history of the Marshall Islands began when fifteen-year-old Jetñil-Kijiner chose the subject as her school history project. It starts with the US governor of the Marshall Islands persuading residents to leave their homes "for the good of mankind and to end all world wars."

The digital video poem *ANOINTED* (2017) was written and performed by Jetñil-Kijiner

and directed by Daniel Lin, a filmmaker, photojournalist, and Director of PREL. It tracks a parallel story with *History Project: A Marshall Islands Nuclear Story* through tales and legends of Runit Island and its nuclear testing legacy.

The Runit Dome, also called The Tomb by locals, is a 115-meter diameter, forty-six-centimeter-thick dome of concrete at sea level, encapsulating an estimated 73,000 cubic meters of radioactive debris, including plutonium-239. From 1977 to 1980, loose waste and topsoil debris scraped off from six different islands in the Enewetak Atoll were transported here, mixed with concrete, and stored in the nuclear blast crater created by the nuclear test on May 6, 1958. In order to save costs, the original plan to line the porous bottom crater with concrete was abandoned. In 2013 the US Department of Energy reported that soil outside of the dome had a higher level of radioactive contamination than inside the dome.[9] The greater danger is leaching of the radioactive element and heavy metal toxin plutonium from the dome. The nuclear waste has contaminated the groundwater. Shellfish with detectable radioactivity have been found in adjacent waters, raising concerns about the resultant bioaccumulation of radioactivity in the food chain, affecting not only consumption but also the fishing industries of adjacent neighbor nations and Hawai'i.[10] Coconuts on Bikini were still radioactive because coconut palm trees absorb caesium-137 and other radioactive elements from the soil. These elements are then concentrated in the fruit.[11] Cracks have appeared in the dome's collapsing concrete shell and rising seas due to climate change will soon lap its margins. A typhoon could split the structure open and spill its contents into the open sea.

ANOINTED is marked by Jetñil's haunting words, "I'm coming to meet you. . . . Will I find an island or a tomb? . . . You were a whole island, once," spoken as she stands alone in a receding image, dwarfed by the bleak concrete concavity capping the deadly contaminated wastes of Native lands beneath her bare feet.

Solomon Enos (Kanaka Maoli), an artist, illustrator, game-designer, educator, and artist, collaborated with Jetñil-Kijiner and the University of Edinburgh on the 2018 graphic novel *Jerakiaarlap*, a Marshallese aphorism that translates to "point of no return." It is about the Bikini Atoll community in Majuro and Hawai'i and posits a futuristic return of Marshallese who were subjected to forced migration, to their islands now transformed by biotechnology. The native Hawaiian multimedia artist takes the reader on an epic voyage through the history of the Marshall Islands, navigating through traditional stories focused on the Indigenous community's accomplished seafaring heritage of sail-making, canoe-making, and navigation. This graphic novel grew from Jetñil-Kijiner's poem "Monster," which explored Marshallese women's fertility problems resulting from

the "slow violence" and "long dyings" of nuclear irradiation. Rob Nixon's "slow violence" conceptualizes slow-moving injurious and deadly harms stemming from human-caused environmental degradation or climate change. It is a form of violence that is "neither spectacular nor instantaneous, but rather incremental and accretive, its calamitous repercussions playing out across a range of temporal scales. Slow violence poses a problem of visibility and representation insofar as its effects are often unseen to most people, particularly to those in positions of power.[12] As Professor Keown posits, "The conclusion of *Jerakiaarlap* re-imagines the capital of the Marshall Islands as a 'Neo-Majuro,' a futuristic atoll that has become a sentient being rising well above sea level (with the aid of biotechnology), by ingesting piles of waste matter salvaged and transported from the western nations that created the contemporary climate crisis . . . They are welcomed by a small team of resident Marshall Islanders and 'coconut bio-bots' who operate bio-plastic systems that convert global waste into healthy soil . . . the technology evolves within the text and carry us towards more sustainable ways of living."[13]

Honolulu-based Joy Lehuanani Enomoto (Kanaka Maoli) engages with issues of ancestral memory, violence within land and seascapes, extractive colonialism, demilitarization, and other issues affecting the peoples of Oceania. A visual artist, archivist, and social justice activist, Lehuani Enomoto is also Black, Japanese, Scottish, and Punjabi. She states, "Driven by our ancestors, our rivers and our mountains, my process is not an individual practice, I am committed to collaborating with other artists/ writers and communities who are fighting for social justice and the protection of our sacred lands and waters."[14]

On November 1, 1952, the United States detonated the world's first hydrogen bomb on a large atoll called Eniwetok in the Marshall Islands in the South Pacific. H-bombs, which get their power from fusion, are 1000 times more powerful than atomic bombs, which derive their force from fission. The creation and detonation of the first hydrogen bomb on the Eniwetok Atoll allowed the United States to temporarily step ahead of the Soviets during the arms race of the Cold War. Overall there were forty-three nuclear tests conducted at Enewetak from 1948 to 1958.

Enomoto presents her mixed media work *Nuclear Hemorrhage: Enewetak Does Not Forget* (2017), a reflection on the forever-changed lands and waters of this atoll in the Marshall Islands by nuclear violence, but which remains intact in the memories of her people. As radioactive contaminants leach into the ocean, the ring of green represents the hope of restoration and the memory of what existed. The dome appears to be built by the sea fan, a colony of soft coral animals without a stony skeleton, that attaches itself in sand rather

than a hard substrate. The artist states, "In the Hawaiian origin chant, the Kumulipo, coral and coral polyps are the foundations of life." Its flat fan structures resemble a network of nourishing blood vessels, branching from a stem anchored at the bottom with a structure resembling a placenta, the body's nourishing organ between old and new growths.

No'u Revilla (Kanaka Maoli and *maohi*-Tahitian) is an Indigenous poet, performer, and educator of Hawaiian and Tahitian descent. She is committed to thinking through and creating space for new practices of poetry and poetics and is particularly invested in creative projects grounded in aloha, 'aina, and intersectional justice.

Synchronous with Enomoto's artwork, Revilla's poem in large graphic format is inspired by Jetñil-Kijiner's poem and installation *Islands Dropped from a Basket: A Letter from a Micronesian Daughter to Hawai'i.* Jetñil-Kijiner's basket is part of the creation legend that the Marshall Islands were formed by a demon dropping five islands from a *banonoor* in the process of stealing food in Majuro. The *banonoor* is a specific type of handmade Marshallese basket, woven from a section of a palm frond, used to carry and store food and other goods. Revilla celebrates the basket as a metaphor for links to Oceanic transgenerational knowledge, revelation, healing, and sustenance.

From 1966 to 1996, France carried out 193 nuclear tests in French Polynesia. The French government denied responsibility and the extent of plutonium fallout was kept hidden. Plutonium fallout from nuclear testing on Mururoa and Fangataufa atolls in the 1960s and 1970s hit the whole of French Polynesia, a much broader area than France had previously admitted. But of nearly a hundred dossiers, only a dozen people have received compensation. Others on different tests wore shorts and had no sunglasses; they were told simply to shield their eyes and turn their backs at the time of the explosion.[16] It wasn't until 1998 that France signed and ratified a treaty imposing a total ban on nuclear testing in Polynesia.

Alexander Lee's printed curtain installation *Te atua vahine mana ra o Pere (The Great Goddess Pere)—L'Aube où les Fauves viennent se désaltérer* (2017) reflects on French Polynesia and its nuclear history through Pere, the Polynesian goddess of fire who traveled from Tahiti to Hawai'i. The tree that bears *'uru* (breadfruit), a Polynesian staple, is the basis for Lee's leaf motifs, metaphors for transformation due to irradiation. It represents sustenance in dire circumstances, as in the Tahitian legend of a man transforming himself into a breadfruit to feed his starving children.

For Lee, the image of the nuclear explosion in the accompanying prints is a historical extension of Pere's volcanic eruption. Mushroom clouds thus become potent symbols of the social, political and environmental impact of modernity."[17]

TE FANAU'A 'UNA 'UNA' NĀ TE TUMU —THE SENTINELS (2021) is a site-specific continuous mural painting. The artist remarks, "I was interested in thinking about my own Polynesia and seeing how one could imagine the future." The large-scale work unfolds as a continuous landscape painting and diorama on the walls of IAIA Museum of Contemporary Native Arts (MoCNA). Two purposefully charred vitrines encase a series of porcelain artifacts: flutes, fingerlinks, funnels, fishing wraps, genital wraps, ceremonial utensils, and mnemonic devices. Lee provokes viewers to speculate whether the objects are relics of a nuclear explosion or archaeological finds scorched by Pele's volcanic retribution.[18] It is ironic and fitting that these materials were charred in Hawai'i then transported to New Mexico, with its own history as the site of the Manhattan Project in Los Alamos and the Trinity Site test site near Alamogordo.

Tahiti-based Chantal Spitz's (Ma'ohi) *L'Ile des rêves écrasés (Island of Shattered Dreams)* is the first-ever novel by an Indigenous French Polynesian writer and tells the family saga of several generations of Ma'ohi and a family experiencing the colonization of their Indigenous lands. In a live reading by the author, the subplot of a doomed love story is set against the background of French Polynesia in the period leading up to the first nuclear tests.

Indigenous Samoan Dan Taulapapa McMullin is a post-colonial Oceania *fa'afafine* (non-binary gender) artist, poet, writer, and filmmaker. Their video poem installation *Te Mau Ata: Clouds* (2021) incorporates painting, appropriation, collage, and text that addresses nuclear testing, global warming, and settler racism in American Micronesia and French Polynesia. McMullin employs contemporary storytelling within fairy-tale-like contexts and utilizes the metaphors of clouds as erasure of peoples and the environment. Based on their original research, the artist queers the narratives of American and French science and militarism, as it played out tropes of desire and punishment. In addition, the installation includes several radiation mats made of vinyl, based on existing industrial radiation designs and altered into island motifs by the artist. The accompanying painting shows the major players on both sides: the Indigenous and the military in an "encounter" scenario that invokes "first contact" imagery of Natives and explorers. Segments of bodies in the painting are obfuscated to evoke loss, tragedy, and chaos.

The radioactive fallout from French Polynesia extended downwind thousands of miles to the American territory of Guam. The Radiation Compensation Bill, derived from a 2005 study, established that nuclear weapons testing between 1946 and 1963 affected individuals. The report established a correlation between the nuclear testing and the high incidence of cancer, the second leading cause of death in Guam.[19]

Miriquita "Micki" Davis is a CHamoru artist who investigates and expands notions of artistic collaboration in the contexts of personal, family and community memory, feelings of absence and presence, separation, connection, personal memory, and loss.[20] She presents *Pacific Concrete: Portrait of Christian Paul Reyes* (2019), about her cousin Christian, who had multiple congenital anomalies and survived only a year of life. The work gives rise to questions of the long term and silent effects of radiation exposure across the Pacific. Davis's installation consists of a postcard rack holding images of Christian and his family that tells a story of devotion and love in the aftermath of profound tragedy and loss. The installation contains a traditional CHamoru woven mat. The artist reflects, "Christian Paul Reyes was only with us for a short time, but the love that his family gave him continues to this day. I remember him very clearly as a child, and later when his father would speak of him he would never refer to him in the past tense. He is present then, as he is today."

As of 2017, the Justice Department had awarded more than two billion dollars in "compassionate compensation" to eligible claimants under the proposed 2019 Radiation Exposure Compensation Act Amendments (RECA). No one from Guam has yet received a cent from this program. The RECA program expires in 2022, but the Justice Department stopped receiving applications in 2020 to allow a two-year period to process the compensation.[21]

The literal and figurative tragic fallout, both radioactive/nuclear and carcinogenic/teratogenic sequelae, of Native peoples of atomic bomb testing in Oceania was the result of the perfect storm of Cold War saber-rattling, persistent postcolonial attitudes by world powers with beliefs that the vast Pacific was essentially vacant and its Indigenous peoples trivial. Government awards to compensate the victims of these crimes against humanity have gone unresolved and faded from public view with ignorance and apathy. Given the half-life of plutonium at 24,000 years, it is crucial that artist-activists and exhibitions like *Exposure* keep the threats of present and future radiation catastrophes exposed with strident and persistent voices.

Endnotes

1. "Fallout on Counties Downwind from French Pacific Nuclear Weapons Testing," Pace University, accessed September 3, 2021, https://www.fesny.org/fileadmin/user_upload/Pacific-Downwind-PosObs-Country-Report-12-2h0qcbp.pdf.

2. Michelle Keown, "Waves of destruction: Nuclear imperialism and anti-nuclear protest in the indigenous literatures of the Pacific," Journal of Postcolonial Writing 54, no. 5 (2018): 585–600.

3. Keown, "Waves of destruction."

4. Keown, "Waves of destruction."

5. "Nuclear Savage: The Islands of Secret Project 4.1," Zinn Education Project, accessed September 3, 2021, https://www.zinnedproject.org/materials/nuclear-savage/.

6. Keown, "Waves of destruction."

7. "The United States' Nuclear Testing Programme," Comprehensive Nuclear-Test-Ban Treaty Organization, accessed September 3, 2021, https://www.ctbto.org/nuclear-testing/the-effects-of-nuclear-testing/the-united-states-nuclear-testing-programme/.

8. Aaron Wiener, "America's Real Migrant Crisis Is the One You've Never Heard Of," Mother Jones, December 29, 2016, https://www.motherjones.com/politics/2016/12/hawaii-micronesia-migration-homeless-climate-change/.

9. Isabel Hancock, "A blast from the past: the Pacific's nuclear legacy," Foreign Brief, July 10, 2019, https://www.foreignbrief.com/asia-pacific/a-blast-from-the-past-the-pacifics-nuclear-legacy/.

10. Hancock, "A blast from the past."

11. "The United States' Nuclear Testing Programme."

12. R. Nixon, "Slow Violence, Gender, and the Environmentalism of the Poor," The Journal of Commonwealth and Postcolonial Studies 13, no. 2 (September 2006): 14–37.

13. Michelle Keown, email to the author, August 21, 2020.

14. Joy Lehuanani Enomoto, accessed September 3, 2021, https://www.joyenomoto.com/about.html.

16. Angelique Chrisafis, "French nuclear tests 'showered vast area of Polyneisa with radioactivity,'" The Guardian, July 3, 2013, https://www.theguardian.com/world/2013/jul/03/french-nuclear-tests-polynesia-declassified.

17. Ngahiraka Mason, To Make Wrong/Right/Now, Honolulu Biennial exhibition catalog (Honolulu: Honolulu Biennial Foundation, 2019).

18. Mason, To Make Wrong.

19. Mar-Vic Cagurangan, "Guam included in RECA expansion bill," Pacific Island Times, March 29, 2019, https://www.pacificislandtimes.com/single-post/2019/03/29/Guam-included-in-RECA-expansion-bill.

20. Carurangan, "Guam included."

21. Pacific Island Times News Staff, "US Senate panel to hear radiation compensation bill," Pacific Island Times, June 13, 2018, https://www.pacificislandtimes.com/post/2018/06/14/us-senate-panel-to-hear-radiation-compensation-bill.

EXCAVATING URANIUM IN KUANNERSUIT AND IN GREENLANDIC ART

Nivi Christensen

In South Greenland, on the outskirts of the town of Narsaq, is a mountain called Kuannersuit, which has been one of the key areas of interest in the discourse about uranium mining in Greenland. Kuannersuit has a high occurrence of rare earth materials and uranium. The latter has been presented both by the Greenlandic Government and by the company as a by-product, but the planned mine is not profitable without it. The prospect of uranium mining at Kuannersuit was the reason for the abolishment of the Greenlandic ban on uranium that took place in 2013. Today the area is still the starting point for most current discussions on the issue, and it is closest to becoming a mine that extracts radioactive materials in Greenland.

On October 24, 2013, the Greenlandic newspaper *Sermitsiaq* wrote, "A majority in Inatsisartut [The Parliament of Greenland] has adopted the abolition of the zero tolerance on uranium. Fifteen voted in favor [of the abolition]. Fourteen against." [1] This means that the decision was passed with the lowest possible margin; the majority was obtained with only a single vote. Usually, decisions in parliament are addressed over a long time span, but the first time the parliament treated the issue had been only three weeks earlier, leaving very little time for the Greenlandic people and environmental organizations to react. The abolition paved the way for Naalakkersuisut (The Government of Greenland) to process applications for mining projects for uranium and other radioactive minerals, both as by-products and as main products. [2]

Aleqa Hammond was Naalakkersuisut Siulittaasuat (Premier of Greenland) in 2013. She stated that her reasoning for abolishing the zero-tolerance policy on uranium mining was the need for economic growth: "We cannot live with the unemployment and the living cost rising while our economy is stagnant. It is therefore necessary that we abolish the zero tolerance for uranium now." [3] A minority consisting of Inuit Ataqatigiit and Demokraatit had demanded a postponement of the resolution until a nationwide referendum was held, but the amendment to postpone the decision and the referendum was also rejected by a small majority.

Greenland has very little mining experience. Currently, there are two active mines, one in South Greenland where gold is excavated and one in West Greenland not far from Nuuk, where Greenlandic rubies are excavated. As of my writing, no current or former mines are excavating radioactive materials. However, since the abolition of the zero-tolerance policy in 2013, interest in excavating uranium has been rising, and news from May 2020 confirms that several companies now have exploration permits in the area, including the French state-owned company Orano, which only works with uranium.[4]

The privately owned company Greenland Minerals has been required by law to report on its projects' environmental and social impact; their VVM report has been pending for a long time. A version of the report was rejected in 2018, but a new, updated version was submitted to the department of minerals and foreign affairs in 2020 and was released for a public hearing on December 17, 2020. The hearing was then postponed until March 12, 2021.[5] As I write this, the media are preparing articles and debates to be published in the following months, as discussions around the VVM report continue.

In 2018, *Sermitsiaq* called the situation concerning uranium "the most inflamed political issue of recent times."[6] In 2009, Greenland elected to transition from Home Rule to Self-Government[7], and the Self-Government Act went into effect on June 21 of that same year. With Self-Government, Greenland gained the right to its own land. Mining in general was a key part of the discussions during the election. When the Government of Greenland voted to abolish the ban on uranium extraction, it was therefore exclusively a Greenlandic decision. Many Danish politicians opposed abolishing the ban, calling the decision a national security issue—a political area still governed by the Danish parliament. This created a lot of tension in the political relations between Greenland and Denmark; Denmark still holds a zero-tolerance policy toward radioactive materials.

The embodied pain
Since the beginning of the twenty-first century, there has been increased discussion about mining uranium in Greenland. The most well-known artistic interpretation of this discourse was Bolatta Silis-Høegh's direct and brute solo exhibition entitled *Lights On Lights Off* (2014). The exhibition contained large-scale, gloomy, dramatic self-portraits, many of which contained blood, which Silis-Høegh created as a direct reaction to the Greenlandic government's abolition of the ban on uranium in October 2013. Silis-Høegh has explained how she fell physically ill when the ban on uranium was lifted, and how this forced her to create artworks in response. It was only partly because of the actual lifting of the ban that she was enraged; she also felt that the people of Greenland had not been properly informed or consulted in a process that only took three weeks from proposal to the lifting of the ban. In the show's exhibition catalog, art

historian David Winfield Norman writes, "This was the spark that inspired Bolatta's rage, embodied in blood and scars, her naked flesh conveying both vulnerability and the raw source of these emotions. From this source Bolatta turned to painting in an act of expressive necessity."[8]

Silis-Høegh' painting *Outside* (2014–2015), featured in *Lights On Lights Off*, is two meters high and depicts the profile of a naked female body with the bloody skull of a sheep. The body is the artist's own. She holds her hands on her belly, suggesting she is carrying a child. Silis-Høegh is from South Greenland and knows the town Narsaq very well. From Narsaq the mountain Kuannersuit is visible, as is the camp surrounding the area where the first mine excavating uranium will be. The area of South Greenland is known to Greenlanders as the pantry of Greenland. The whole area is covered with the numerous sheep farms for which the area is known, and whose meat is sold all over the country. By situating her hands on her belly and replacing her own head with that of a sheep, Silis-Høegh is referring to the fact that reproduction in areas with radioactive contamination often results in deformations to both humans and animals. She is addressing how long-term, generational damage might affect both animals and humans in South Greenland. Is it a woman with a head of a sheep, or a sheep with the body of a woman?

In November 2020, I presented works by Bolatta Silis-Høegh at a panel for a conference in Alta, Norway. The conference was called Eadnámet Maid / Nunarput Aamma / Land Too, was arranged by the Sápmi artist collective Daidda Dallu in Kautokeino, and focused on violence and the abuse of nature.[9] At the end of the panel discussion, the moderator commented that he could see a similarity in the way Sápmi artists and Greenlandic artists address the abuse of land in their works. He noted that the artists feel the pain conducted on the land as pain in their own body—bruises on the land become bruises on the body. Though this is not true for all Greenlandic artists working on environmental issues, there is some truth to it. Silis-Høegh's work is a direct response— she felt physically ill when the ban was lifted—not just a reflection, not just a concern, but an embodied physical retort.

Like Silis-Høegh, the Greenlandic artist Ivinguak Stork Høegh has been making several works of art that reflect directly on the mountain of Kuannersuit. The seriousness, pain, and darkness in Silis-Høegh's works of art are also present in Stork Høegh's artworks, although the latter artist manifests those emotions through humor and bright colors. Her digital artwork *Qaartorsuaq* (2016), which in Greenlandic means the big explosion, features a beautiful mountain range with a big explosion above. The scene is similar to an action movie's typical huge blasts and fires. The mountain that is blasted away in

the paintings is the mountain of Kuannersuit. Below the work's dramatic and playful surface is a serious concern for the beautiful nature that will be destroyed, as well as how the mining may create a boom of environmental crises in the area. There has been a lot of talk about dust containing uranium, and how dust from mining will slip through and enter drinking water, plants, and surrounding areas. In Stork Høegh's artwork, one can almost feel the dry dust from the explosion spreading on the beautiful landscape around the mountain. Stork Høegh's works often combine images of the unfamiliar with the familiar, the local and the foreign. Her works ask, what if we made a mine and it exploded in smoke and dust?

The Greenlandic performance artist and poet Jessie Kleemann, like Bolatta Silis-Høegh, works with her own body, but directly on the land. Her video performance *Arkhticós Doloros* (2021) is followed by a poem that reads in part, "nunap issua tassa uanga issora soil on arctic lands, it is as you know my body of soil," and establishes a direct connection between body and earth.

The video begins with images of the icecap of Greenland. The sun is shining brightly, and a large river of melted ice is visible in the background. In spite of the sunlight, the scene is obviously cold and windy. In the foreground, on the cold ice of the Sermeq Kujalleq Glacier close to the town Ilulissat, Kleemann struggles inside a huge swath of black fabric. She stands barefoot on the soaked, ice-cold fabric, the sun melting the ice, and the wind pushing and pulling as she struggles to hold onto the black fabric. The wind and the cold are overwhelming.

With this performance, Kleemann is subjecting herself to the damage inflicted on the ice trough global warming, and failing to cope with the pain. Her movements underscore the idea that we are the ones who end up suffering from the same pain that we inflict on the earth. By the end of her performance, she cannot bear the cold and the ice; she has to stop. This embodied feeling of pain is a similar embodiment as that of Bolatta Silis-Høegh. Silis-Høegh does not inflict the pain, but feels it nonetheless. Kleemann ends up crying, yet strong, powerful, and resilient. It is that kind of embodiment of pain that the moderator of the Sápmi conference in Alta was referring to.

"Arkhticós Doloros means that we are all in it: it is my pain, it is the artic in pain, I am in pain, the Great Polar Bear is in pain right now," Kleemann writes in her reflection of *Arkhticós Doloros*.

In general, Greenlandic artists are engaging with discussions that affect land that is close to their homes. Currently, the discussions about mining, and especially mining radioactive materials, are taking place in offices by political and economic operatives in the capital of Greenland, Nuuk, as if the questions uranium mining raise are hypothetical. The artists I discuss above show that the issues have a concrete ground and impact, that the land in question is an actual place with animals, mountains, and life.

From looking only at Greenlandic artists, one might get the impression that there is a lot of resilience against uranium mining. This might be true in the art world, but it is not all true for the rest of the public. Here in Greenland, the discussion has created two separate camps. The environmentalist are afraid, enraged, and are fighting against the mining projects. But for many people in Narsaq, the prospect of a mine at Kuannersuit is a dream come true. Many eagerly anticipate the opening and argue that the planned mine in Kuannersuit will create jobs, infrastructure, and general economic growth in the town, which in recent years has suffered from a decreasing population and widespread poverty.

At this moment, people are responding to the VVN report, and despite the coronavirus, language issues, and much more, it still seems true that the situation around uranium is "the most inflamed political issue of recent times," and that it will continue to be so in the following year.

Endnotes

1. "Nultolerancen over for uran er ophævet," *Sermitsiaq*, October 24, 2013, accessed March 24, 2021, https:// sermitsiaq.ag/node/160145. Translated by the author.

2. "Nultolerancen over for uran er ophævet," *Sermitsiaq*.

3. "Nultolerancen over for uran er ophævet," *Sermitsiaq*.

4. "Fornyet uran-interesse bekymrer miljøorganisation," *Sermitsiaq*, May 3, 2020, accessed March 24, 2021, https://sermitsiaq.ag/fornyet-uran-interesse-bekymrer-miljoeorganisation. Translated by the author.

5. The full VVN report is available online: https:// naalakkersuisut.gl/da/H%c3%b8ringer/Arkiv-over-h%c3%b8ringer/2020/1812_kuannersuit.

6. "Krigen om uran vil blusse op igen," *Sermitsiaq*, September 18, 2018, accessed March 24, 2021, https:// sermitsiaq.ag/krigen-uran-blusse-igen. Translated by the author.

7. Home Rule was the first parliament of Greenland and was established in 1979. It moved the political decision making from Denmark to Greenland on specific areas. But decisions regarding land and mining were kept in Denmark until Self-Government was obtained in 2009. The Danish parliament is still involved in political decision-making regarding certain areas such as foreign affairs, defense, and national security.

8. David Winfield Norman, "Preface," *Lights On Lights Off* (self-published, 2015), 3.

9. Dáiddadállu Artist Collective website, accessed March 24, 2021, https://www.daiddadallu.com/eadnametmaid-5-8-november-2020/. Translated by the author.

10. "Krigen om uran vil blusse op igen," *Sermitsiaq*.

WHEN THE WIND BLOWS: OKI AND KOHEI FUJITO

Satomi Igarashi

The traditional Ainu costume is decorated with a series of embroidered wave and spiral patterns with thorns protruding on all sides decorating the collar, sleeves, and hem. This is because Ainu patterns with thorns are believed to protect the body from demons, just as plants protect themselves with needle-like thorns. Kohei Fujito (1978–) is an Ainu artist. He combined 120 iron plates designed with Ainu patterns for the exhibition *Exposure*. In the center of the object, a painted deer skull is held high. The Ainu revere all things in the universe as *Kamuy* (meaning "deity" in the Ainu language). The most powerful and highest-ranked *Kamuy* is the brown bear; the deer is *Kamuy* as well. The meat of the deer is used as food, and its fur is used as clothing to protect Ainu from the cold. Kohei says that he wants to respect the deer as *Kamuy*, as they were indispensable to the Ainu way of life. The deer skull has wider antlers and seems to be looking around. How does *Kamuy* see the world today?

In March 2011, invisible demons spread from a small Japanese port facing the Pacific Ocean. They flowed noiselessly, odorless, on the wind northeast to the Pacific Ocean, southward, raining down and dispersing further west, north, and south. March 11, 2:46 pm. The massive 9.0 magnitude earthquake and tsunami struck eastern coastal regions of Japan, causing a devastating accident at the Fukushima Daiichi nuclear power plant in Fukushima Prefecture. The reactors in Units 1, 2, and 3, which were in operation, were automatically shut down, but the external power supply was lost and the core could not be cooled. Nuclear fuel melted in Units 1, 2, and 3. The pressure vessels of those reactors melted down. According to the International Nuclear and Radiological Event Scale (INES) of the International Atomic Energy Agency (IAEA), the accident has been certified as level 7, the worst nuclear accident in history, equaling Chernobyl. According to a report by Tokyo Electric Power Company, Incorporated (TEPCO) and the Japanese government's Fukushima Nuclear Accident Independent Investigation Commission, the amount of radioactive material released into the atmosphere from Units 1, 2, and 3 were approximately 900 Peta becquerels. This is one-sixth of the amount released at Chernobyl. However, Eiichiro Ochiai, chemistry PhD, points out that this is an

underestimate. At the time of the accident, all of the radiation monitoring posts installed around the facility were inoperative due to the loss of power. The dispersal of radioactive material was only an estimate based on measurements that could be taken on land. We don't know how much has leaked into the Pacific Ocean. In other words, no one knows the exact amount.

On August 6, 1945, a uranium bomb was dropped on Hiroshima City. Three days later on August 9, a plutonium bomb was dropped on Nagasaki City. On March 1, 1954, a Japanese tuna fishing boat, *The Lucky Dragon No. 5*, was exposed to radioactive fallout from the US hydrogen bomb test Bravo at Bikini Atoll near the Marshall Islands, exposing twenty-three crew members to radiation. Then, on March 11, 2011, the Fukushima Daiichi Nuclear Power Plant suffered an accident. Hiroshima, Nagasaki, *The Lucky Dragon*, and Fukushima are synonyms that should not be forgotten when discussing nuclear disaster and contamination. They have also become subjects that cannot be overlooked when discussing contemporary art. In Hiroshima, 140,000 people died. In Nagasaki, 74,000 people died. The testimonies of those who survived the hellish disasters have been made into books and movies. To keep the memory of Hiroshima and Nagasaki alive, artists have created requiem sculptures and paintings, as well as video works wishing for nuclear abolition. *The Lucky Dragon No. 5* was operating 160 kilometers east of the point where the bomb was dropped; however, white ash fell for four to five hours, exposing the crew to external and internal radiation, and six months later, one of them died. Based on this incident, the movie *Godzilla* was produced. The movie was released in November 1954 and featured a monster that had been forced to flee its home due to hydrogen bomb testing. Some books and a brass band piece were also produced about this incident. In 1960, Ben Shahn (1898–1969) used the incident as a motif for his series of paintings *The Lucky Dragon*. Fukushima has also been a significant theme in the work of artists living in Japan, as it has greatly affected their minds. They are attempting to visualize the invisible radiation. They give form to the fear of not being able to escape from it, and specialize in the reality of Fukushima, presenting it as a problem to be confronted.

One such artist is OKI (1957–), an Ainu music producer and player of the traditional Ainu instrument, the *tonkori*. He not only carries on the tradition but also believes in the new possibilities of Ainu music. His DUB AINU BAND has been participating in music festivals around the world since 2004, including World of Music, Arts, and Dance (WOMAD Festival). OKI is also one of the artists who was shocked by the Fukushima accident and could not help but take action. He says he was moved by Rankin Taxi's (a Japanese reggae musician) anti-nuclear song "You Can't See It, and You Can't Smell It

Either" right after the Fukushima nuclear accident. In April 2011, Rankin Taxi rewrote its lyrics and OKI's DUB AINU BAND joined him for a new recording.[1] The song is comical and cynical. Rankin Taxi sings, "Radioactivity is strong, no one can beat it. It doesn't discriminate, no matter who you are. No one can escape. And it's not fair because you can't see it or smell it." This is the message of the antinuclear protest groups, who often employ dark humor. The song was distributed as part of the East Japan Earthquake Relief Project. After releasing it, OKI stated on behalf of the Ainu at the Permanent Forum on Indigenous Issues held at the United Nations Federal Building in New York City on May 25, 2011, "Those who worshiped nuclear power created a safety myth. The myth was that it was safe, that it would never leak, and that it could withstand an earthquake. But the reactor that was supposed to be able to withstand any tremor had a meltdown. The myth of safety has collapsed. Now we are watching the radiation leaking out of the reactors, helplessly. Every day, unimaginable amounts of radiation are spreading, and the contamination of crops and marine products is increasing." He said that radiation, which no one can control, is the worst demonic god with eternal life, and emphasized the importance of Indigenous peoples joining forces and taking a step toward nuclear abolition.

OKI lives in Hokkaido, a northern island of Japan and one of the first Ainu settlements. Right now, there is an ongoing debate in Hokkaido about whether to accept nuclear waste. This reminds me of an Ainu man who asked a power company that had purchased land for a thermal power plant in Hokkaido, "Did you also buy the sky and the sea?" In 1973, Ainu fishermen were opposed to the construction of thermal power plants because they would destroy the environment. This was before the same power company built a nuclear power plant in Hokkaido. Now, in Hokkaido, surveys have begun to select sites for the disposal of high-level radioactive waste in Suttu Town and Kamoenai Village. Both have Ainu names that have been retained, and *Kamoenai* means "beautiful divine stream" in the Ainu language. Noriko Ishiyama, a professor at Meiji University, declared, "We need to listen to the voices of the people who live there now, the Indigenous people who see the land as their homeland."

The aforementioned Kohei Fujito lives in Akan, Hokkaido, with his family. While he uses traditional techniques to create his wood crafts, he also creates works using iron and acrylic materials. He chooses materials and uses modern techniques without being concerned with tradition. He says," If the old Ainu had any new techniques, I'm sure they would have adopted them. I think the Ainu way of making things is to create what is needed now, regardless of the genre or method." For the works in *Exposure*, the Ainu patterns were cut out by applying a laser to a steel plate. One side of the iron plate is covered with red rust, corroded by the invisible oxygen in the air. Kohei tells us the

following: "When the accident at the Fukushima nuclear power plant occurred, I became hypersensitive to the direction of the wind and closed the curtains around the house. I realized that I could not protect my family. I wanted to make curtains that would be able to protect my family, and this work was born."

We cannot directly see or feel the demons known as radiation. All we can know is the amount of radiation measured by a Geiger counter. But is this amount correct? Are the measurements on a Geiger counter all there is? For the Ainu, the wind is also one of *Kamuy*. The *Kamuy* of the wind brings invisible demons. When the wind blows, can we protect ourselves from that wind?

Endnotes

1. *You Can't See It, and You Can't Smell It Either*, 2011, produced by OKI and released under the name of Rankin Taxi & DUB AINU BAND. The music video was directed by Takahiro Morita. The English subtitles are by Peter Barakan, a broadcaster in Japan.

STONES, SPIRITS AND THE UNMASKING OF THE COLONIAL IN NUCLEAR NARRATIVES

Tania Willard (Secwepemc Nation)

I am not sure I can imagine what my ancestors would have thought of nuclear energy and the nuclear bomb. I am not sure I can even today conceptualize the awesome power and destruction; maybe none of us can. We rely on reports, scientists, digested information that we try to assimilate into a picture, a picture that is simultaneously now, our past, and our future. The atoms of time itself are split—time is nuclear, geological, not human, though it has signaled the Anthropocene. Artists and artwork can help us do more than conceptualize what is incomprehensible in terms of nuclear impacts—they can make us feel it. Through feeling nuclear histories, their impacts and their futures, we can remind ourselves that though nuclear time is beyond our time it also implicates generations of our future ancestors. Perhaps we can remember earth time in our bones in the same way radiation stains everything it touches—what is left of the signature of spirit? In *Exposure: Native Art and Political Ecology*, Indigenous artists Carl Beam, Bonnie Devine, David Neel, and Adrian Stimson remind us of this marrow memory and its influence on futurity: a warning in your blood, a sickness that makes your hair fall out, things that need earth time to heal.

The late Carl Beam, an Anishinaabe printmaker, featured atomic bomb architect Albert Einstein several times in his print-based work. His portraits of Einstein were shown in the Vancouver Art Gallery's 2018 exhibition *BOMBHEAD*, curated by Canadian curator John O'Brian, who has also theorized about the atomic bomb in photography in *Camera Atomica* (2015) at the Art Gallery of Ontario. In his catalogue essay for *BOMBHEAD*, O'Brian says, "Art tells us about nuclear threat by making it visible through representation."[1] I would add this is in contrast to the invisibility of radiation. What Indigenous art about the nuclear makes visible is two-fold: it visualizes untold stories of Indigenous peoples and lands as part of nuclear testing and mining, as well as the spirit of the sickness that Indigenous people saw long before the splitting of the atom. Mita Banarjee points to this two-fold perspective in her important writing on the history of Indigenous rights and nuclear testing in the Marshall Islands in the Pacific: ". . . given that the consequences of nuclear testing in allegedly 'remote' parts of the globe had to

be borne by Indigenous populations, nuclear testing also raises questions of Indigenous rights."[2] This link is critical to the works in this exhibition, as it connects the already established trajectory of cultural genocide and ecocide as strategies of settler colonialism and capitalism to nuclear destruction as the inevitable outcome of settler colonial politics.

In one striking image by Carl Beam these links are made even more evident. In *Sitting Bull and Einstein* (ca. 1990), the artist juxtaposes photographic images of the two eponymous figures. We see Sitting Bull on top of the picture plane as an inversion of Western systems that would usually place the genius of Einstein on top. Instead, we are asked to think of the genius of Indigenous ways of knowing that warn against the disconnected rationalism that Western science represents. Here spirit is stronger; in this image we are not vanishing. Sitting Bull assumes what Jolene Rickard refers to as "visual sovereignty,"[3] which destabilizes our common attributions of the coming of the Atomic Age. Beam's composition alludes to the deep disparity in the valuation of Indigenous knowledge, which Mita Banarjee characterizes as "a difference in legal and cultural epistemologies."[4] These differences or strategies of the genocide of Indigenous peoples in the Americas underlie the land theft, disease propagation, cultural loss, and forced assimilation in the experience of Indigenous peoples under colonization that simultaneously hearkened a new age, the Atomic Age, wherein the "legitimacy of nuclear testing was hence made discursively possible by the myth of the vanishing Indian, or the "nomadic savage."[5] In Beam's visual inversion he makes Sitting Bull seen. He un-vanishes him, and in doing so surfaces Indigenous rights—not only environmentalism, but cultural, social, and political Indigeneity.

In Adrian Stimson's work *Fuse 3* (2010), the artist restores the Buffalo through painting and depicts this relative against the background of a nuclear explosion. This work, exhibited originally in conjunction with other works dealing with nuclear histories, *Bison Fission* and *Fuse 1–4* (2010), again shows a hierarchy that places Indigenous rights, histories, and knowledges ahead of atomic representation. In an essay about this body of work, Lyn Bell states, "Stimson crumples and folds time, bringing the past of the buffalo holocaust and the present moment of nuclear time together in the space of the gallery. In these atomic visions, the past keeps returning as the future, invoking the hidden history of 'radioactive colonialism': a history of nuclear tests, uranium mining and nuclear waste disposal on Indigenous lands across North America, including Northern Saskatchewan."[6] In his *Fuse* series, Stimson examines the histories of uranium mining in Canada within Indigenous lands and territories and equates the impacts of the destruction of the Buffalo as a representation of colonialism. He explains, "The almost total annihilation of the Bison and the people that relied on them happened in a relatively short time, like the flash of an atomic explosion."[7] The mushroom cloud becomes akin to the archival images

of the inconceivable mountains of Buffalo bones from the mid 1800s[8] that signaled the progress of settler colonial culture. We now know this included nutrition experiments on Indigenous peoples, and the loss of the Buffalo was part of a strategy to compel them to submit to colonial authority and governance.[9] Those photographs of piles of buffalo bones *are* mushroom clouds to Indigenous people—they are the sharp and explosive fission of our lands and cultures split away from us.

Stimson's *Fuse* series comments on landscape painting of the Americas by inverting the compositional focus, the wintry land is in the distance whereas the central buffalo becomes a representation of the landscape, and the mushroom cloud in the background is a document of the devastation of settler colonial impacts on Indigenous people and lands. Wherein the settler landscape artists often disappeared Indigenous people from the land, Stimson discusses in his artist statement how *Fuse* disrupts the Canadian landscape, "inserting indigenous ecologies into the dialogue and interrogating the violence and trauma that is the history of the colonial state."[10] Bell writes further about Stimson's imagery of the atomic bomb: "In the metaphor of the A-bomb, Stimson summons up the destructive power of the West's human-centric technological worldview and the irreversible harm it has done to the lifesystems of the planet." She continues, "In Stimson's exhibit, the image of the A-bomb has a double injunction. For viewers familiar with Indigenous prophecy, the shape of the atomic plume can also be read as the gourd of ashes in Hopi prophecy."[11] In Stimson's fission he splits open the colonial realities that reinforce ongoing colonial impacts, but he also reveals the potential of the Buffalo to supplant the force of the explosion, hinting at the power of Indigenous resurgence to overcome the legacies of colonial history and to present realities and unformed futures. Stimson poses a series of questions in his statement about the work that continue to be relevant: "Given the magnitude and destruction that the colonial project had and continues to have on First Nations and the environment, can this be forgiven? Or is the settler nation Beyond Redemption?"[12]

In Anishinaabe artist Bonnie Devine's installation *Phenomenology* (2015), a simple stone accompanies a series of ghostly, figural muslin sheets. The stone is a uranium rock from Serpent River Ontario, part of the artist's home territories. Curator John G. Hampton says of Devine's installation, "Bridging Anishinaabe understandings of the Manitou (spirit) within stones and Western scientific/industrial understandings of radioactivity, Devine makes manifest our immaterial relationship with the material presence of stones, and with the energy they emit."[13] A simple stone contains within its stone-spirit the possibility of incalculable damage; this is one example of how Indigenous peoples have deep respect for their lands. Our land holds this power—this stone holds the power that was left in peace for many human lifetimes but that settler colonialism and

imperialism unleashed. What ghosts have they created? In 1953, uranium was found in a mountain sacred to Anishinaabe people near Genaabaajing, the Serpent River First Nations Reserve, and the subsequent mining led to a poisoning of the entire Serpent River watershed. Poisoning a river leads to another mountain of bones, an extinction of spirit that welcomes the death culture of colonization. The emittance, the radioactive signature, of this stone sits silent and loaded in the center of Devine's installation. It holds the weight and spirit of the stories of the lands and waterways poisoned. I read the figural muslin sculptures that accompany it as specters of colonial history and simultaneously as flags of peace and of surrender, a surrendering not to colonization but to the power of the land, a commitment to respect the power of this stone. The languid shapes of the white markers attached to wooden stakes are described by Devine in her artist statement: "Ninety-two maple stakes are draped with strips of white gauze. Lined up in a row outdoors they flutter in the wind quite prettily, but ninety-two is uranium's atomic number and represents the ninety-two protons and ninety-two electrons in a uranium atom."[14]

In picturing nuclear disaster, Paula Rabinowitz writes about the instantaneous moment of an atomic explosion in contrast to the longevity and invisibility of radiation exposure: "This management of time, and thus death, occurs through manipulations of scale; moving in and out of past, present and future reconfigures temporal relationships, because the duration of pastness and futurity, each of which is infinitely long, gets exchanged for the immediacy of the present instant."[15] This present instant becomes a memorial in Devine's installation, a memorial to untold stories, Indigenous histories, knowledges, lands, and waters. In her essay "Indigenous Artists Against the Anthropocene," Jessica Horton argues that rather than relegating contemporary Indigenous artists' works to a category of identity art, they should be understood as a continuum of critique of ecocide as linked to settler colonialism. Horton contextualizes Devine's works, including *Phenomenology* (2015), *Radiation and Radiance* (1999), and others, as important precursors, along with that of other Indigenous artists, of intellectual debate and critique leading to the urgency of climate change today.[16] Devine has described her work as "an attempt to construct a model of a uranium atom using materials from memory and imagination." It is this Indigenous creative sense that in my view deepens the weight of feeling, as opposed to the unfeeling facts of nuclear science. We know that as uranium decays the unstable nucleus emits ionizing particles, but when we can marry that knowledge with the fluttering of the ninety-two white gauze flags in Devine's installations we can more fully understand the unseen, the gentle haunting through time. As the wind blows constant so do the persistent effects of uranium mining in the Serpent River watershed, which have never been fully remediated. In this way, as Horton observes, "Devine uses poetic forms to grasp the enigmatic nature of uranium.

Her decades-long endeavor stemmed from childhood observations of the conical piles of glimmering yellow tailings, byproducts of the mining process that are at once beautiful and highly toxic, strewn through her community." As Horton importantly situates Devine's work in the eco-critical canon, we see how the important work of Indigenous artists in articulating colonial impacts is layered onto histories of the Atomic Age, as a continuation of settler colonial destruction.

This animate universe of indigeneity wherein a uranium stone demands respect is also a universe where the intangible, in contrast to the measurable in Western thought, are important carriers of knowledge. In song, in art, and in music these knowledges can be released and/or revealed. In this way a mask is not only a disguise but a becoming. In David Neel's *Chernobyl Mask (Allusion to Bakwas/Nuclear Disaster Mask* (ca. 1993), a Northwest Coast style cedar mask is painted with large nuclear power plant cooling towers in the center of its forehead. Referring to the proliferation of nuclear energy and to the recent memories of nuclear disasters like Chernobyl, Three Mile Island, and Fukushima Daiichi, Neel's mask can be thought of as animate, as a being itself. Neel describes a particular mask inspired by "the Bukwis, or Wild Man of the Woods, which is a character from Kwakwaka'wakw culture. He is the Chief of the Ghosts and he tricks people into eating his food, which may be disguised as a delicious salmon but is in fact grubs or rotten wood. Afterwards, his victims are trapped in the land of the ghosts."[17] Is this where we find ourselves today in the post-nuclear age: in a land of ghosts? Implicating our humanity, this mask becomes a history lesson, the history of our ongoing presence of destruction and what Zoe Todd refers to as "Indigenizing the Anthropocene."[18] Todd argues precisely for the importance of decolonizing Western colonial policies and concepts that are the architecture of the Atomic Age, or what we might refer to as the "Settlerocene." In Neel's mask the iconic nuclear cooling tower inhabits the third eye of the mask, pointing to conception, to thought, and perhaps the danger of pure rational thought devoid of spirit. The invisibility of the trauma of rational science on the world is animate, and perhaps when we can see it we can banish it, when we feel this loss, when we can visualize genocide, we will heal the splitting that rhetorical theorist and critic Danielle Endres in her essay on Yucca Mountain nuclear waste siting calls "nuclear colonialism."[19] Nuclear colonialism, Endres goes on to say, was an idea coined by Ward Churchill and Winona Laduke variously as radioactive or nuclear colonialism and points to the disproportionate and discriminatory histories of nuclear mining, testing, waste storage, and hazards on American Indian communities.

In their works, Beam, Devine, Neel, and Stimson all reveal an emotive, experiential, and deeply critical interrogation of the nuclear story as the absence of Indigenous voice along with intrinsic links to settler colonialism. My curatorial selection for *Exposure*

was intended to spark not a detonation, but an implosion of the interiority of settler colonization. The persistent effects of radiation in the environment and in the body are layered with the persistent, invisible, and harmful effects of colonization. The need to unmask and accuse the roots of nuclear arms as tied to the same ideologies that gave rise to colonial and imperial power are felt within the works of these artists. They pose questions not only about nuclear power but about colonial power—where does it seep? The mushroom cloud is more than just a visualization of an atomic bomb; it is a reinforcement of Indigenous prophecy, an oral and mnemonic archive of the destruction and the ongoing impacts of settler colonialism globally. We need to return to a culture of respect—we need a resurgent power to heal these scars, these piles of bones, this ongoing genocide of spirit. We need a stone, a surrender, an inversion, a conversion, a mask to help us feel the incomprehensibility of nuclear crimes. If we let these spirits speak, what will they tell us?

Endnotes

1. *BOMBHEAD*, exhibition catalogue, Vancouver Art Gallery, 2018.

2. Mita Banerjee, "Nuclear testing and the 'Terra Nullius Doctrine': From life sciences to life writing," in *Property, Place and Piracy*, ed. James Aranitakis (New York: Routledge University Press, 2017).

3. Jolene Rickard, "Diversifying Sovereignty and the Reception of Indigenous Art." *Art Journal* 76, no. 2 (Summer 2017): 81–84.

4. Banerjee, "Nuclear testing."

5. Banerjee, "Nuclear testing."

6. Lynn Bell, *Adrian Stimson: Redemption*, exhibition catalogue, Mendel Art Gallery, Saskatoon, SK, 2010.

7. Adrian Stimson, Artist Statement, 2020.

8. Pile of Buffalo bones, Saskatoon Public Library Local History Room Slide Collection, LH-2823.

9. James Daschuk, *Clearing the Plains: Disease, Politics of Starvation, and The Loss of Indigenous Life* (Regina, SK: University of Regina Press, 2013).

10. Stimson, Artist Statement.

11. Bell, *Adrian Stimson*.

12. Stimson, Artist Statement.

13. Bell, *Adrian Stimson*.

14. Bonnie Devine, Artist Statement, 2020.

15. Paula Rabinowitz, "Love the Bomb: Picturing Nuclear Explosion," in *The Routledge Companion to Photography Theory*, eds. Mark Durden and Jane Tormey (New York: Routledge, 2019).

16. Jessica L. Horton, "Indigenous Artists Against the Anthropocene," *Art Journal* 76, no. 2 (Summer 2017): 46–69.

17. David Neel, Artist Statement from personal correspondence with the author, August 31, 2020.

18. Zoe Todd, "Indigenizing the Anthropocene," in *Art in the Anthropocene: Encounters Among Aesthetics, Politics, Environments and Epistemologie*s, eds. Heather Davis and Etienne Turpin (Open Humanities Press, 2014), 241.

19. Danielle Endres, "The Rhetoric of Nuclear Colonialism: Rhetorical Exclusion of American Indian Arguments in the Yucca Mountain Nuclear Waste Siting Decision," *Communication and Critical/Cultural Studies* 6, no. 1 (March 2009): 39–60.

GOVE MINE

Siena Mayutu Wurmarri Stubbs

Dhuwalamdja Gumatj, Yirrkala, Arnhem region, Australia

I'm seven years old. The voices of the big kids at the back of the bus set the tone for the twelve-minute drive to the mining town Nhulunbuy. Gove. We round the corner out of Yirrkala and onto "the limit." The stretch of road in which an invisible line on a map determines the limit that alcohol is allowed to be consumed, as it is restricted from the dry area of my community. All I am focused on, as I sit in between my two best friends, Gawiya and Leila, is what song will play next on Gove FM.

The next landmark in the drive is the bridge. No, not a bridge for an inlet from the Arafura, nor a little river. It's the bridge over the Gove mine, so we don't have to disturb the big trucks while they work to dig up the land. The next step of the trip rounds another corner before the turnoff to town. At some point in my life, a huge mound of red dirt was placed here to hide the activity of destruction happening so close to the road. But the bus is high enough to see over. To watch the forest turn into a red desert stretching to the horizon.

In year ten, I actually applied to do my job experience at the mine. Hoping to match my dream to be a scientist that lived in a rainforest. The juxtaposition was uncanny. I was in the belly of the monster. After working there for three days, I asked to cut the experience short. Let's just say, I didn't find comfort in the fallen ceilings, deserted office spaces, and conversations of how long my colleagues had left until they were eligible to retire.

Whether we like it or not, the resources are running out. Fifty years is almost up. *It's okay. We'll pack up our mess. We have all we need. You can have your land back.* When this is all we've known for half a century, it's hard to think about how to piece the land back together.

Shakespeare knows, *Come what, come may, Time and the hour runs through the roughest day.*

UNDER THE CLOUD: EARLY NATIVE AMERICAN NUCLEAR ART BY JUSTINO HERRERA AND WILLARD STONE

Elizabeth Wise

At the time of my writing, the world is nearing the seventy-sixth year of the Atomic Age. Currently and in recent decades, Indigenous artists have been creating art that challenges the lacunae in Atomic Age scholarship, namely the absence of documentation of Indigenous experiences in relation to the era. The rife mistake in this is that often Indigenous experiences have been some of—if not *the*—most directly impacted by the nuclear development. Furthermore, today Indigenous peoples remain some of the most directly affected by it, as well as the least heard. Therefore, it makes sense that contemporary artists have made efforts to increase their visibility by taking on subjects related to nuclear proliferation and uranium mining. But even as these artists, many of whom are represented in *Exposure*, engage in this work, it remains important to acknowledge the absence in art historical discourse of engagement with Native American artists such as Willard Stone (Cherokee, 1916–1985) and Justino Herrera (Cochiti, 1919–2006), who utilized art to challenge the government-censored rhetoric of the new age as early as 1946 and the 1950s, respectively.

Considering the US government's remarkably successful concealment in the media of information concerning nuclear happenings and effects in general— including the media in occupied Japan[1]—Herrera and Stone explicitly rejected and challenged such censorship. Examples include concealed safety equipment and information from Pueblo workers at Los Alamos National Laboratory (LANL) and uranium mines[2], mushroom cloud photographs that focus on the scientific achievement and erase environment and people impacted by the explosions[3], and the pre-prepared statement for papers to quiet witnesses of the Trinity blast calling it a remote ammunition magazine explosion worthy of "negligible" concern.[4] Herrera's and Stone's explicit titles and representations demand deeper consideration of the "facts"—whether the government's chosen "facts," the concealed and unknown facts, or the ignored facts. In 1946, Stone's wood-carved sculptures *Birth of Atomic Energy* [Fig. 1], *International Peace Effort*, and *Our Atomic Baby* address the tension between Russia and the United States and his apprehensions of this new era's birth. In his 1950s watercolor *That is No Longer Our Smoke Signal* [Fig. 2],

FIG. 1, LEFT:

Willard Stone (Cherokee), *Birth of Atomic Energy*, ca. 1950

Wood, 24.25 × 7.375 × 7.375 inches

Gilcrease Museum, Tulsa, Oklahoma

FIG 2, RIGHT:

Justino Herrera (Cochiti), *That Is No Longer Our Smoke Signal*, ca. 1950s

Watercolor and pencil on paperboard, 14 × 18 1/8 inches

Smithsonian American Art Museum

Corbin-Henderson Collection, gift of Alice H. Rossin

Herrera depicts the ongoing presence of settler colonialism and its subsection of nuclear colonialism, as well as ongoing Pueblo culture resilience. His composition balances colonial institutions built within a Pueblo with the central, dominant assemblage of a mushroom cloud and capital cupola on a Pueblo man in traditional dress.[5]

In 1946–48, Stone was prolific as an artist-in-residence at the Gilcrease Museum in Tulsa, Oklahoma, during which he completed over forty sculptures, including the three Atomic Age works mentioned above. *Birth of Atomic Energy* was the first of these three works, and one of the two that Stone deemed his most important during the entire residency.[6] The carving reflects the intense seduction of science and achievement that propelled the Atomic Age into being with the creation of the atomic bomb. The idealized nude woman represents the Siren-esque allure of scientific success and power yielding blinders to any less advantageous—much less harmful—effects. The two arms representing Russia and the US are in a sense competing both to father and doctor this birth. In both the birthing and seductive senses, the contours of the arms represent "science working on cracking the atom."[7] As the hands pull apart, opening an atom, they create a lining resembling a vulva within which reveals the highly sexualized nude woman—a form synonymous here with the appeal and dangers of the atomic bomb. The woman and the stylistically sensual contours surrounding her seem to further resemble more detailed genitalia connected to sexuality and birth. By 1946, the mushroom cloud was already iconic. Therefore, her crowning mushroom cloud visually consecrates the sculpture's reference to the new era.

Our Atomic Baby further explores the birthing metaphor in *Birth of Atomic Energy*, though instead of a mature, nude woman, a baby represents the new era. Bottom to top, the narrative begins with the test tube of atomic science out of which spill "immature babies boiling out. . . to represent scientific failures."[8] Then, a mushroom cloud also plumes out of the tube upon which sits a baby armed with two knives and a cone-helmet engraved with another mushroom cloud. In Oklahoma, it is unlikely that Stone would have been aware of the unusually high infant mortality rate in the year after Trinity, about which the (LANL) and the US government refused to accept evidence[9], yet he has depicted stillborn babies flowing out of a test-tube, as well as a mutant baby born holding knives. Thus confluence of images speaks to his apprehensions of what the new age has unleashed. Indeed, the general critique in *Birth of Atomic Energy* and *Our Atomic Baby* seems directed toward the government-censored information available to the public.

While Stone's carvings reveal apprehension, blindness, and universal tension, in *That Is No Longer Our Smoke Signal* (ca. 1950s), Justino Herrera represents the continuing presence of settler colonialism. The composition's friar and church represent centuries of Franciscan priests' assimilation and warfare,[10] the school teacher represents the history of government-run assimilation schools, her "victory roll" hairstyle[11]—and the mushroom cloud—specify the World War II/early Cold War period, the US Capitol dome represents Manifest Destiny's attacks on Native Americans and the government's control of rhetoric and facts, and the white-coated scientist and mushroom cloud represent the onset of nuclear colonialism. The Pueblo man and woman occupy the unmistakable bottom of the column central to the composition and narrative. The Pueblo man overlaps with the center of the Capitol, and his upraised arm and finger point upwards leading the eye to the cupola, which aligns perfectly within the vertical cloud beam. Together, they lead the eye to the cloud's mushrooming expansion—as nuclear colonialism is a new expansion of settler colonialism. The couple's traditional dress depicts their defiance of total assimilation despite the continued presence of these institutions. Another subversive detail lies in the black, "un-enlightened" interiors, which are offset by the pale doors to the school and church, and the white-washed facades.

Herrera attended the Santa Fe Indian School from 1937–1940, where he learned the Studio Style of watercolor reflected here. This school began as one of the many assimilation boarding schools. In 1942, the US government acquired Los Alamos for the top-secret LANL: the new headquarters of the Manhattan Project, only fourteen miles north of Cochiti.[12] LANL carried out the experiments and construction of the world's first atomic bombs including "The Gadget," the very first successful atomic bomb. On July 16, 1945, The Gadget was tested in Alamogordo, New Mexico, at Trinity Site a couple hundred miles south of Cochiti, though the shock wave, sound, and light impacted varying radiuses, even breaking windows as far away as 180 miles,[13] and radioactive fallout spanned an area the size of Australia for months to come.[14] After serving a three-year tour in World War II, Herrera returned home. In this painting, he reveals his unique awareness of assimilation and settler colonialisms present for centuries on his culture, and now the new variant of nuclear colonialism forming near his home.

LANL was chosen for its complete isolation, except for the neighboring Pueblos and their ancestral lands, upon some of which LANL resides.[15] Many nearby Puebloans, including Cochiti, were hired for labor and housework, though uninformed of the top-secret project or risks. It would be years before comprehension of health or environmental effects would become more evident to these workers and communities. Scholar Dr. Valerie Kuletz wrote about the nuclear scene in 1998, but her observations

could have been written in the 1940s or today: "In this Indian country two landscapes—Indian and nuclear—meet at nearly every point of the nuclear cycle, from uranium mining to weapons testing to the disposal of nuclear waste." New Mexico remains a particularly active site for these activities.[17]

The title and central visual domination of the mushroom cloud in Herrera's watercolor directly connect Pueblo smoke signs and the atom bomb at the narrative's core. Presumably, the Pueblo man speaks the painting's title to the Pueblo woman with one arm around her and the other pointing up to the cloud. Reportedly, smoke signs have the ability to reach distances as far as 250 miles,[18] and a number of accounts prove their high efficiency to communicate messages. Such messages were critical to trade, ceremony, and warfare.[19] The cloud looms over the Pueblo, and the work's title implies that the Pueblo's tribally specific smoke sign has been subsumed. Considering these categorical purposes and the artist's comparison of an atomic cloud to a smoke sign insinuates cultural warfare. Indeed, settler and nuclear colonialisms and the proximity of LANL forced the trade economy into a cash economy, threatened and altered ceremonial life through legal and religious assimilation pressures.[20] Lands, ceremonial sites, waterways, and people also continue suffering the effects of nuclear contamination. Herrera subversively paints his awareness of the Atomic Age's impacts on Pueblo communities, if not his own Pueblo specifically, and the age's ties to systemic practices of settler colonialism.

Though these works by Willard Stone and Justino Herrera are nearly as old as the Atomic Age itself, they speak to issues that are as pertinent today as ever. Like the Atomic Age, settler and nuclear colonialisms have not disappeared. Dangers of atomic energy have slowly become less veiled, and atomic weapons maintain a central space within international tensions. Appreciating art such as Willard Stone's and Justino Herrera's further underscores the need for contemporary artists to continue to address the same, lasting issues in their current forms.

Endnotes

1. For more information on US government concealment on nuclear issues, see Leslie M.M. Blumes, *Fallout: The Hiroshima Cover-up and the Reporter Who Revealed It to the World*, (New York: Simon & Schuster, 2020), and Alison Fields, *Discordant Memories: Atomic Age Narratives and Visual Culture*, (Norman: University of Oklahoma Press, 2020).

2. See Fields, *Discordant Memories*; and Andrew G. Kirk, *Doom Towns: The People and Landscapes of Atomic Testing, A Graphic History*, illus. Kristian Purcell, (New York: Oxford University Press, 2017).

3. See Fields, *Discordant Memories*; Kirk, *Doom Towns*; and Blume, *Fallout*.

4. See *Clovis News Journal*, Clovis, New Mexico, July 16, 1945, 6.; Kirk, *Doom Towns*; and Ferenc Morton Szasz, *The Day the Sun Rose Twice: The Story of the Trinity Site Nuclear Explosion July 16, 1945*, (Albuquerque: University of New Mexico Press, 1984).

5. "Nuclear colonialism" was coined as a term in 1992 by Jennifer Viereck, a US activist of anti-nuclear weapons testing. For definition, see Elizabeth Tynan *Atomic Thunder: The Maralinga Story*, (Sydney: NewSouth Publishing, 2016), 3: "the taking (or destructing) of other peoples' natural re-sources, lands, and well-being for one's own, in the furtherance of nuclear development."

6. Carol Harolson, ed., *Willard Stone*, (Tulsa: Gilcrease Museum, 2009), 10.

7. Harolson, *Willard Stone*, 114.

8. Letter from Willard Stone to Martin Wiesendanger with description and drawing of recently completed work, "An Atomic Baby," July 13, 1946.

9. Robert Alvarez and Kathleen M. Tucker. "Trinity: The most significant hazard of the entire Manhattan Project," July 5, 2019, https://thebulletin.org/2019/07/trinity-the-most-significant-hazard-of-the-entire-manhattan-project#_edn1.

10. Christopher Vecsey, "Pueblo Indian Catholicism: The Isleta Case," *U.S. Catholic Historian* 16, no. 2 (Spring, 1998), 1-19.

11. Victory Roll style was popular 1940-1945, therefore associated with WWII.

12. The first closest is San Ildefonso Pueblo, which shares a border with LANL. LANL occupies ancestral lands of San Ildefonso. See Daniel S. Pava, "Tribal and Error: Beyond Consultation: Los Alamos National Laboratory and Its' Native Neighbors," PowerPoint presentation on August 7, 2018 at the Western Planner/Tribal Planning Conference in Ft. Hall, Idaho, 5, 11, 15. For more on the U.S. government's conflicting accounts of acquiring this land, see Groves, *Now It Can Be Told*, 67; Robert Jungk, *Brighter Than a Thousand Suns: A Personal History of the Atomic Scientists*, trans. James Cleugh, ed., (London: Harvest Book Harcourt, Inc., 1958), 129; and Bradbury Science Museum film: *The Town That Never Was*, https://www.youtube.com/watch?v=9LLzBWQY7m0.

13. Groves, *Now It Can Be Told*, 301.

14. Andy Kirk, *Doom Towns*, 276-277.

15. For example of nuclear colonialist mindset, see Groves, *Now It Can Be Told*, 415.

16. Valerie L Kuletz, *The Tainted Desert: Environmental Ruin in the American West*, (New York; London: Routledge, 1998), 12.

17. Fields, *Discordant Memories*, 67.

18. Ward Beers, "Fire and Smoke: Ethnographic and Archaeological Evidence for Line-of-Sight Signaling in North America," *Enduring Curiosity, Generous Service: Papers in Honor of Sheila K. Brewer* 40 (2014), 24.

19. Beers, "Fire and Smoke," 29.

20. For more on Bursum Bill and legal threats to ceremonial dances, see Sasha Scott, "Awa Tsireh and the Art of Subtle Resistance," *The Art Bulletin* 95, no. 4 (December 2013), 597-622; and J. J. Brody, *Pueblo Indian Painting: Tradition and Modernism in New Mexico, 1900-1930* (Santa Fe: School of American Research, 1997).

GLOSSARY

Anangu – Means "people" in Pitjantjatjara and Yankunytjatjara. It is used to define the group of Aboriginal Australians who live in the Anangu Pitjantjatjara Yankunytjatjara (APY) Lands.

Barama – Ancestor creator relating to the Yirritja moiety (Yolŋu Matha word)

Country – Proper noun. Country to Aboriginal Australians is sentient land; it encompasses more than just creeks, hills, rock outcrops and waterholes. Country includes all living things, seen and unseen. It includes people, animals, but also weather, seasons and Ancestors that have existed in place since time immemorial.

Dhuwa – One of the two balancing halves of the world (moiety), Yirritja or Dhuwa. They form a duality system that keeps past, present and future life in balance. (Yolŋu Matha word)

Gapu – water (Yolŋu Matha word)

Kapi – water (Pitjantjatjara word)

Kulata – spears (Pitjantjatjara word)

Kungka – woman (Pitjantjatjara word)

Kunmanara – Sorry Business name used instead of the name of a deceased person (Pitjantjatjara word)

Kupi kupi – mini tornado (Pitjantjatjara word)

Marali – The spiritual traveling of the ngangkari (Pitjantjatjara word)

Ngangkari – traditional bush doctors (Pitjantjatjara word)

Ngura – earth, land, Country (Pitjantjatjara word)

Piti – Pitjantjatjara word for the coolamon. The coolamon is a traditional carrying vessel or dish with curved sides that is unique to southeast and northeast Australia. Their shape is similar to a canoe and is used to cradle babies; carry water, fruits, or nuts; winnowing grains in the traditional bread-making process; and to protect against rain.

Tarnanthi – To rise, to come forth, spring up or appear (Kaurna word)

Tjilpi – senior men (Pitjantjatjara word)

Tjukula – rockholes (Pitjantjatjara word)

Tjuta – many (Pitjantjatjara word)

Yirritja – One of the two balancing halves of the world (moiety), Yirritja or Dhuwa. They form a duality system that keeps past, present and future life in balance. (Yolŋu Matha word)

Yolŋu – Means "person/people" in Yolŋu Matha. It is used to define the group of Aboriginal Australians who live in and around northeast Arnhem Land.

ACKNOWLEDGMENTS

The Ford Foundation, the Andy Warhol Foundation for the Visual Arts, as well as many collaborators made this publication and exhibition possible. A special thank you to the catalog co-authors and co-curators—iBiennale Director Dr. Kōan Jeff Baysa; Hokkaido Museum of Modern Art Chief Curator and Vice Director Satomi Igarashi; Nuuk Art Museum Director Nivi Christensen (Inuit); Art Gallery of New South Wales Assistant Curator of Aboriginal and Torres Strait Islander Art Erin Vink (Ngiyampaa), independent curator Tania Willard (Secwepemc Nation), and MoCNA Chief Curator Manuela Well-Off-Man—for advancing the scholarship of contemporary Native American art with their contribution to the exhibition and catalog.

I appreciate all the exhibition artists who generously loaned us their artworks for this exhibition. Many thanks to the Alberta Foundation for the Arts, Art Gallery of New South Wales, Art Gallery of South Australia, Australian War Memorial, Carleton University Art Gallery, Fondation Opale, Greenland National Museum, and the Seattle Art Museum for their generous art loans.

A special thank you to David Chickey, Mat Patalano, and Megan Mulry at Radius Books, who provided thoughtful guidance in the overall development of the publication, and to managing editor Chelsea Weathers who worked closely with the catalog authors to shape and fine-tune this publication. Her competence and exceptional editing skills greatly contributed to the quality of the catalog. Thank you also to content editor Manuela Well-Off-Man for overseeing this publication project and ensuring that all the content maintained a high standard in quality. And, thank you to the Art Gallery of New South Wales, the Estate of Carl Beam/Artists Rights Society (ARS); Michigan State University Museum; Seattle Art Museum and photographer Yasumasa Otaki for generously lending images for this publication. Thank you also to Laura Marshall Clark (Muscogee Creek) for her assistance with facilitating the roundtable planning meeting and for her research.

I am especially grateful to all the MoCNA staff for their dedication and commitment to the highest quality in everything they do. Special recognition goes to MoCNA exhibition coordinator and preparator Flannery Durán Barney who contributed to the success of the exhibition through her hard work and outstanding skills in mount-making and installation of complex works of art. Thank you also to MoCNA's graphic designer Sallie Wesaw Sloan (Eastern Shoshone, IAIA 2000) for lending her design skills to the project, and for securing image rights. And to senior manager of museum education Winoka Yepa (Diné) for her contributions to the educational experiences of this exhibition.

Patsy Phillips (Cherokee Nation)

Director, IAIA Museum of Contemporary Native Arts

CREDITS

cover: Detail, Gunybi Ganambarr, *Gapu*, 2017. Photography by Brad Trone

front endpapers: Detail, Alexander Lee, *The Dream of the Haere-pō*, 2021

back endpapers: Detail, Will Wilson, *Mexican Hat Disposal Cell, Navajo Nation* (from the series *Connecting the Dots*), 2020-2021

pp. 20–21: Details, video stills, APY Art Centre Collective, *Kulata Tjuta (Many Spears)*, 2017

pp. 22-23, 26, 28-29, 30-31, 32-33, 34-44, 77-79, 81, 84-85, 95, 98-99, 106-107, 113, 115, 121, 124-125, 151, 153, 155, 165, 167, 183, 185-187: Photography by Brad Trone

pp. 24-25, 27, 63-65, 87, 89, 101-103, 108-109, 111, 117, 119, 127, 128-129, 135, 141, 157-159, 161-163, 169-171, 173-175: Photography by Addison Doty

p. 91: Photography by Jeanette Philipsen and Petra Kleis

pp. 92-93 *Bolatta Silis-Høegh: Lights On Lights Off* © David W. Norman, originally published in 2015

Operating on the belief that the arts—all arts—are vital to our culture, RADIUS BOOKS is a 501(c) (3) non-profit organization with a focus on photography and fine art book publishing. In addition to publishing, Radius encourages aspiring artists through educational workshops and community events, and distributes books of artistic and educational value for a wide audience.

RADIUS BOOKS donates copies of every title we publish into a nationwide network of libraries and schools, with the hope and expectation that these books will reach and inspire new audiences.

RADIUS BOOKS
227 E. Palace Avenue, Suite W, Santa Fe, NM 87501
t: (505) 983–4068 | radiusbooks.org

Available through
D.A.P. / DISTRIBUTED ART PUBLISHERS
75 Broad Street, Suite 630, New York, NY 10004
t: (212) 627–1999 | artbook.com

ISBN 978-1-942185-90-1

Library of Congress Cataloging-in-Publication Data
available from the publisher upon request.

DESIGN: David Chickey & Mat Patalano
EDITING: Chelsea Weathers
PRE-PRESS: Dexter Pre-Media

Printed by Editoriale Bortolazzi-Stei, Verona, Italy

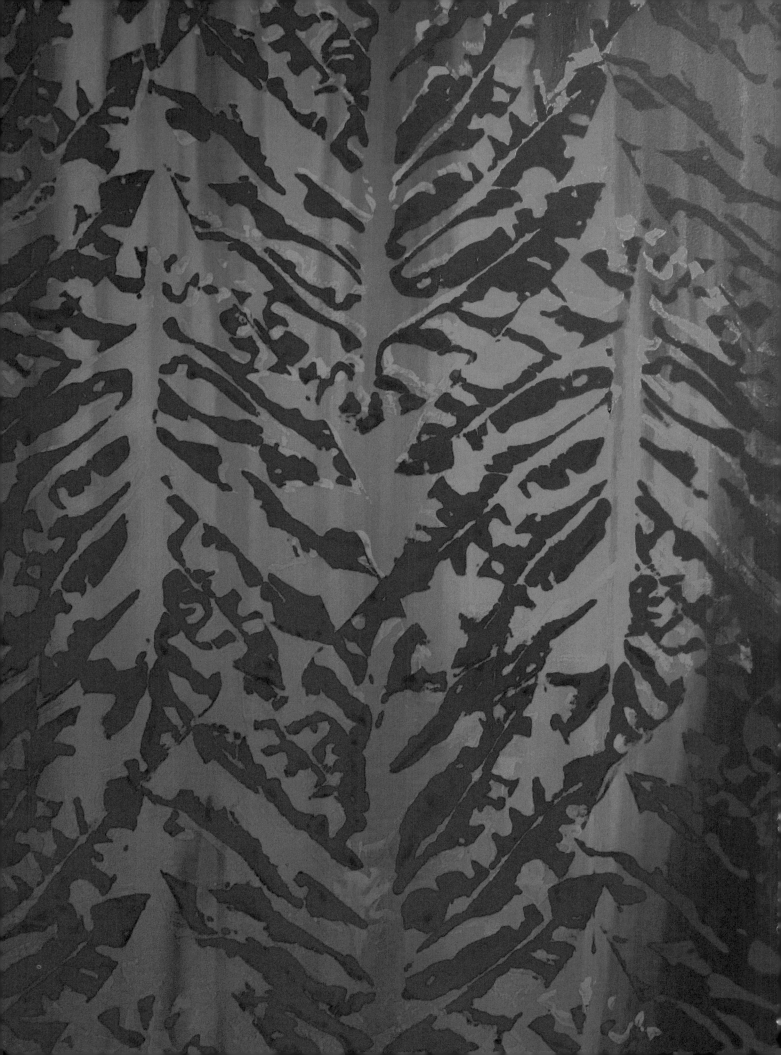